THE LEAGUE OF
LADY POISONERS

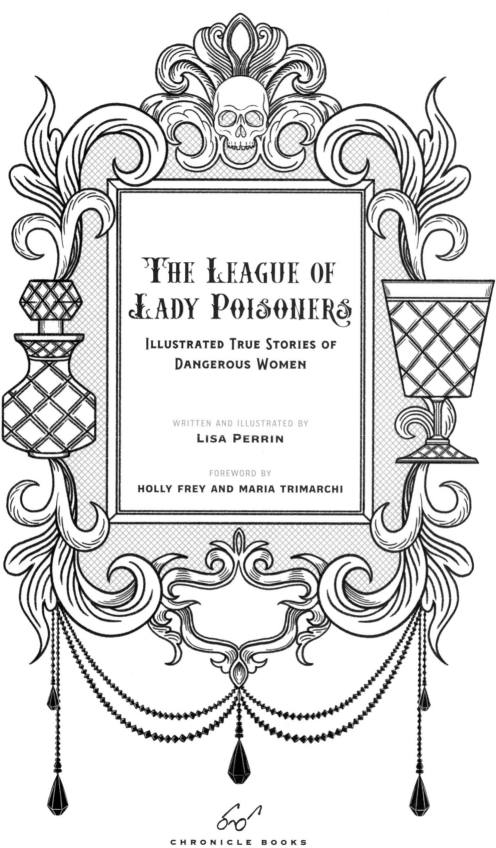

The League of Lady Poisoners

Illustrated True Stories of Dangerous Women

WRITTEN AND ILLUSTRATED BY
Lisa Perrin

FOREWORD BY
HOLLY FREY AND MARIA TRIMARCHI

CHRONICLE BOOKS
San Francisco

Library of Congress Cataloging-in-Publication Data

Names: Perrin, Lisa, author.
Title: The league of lady poisoners : illustrated true stories of dangerous
women / written and illustrated by Lisa Perrin ; foreword by Holly Frey
and Maria Trimarchi.
Description: San Francisco : Chronicle Books, [2023] | Includes
bibliographical references and index.
Identifiers: LCCN 2023003383 | ISBN 9781797215884 (hardcover)
Subjects: LCSH: Women poisoners—Case studies. | Poisoning—Case
studies.
Classification: LCC HV6553 .P47 2023 | DDC
615.9/040243641—dc23/eng/20230310
LC record available at https://lccn.loc.gov/2023003383

Manufactured in China.

Design by Kayla Ferriera.

10 9 8 7 6 5 4

Chronicle books and gifts are available at special quantity discounts
to corporations, professional associations, literacy programs, and other
organizations. For details and discount information, please contact our
premiums department at corporatesales@chroniclebooks.com
or at 1-800-759-0190.

Chronicle Books LLC
680 Second Street
San Francisco, California 94107
www.chroniclebooks.com

FOR MY PARENTS,

WHO REALLY HOPED MY FIRST BOOK WOULD
BE A NICE CHILDREN'S PICTURE BOOK.

Contents

FOREWORD

HOLLY FREY AND MARIA TRIMARCHI

BACK IN EARLY 2020, WE FOUND OURSELVES IN A HOTEL IN SAN FRANCISCO, trying to break the first season of our podcast, *Criminalia*, which covers historical crimes. It had gone through a number of shifts already at that point. What began as an executive asking, "Have you heard about this Giulia Tofana person? Is there a show in that?" had started a brainstorm about how to tell the stories of poisoners. At first, we thought that Tofana's story would be the entire podcast. But we soon realized that there wasn't enough information about her available to sustain an ongoing show, or even a season. Then, we thought, *Maybe a season of women poisoners.*

And as we sat in the hotel's hospitality room combing through lists of poisoners, we had some revelations. One, there were a *lot* of them. Two, not all these women were inherently cruel or scheming. Some of them were, sure, but there were so many who, when you took in the times, places, and nuances of their stories, simply emerged as desperate. And then, in some cases, the women whom history had painted as cutthroat poisoners may not have been involved in any such activities after all. (Pour one out for Lucrezia Borgia.) But more than anything, we became keenly aware of how frequently the women in these stories had become caricatures in modern references to them. And as we dug deeper, especially once we started making the show, we always sought to find their humanity.

Tillie Klimek was a woman who cruelly killed multiple husbands, neighbors, children, and even dogs she didn't like by using Rough on Rats rodent poison. She is, without question, a villain. There's really no way to reform her. But her trial nonetheless shed some light on bias in the criminal justice system. Over

the several years prior to Klimek's trial, twenty-eight other women also went on trial for murder. Two dozen of them were acquitted. Two dozen women, who, unlike Klimek, were considered conventionally attractive. Klimek, on the other hand, was raked over the coals in the press not just for being an alleged killer, but also for committing the sin of not being pretty. Her 1923 sentence—prison with no possibility of parole—was the harshest ever given to a woman in Chicago at the time. Several jurors thought the sentence was too light and that she should have been executed.

Equally intriguing is the case of Lydia Sherman, often called Connecticut's Lucrezia Borgia. (Funny how "Lucrezia Borgia" was so connected to "poison" that the name became shorthand for any prolific poisoner.) Sherman was a wife and mother who turned to poison as her family hit hard times. Her husband lost his job and sank into a depression, and according to her confession, she ended his life rather than let him linger in a state of what she called "uselessness." She then poisoned her stepchildren for reasons she framed as humane: They couldn't live without their father. She repeated this scenario with additional husbands and children, inheriting some money along the way, but using poison more as a problem solver than any kind of income generator. She was eventually tried for one of her murders and went to prison for it. When we look at it now, it's clear that the punishment did not fit Sherman's state of mind about the crimes. Anyone who did the thing she did, and then confessed casually to it, would be a candidate for a psych evaluation today, but not so in the 1870s. Many people with mental illness are not in any way dangerous. There were—and still are—countless people who languish in prisons, in circumstances that exacerbate preexisting conditions, instead of benefiting from mental health treatment. And if we consider Sherman's story as a whole, we might also see how she may not have felt compelled to kill her first husband if *he* had had access to mental health care for his depression. The tragedy of the lives lost at Sherman's hand offers an opportunity to examine how we have progressed in our understanding of human behavior.

Another case that might make you question what you thought you knew about good and evil is the Death Row Granny, Velma Barfield. During her childhood, Barfield was abused by her father, and as her family was impoverished, she turned to petty theft as a way to get a little extra cash. Even after she got away from home and had her own family, it seemed like she couldn't catch a break: Among other moments of bad luck, she was the victim of a hit-and-run accident that left her with chronic pain. She spiraled through a series of bad decisions, attempting to take control of her fortunes through forgery and poisoning. Barfield, who spent time as a caretaker, maintained that she had murdered accidentally. She had only intended to sedate her victims so she could take money from them to support her growing prescription pill addiction. Regardless of whether she *meant* to kill anyone, she did. Barfield was sentenced to death, despite psychiatric experts and her legal team appealing in the hopes of having

her ruled "not guilty by reason of insanity." There are details about Velma that don't align with how you might envision a serial poisoner. She reportedly deeply mourned every person she poisoned. And the outfit she chose to wear to her execution consisted of her favorite pink pajamas and blue house slippers. Her requested last meal was Cheez Doodles and a Coke. During the time between her conviction and her execution, which took place in autumn of 1984, Barfield became a born-again Christian who ministered to other incarcerated women. She gained a significant number of supporters who pressured North Carolina governor Jim Hunt to stay her execution, but with no success. There were hundreds of protesters outside the prison the day her sentence was carried out. And in one last gesture of goodwill, Barfield had become an organ donor. Barfield is another example of a woman who unquestionably did kill multiple people with poison. However, there was also a more civilized and perhaps softer side to her, as evidenced by some of her behaviors. Her memoir points squarely to her addiction to painkillers as what she herself believed to be the cause of her bad behavior.

We're well aware on our podcast that evil is an equal opportunity employer. There have been plenty of bad deeds and crimes in history committed by a vast array of humans. These women we just mentioned and many more are, without a doubt, poisoners. There's no getting around it. It's natural to categorize them as bad or evil as a summation of their lives; deciding whether others are threats is part of human behavior, an instinct that helps us stay safe.

When we're looking at crimes throughout history, we have the benefit of facing no imminent threat from the people we talk about. We're able to look into the nooks and crannies of their lives without fear, and often, a given story has many more layers than any one categorization could ever encompass. All of these people were more than their trials, their reputations, or the scary nicknames that identified them as killers. Every one of them was someone's kid, a person with their own hopes and dreams—often without the opportunity to pursue those dreams.

Thinking of that hotel meetup where we laid the groundwork for our season on lady poisoners, we had no idea the journey the season would take us on and just how much we would find ourselves thinking about our subjects not as poisoners first, but as people.

That's why books like this are so important. We live in a world full of instant categorization and labeling, but no one person can be summed up with one word or label. If you can look more closely at these women poisoners you might instantly think of as bad, and see their humanity as well, you'll think more expansively about almost everyone you encounter. The world becomes a much richer place filled with actual humans instead of categories.

And as a bonus, you'll almost certainly learn to spot the signs of arsenic poisoning.

INTRODUCTION

"I WOULDN'T EAT THAT IF I WERE YOU."

Imagine a seat has been offered to you at a heavy wooden banquet table in a grand, cavernous hall. The other guests are already seated, napkins on laps, with empty plates in front of them. Everyone smiles through closed lips. In the middle of the table, the sumptuous food is piled up so high on fine china you can hardly see the other guests. The room is so dimly lit by candlelight that you almost don't notice the cracked dishes, wilting floral centerpieces, sandy grit at the bottom of the wineglasses, or the feeling of dozens of suspicious eyes focused intently on you.

At this dinner party every drink is dubious, every snack is suspect, and all of the guests are unsavory characters. Attending from across time and space, they have brought their signature dishes to share. For a first course, Nannie Doss has prepared her legendary stewed prunes spiked with rat poison—high in fiber, and arsenic. Following that is Yiya Murano's classic tea and pastries laced with cyanide, and, if you make it to dessert, there are the decadent chocolate creams Christiana Edmunds has injected with strychnine. Fortunately, these women have not gotten together to write the world's most gastronomically offensive cookbook. They are all united by the singular toxic trait of being accused or convicted poisoners. But this is hardly the only thing they have in common. Welcome to the poisoner's banquet, which is destined to be a very short engagement.

The time I spent at this metaphorical table researching these scandalous women had some unexpected impacts on my life—you write one book about poison, and suddenly everyone cancels their lunch plans with you. And I'm keenly aware that the FBI has probably been monitoring my Google searches for some

time now. Studying this topic has made me paranoid in new and interesting ways. I'm suddenly aware of how much trust in others is baked into our daily lives: when we go to the grocery store, eat at a restaurant, or attend an everyday dinner party.

I've learned that anything, if misused or ingested in a high enough quantity, can be toxic. One glass of wine is a pleasant way to wind down in the evening; too many glasses of wine, and that's alcohol poisoning. A couple of ibuprofen can reduce a fever, but taking a whole bottle can end your life. Hundreds of years ago, sixteenth-century physician, alchemist, and astrologist Paracelsus recognized that often the only thing separating a medication from a deadly poison was the dose. It is absolutely possible to have too much of a good thing. Think about that next time you enjoy some "Death by Chocolate" ice cream.

Poisons are rarely something that announce themselves in glowing neon green containers with a threatening skull and crossbones as a warning. We encounter toxins all the time and often don't know it. A poison is defined as any substance that can cause harm, illness, or death when absorbed by an organism—via ingestion, inhalation, injection, skin contact, or another method. You'd be surprised (and perhaps distressed) by how many things can do that. Every part of a sunny daffodil flower is toxic (so resist nibbling on an Easter bouquet), and even the most wholesome of fruits, the apple, has seeds that contain a minute amount of cyanide.

But plants, fruits, vegetables, and legumes aren't the only places we might find poisons in our homes. Many of our cleaning supplies would be very dangerous if ingested. The teenagers who foolishly participated in the Tide Pod Challenge can attest to that. (The Tide Pod Challenge was a deeply unfortunate trend circulating in 2018 that evolved from internet memes about how the laundry detergent pods looked and smelled like candy. This led to some young adults chewing on or ingesting them, often with dangerous consequences.) Laundry pods are packaged in polyvinyl alcohol film, which is water soluble, so, although they are intended for use in a washing machine, if they come in contact with the moisture in a human mouth, they will unleash a torrent of chemicals that can cause difficulty breathing, corrosion of the esophagus, and loss of consciousness.

Whether we recognize them or not, potentially toxic substances are commonplace. Cooking and cleaning are two of the most basic activities of ordinary life. They are also domestic tasks that have typically fallen to women, meaning that women have always had access to materials that could be dangerous. And these same women have borne the brunt of a lot of social inequalities, lack of agency, and—in some cases—abuse. It's hardly surprising that a woman pushed too far might consider sprinkling a little something into a cruel husband's coffee.

Before now, you may have heard the expression that "poison is a woman's weapon." I encountered it myself in several different cultural texts. Renowned

mystery novelist Agatha Christie wrote it into *The Mysterious Affair at Styles*, first published in 1920. (Christie herself was very knowledgeable about poisons and their effects from her time training as an apothecary's assistant during World War I.) Quintessential detective Sherlock Holmes said it in the 1945 film *Pursuit to Algiers*. And, more recently, it was mentioned in the HBO adaptation of George R. R. Martin's *Game of Thrones* (season 1, episode 4). With all these examples from fiction, I was curious to know whether this statement was true, where the notion came from, and why it has endured.

Perhaps women are associated with poison because of the long lineage of women working with plants as healers and wisewomen in their communities, mixing up tinctures and salves to cure common ailments. After all, "healer" and "wisewoman" are just a hop, skip, and a jump away from "witch." Anyone who knows how to harness plants to heal might just as easily know how to use them to harm. (Rather unfairly, when men were knowledgeable about these same fields, they were called physicians and pharmacists.)

It might be the simple fact that a murder by poison does not require the same brute physical strength of other homicidal acts and avoids a lot of the messiness that accompanies them. There is also a calculated planning component to a poisoning crime that might benefit from "cunning," "scheming," and "deception," which are traits we tend to associate with wicked women.

There is a long history of linking women and poison. In 1584's *The Discoverie of Witchcraft,* Reginald Scot explained that (and pardon ye Olde English here) women are "the greatest practisers of poysoning, and more naturally addicted and given thereunto than men. . . ." About three hundred years later, Hans Gross, author of *Criminal Psychology,* agreed, saying, "All kinds of murder require courage, willpower and physical strength, poison murder alone does not necessitate any of these characteristics, and since women possess none of them, they automatically murder by poison."

In a splashy 1939 article for the *Tacoma News Tribune*, salaciously titled (and do read this in your best old-timey newsreel voice) *When She Kills, a Woman Chooses Poison! The Female Killer Scorns a Gun, but She Holds Another More Horrible Monopoly on Death*, journalist Thomas Watson cites the work of Dr. Erich Wulffen, author of the book *Woman as Sexual Criminal.* The article reasserts that poisoning is "ideally suited to woman," meaning women possess an inherent knack for this crime, making them really good at it. The article goes on to claim that the first poisoner was the biblical Eve, who, with the help of the snake, poisoned the innocence of *all humankind.*

The chorus resounds: Women are drawn to poison because they are weaker and more duplicitous than men. Men are honest creatures who would do someone the courtesy of stabbing them in their face, but women slink around slyly and commit murder in a more cowardly way. All of these assumptions rely on

harsh stereotypes about women, and notably, all of these accounts are written by men. And it is in light of these long-held beliefs about women and poison that the truth is so much more satisfying.

Deborah Blum, brilliant writer and authority on all things poison-related, wrote an eye-opening article for *Wired* in 2013 called *The Imperfect Myth of the Female Poisoner*. In it, she clarifies for us that poison is a gender-neutral weapon, and, when you actually look at the statistics, a greater proportion of poisoners are *men*. She goes on to explain that according to the U.S. Department of Justice's report on homicide trends in the United States from 1980 to 2008, 39.5 percent of murderers by poison were female and 60.5 percent were men.

Surprised? I was. OK, but that's in a modern context. What about earlier times, like the Victorian era, dubbed by some as "the golden age of poisoning"? Katherine Watson, author of *Poisoned Lives: English Poisoners and Their Victims*, which focuses on the United Kingdom from 1750 to 1914, found that "[o]f those poisoners caught or suspected, male and female perpetrators were in fact almost evenly divided. . ." Poison, it turns out, is a rather unexpected equalizer between men and women when it comes to homicide. Even though just as many, if not more, poisoners have been men, they never garnered the same sinister reputation for this type of crime.

In fact, most *murderers* are men. According to the United Nations 2019 Global Study on Homicide, men are responsible for a whopping 90 percent of all murders committed worldwide, and their weapon of choice is definitely the gun. So many more men than women commit murder that men use every weapon—including poison—more than women do. However, in those rare instances when women do commit homicide, they are more likely to choose poison than a man is, but just because men favor guns so darn much.

That being said, perhaps one reason for the stereotype that women favor poisoning is the fact that women are indeed more likely to be responsible for *serial* poisoning than their male counterparts. This is in spite of former FBI profiler Roy Hazelwood's comment in 1998 that "there are no female serial killers." A great number of women in this book prove Roy to be dead wrong. And because of beliefs that women are simply not capable of mass killing, many female serial murderers tend to get away with their crimes for a longer period before they are suspected. It's also worth noting that these statistics only reflect the cases we know about. We will never know the names of many successful poisoners—because they got away with their crime.

Poisoning crimes are actually quite rare, although they have a striking resonance in our collective cultural consciousness. It may be that all of this hoopla is not really about the fear of poison so much as about the fear of women—especially women who undermine traditional feminine roles and challenge society's order. Historically, women weren't supposed to be able to take men

down easily or have any agency in their marriages, finances, or lives. As you read through the stories collected in this book, you will discover a recurring theme of women trapped in situations over which they had no control because they were women. It's interesting to consider whether they still would have committed their crimes if they had lived in a different time or place, where they had more autonomy over their own lives.

In *Women Who Kill,* first published in 1980, author Ann Jones noted that in the late 1800s women began to seek more social and political equality, much to the dismay of many of the men at the time. "The rights of woman were at issue, but the fear of woman was never far from the surface of any debate. The poisoning wife became the specter of the century—the witch who lurked in woman's sphere and haunted the minds of men." The idea that women—nineteenth-century women, the "angels in the home," the very embodiments of passivity,

nurturing, and obedience—could cause this kind of disruption to the social order was terrifying.

Poisons were shockingly easy to obtain in the United Kingdom and United States beginning in the 1800s, with arsenic being sold as rat poison and in fly-paper available in every grocery and druggist shop. The nineteenth century was saturated with arsenic. It was in everything from skin and beauty treatments to medications, wallpapers, fabrics, and even children's toys. (As tempting as it might be, never lick any Victorian-era antiques!) Arsenic was cheap, plentiful, and easy to procure, *and* it was colorless, tasteless, and odorless, making it easy to disguise in food and drink. It also produced symptoms that mimicked common diseases of the time. For centuries it was the perfect poison because it was very difficult to detect, or to prove someone had been poisoned—that is, until radical improvements in forensic toxicology were made, and science finally began to catch up with the criminals.

It is important to inform you, dear reader, that this is not a "how to" book. You will find no instructions or recipes here. The intention of this volume is to entertain, inform, and visually delight. If you or someone you know has come into contact with a poisonous substance, immediately call 911 or Poison Control at 1-800-222-1222.

Death by poisoning is rarely quick and tends to maximize the victim's suffering. In the Poison Primer to follow I will discuss the unpleasant details that make death by poisoning such an agonizing affair. This is a warning to the squeamish: I think it's critical to understanding these stories to consider what the victims endured and what poison is capable of. My hope is to share the context of the alleged crimes and gain insight into the situations that led to them, not to glorify or condone them.

As I delved deeper into this research, it became very apparent to me that the source really gets to control the narrative of the story. History is inherently flawed because the chroniclers inevitably have a bias, their own opinion or agenda they want to promote. Many of these chroniclers were men who did not always paint women in the best or most compassionate light. And—this is likely already common knowledge to historians—I realized how impossible it is to confidently know the entirety of a story. In so many instances during my research, bits of truth and nuggets of legend were all swimming about, indiscernible from each other.

Critically, it became very evident to me whose stories even get told and whose do not. I strived to make this book as global and diverse as it could be, because I think the themes explored here are universal. But the women I was able to find the most information about, who were the subjects of dramatic newspaper headlines and provocative true crime books, were almost exclusively white. It may be that poison is a white woman's weapon, or that stories regarding people

of color and poison just weren't given the same attention by journalists and scholars or recorded in the same way. And while the League of Lady Poisoners is not a club that everyone wants to be associated with, I wonder how many stories we will never know about because of this racial bias. The same could be said for LGBTQ+ people—the historical record often erases the stories of people who fall outside of traditional gender norms, including queer, trans, and nonbinary people. I suspect this is part of why I was unable to find examples of explicitly queer poisoners to include in this book. Additionally, I focused on some of the more infamous poisoning cases, which do not always reflect who the average poisoner really was. Most poisoners came from working-class or impoverished backgrounds, which compelled them to act out of sheer desperation. But, of course, these characters never get the same attention that is paid to wealthy or prominent figures accused of the same crime.

The role of the media and the press in many of these cases cannot be overstated. Often the story was less about the crime itself and more about the character of the accused—and her appearance. Women who were conventionally attractive and traditionally feminine in their demeanor got more sympathy from the public and had a better shot at swaying the (usually male) jurors to acquit them or find them innocent. To be an ugly or unfeminine murderer was considered a worse crime.

Unless you are a historical true crime junkie, it is likely that many of the names in this book will be new to you. Any true crime fan worth their salt can rattle off a list of famous male serial killers like Ted Bundy, Jeffrey Dahmer, or John Wayne Gacy, but there are women included in this book with much higher body counts who remain relatively unknown. Women killers make us more uncomfortable than male murderers because we just don't expect violence or aggression from women in the same way—and make no mistake, a death by poison is indeed violent. You might be surprised by the ways in which these women break the mold of what we expect killers to look like. Many of them are mothers and grandmothers. And female killers tend to prey on those closest to them, like partners, family members, and friends. Often the only way we can reconcile these women and their actions is to paint them as somehow different from ordinary women, casting them as more masculine, insane, or just plain monsters.

I have primarily focused on historical examples for this book, although poisoning crimes certainly continue to occur. Honestly, reading about the current ones without the veil of time to create distance is really disturbing. Tragedy plus time can equal comedy as well as opportunities for cheeky commentary in a way that would be unpalatable when writing about contemporary crimes. Think of the humor like a candy coating on the bitter poison pill that makes it easier to swallow. At the same time, it's powerful to see that so many of the

same themes and lack of agency continue to play a role in these crimes. The earliest example in this book is from the days of ancient Rome, and the most recent takes us to Buenos Aires in the 1970s. The stories span every continent on the globe except for Antarctica. If your favorite lady poisoner is not here, I apologize. Alas, there was limited seating at the poisoner's banquet table (and limited pages in this book).

This book is organized into collections of stories that share universal human themes, such as work, escape, money, power, anger, and love. I won't go as far as to call them "motives," because motives can be very complex, and a person can have multiple reasons compelling them to commit a crime, or no identifiable justification at all. I am not a professional historian, journalist, toxicologist, forensic scientist, psychologist, or criminologist. I am by trade but a humble picture maker and true crime aficionado who stumbled into this fascinating topic in which multiple disciplines overlap. A project that initially just struck me as macabre and cool ended up becoming a much richer dialogue about history, science, women's rights, botany, witchcraft, psychology, ethics, and the law. There are so many stories, and if this topic continues to interest you, I encourage you to pursue your own research and follow up with the numerous sources I have included at the end of this book.

The popular story that poison is an unhappy wife's secret weapon seems to have made the leap from fictional device to being construed as fact. Perhaps the antidote to all of the poisoning myths is to share as many of the poisoning truths as we can, to talk about these women's stories with context, an open mind, and even a little compassion. We can try to strip away the agendas of the men and the media who sought to paint a singular narrative of the League of Lady Poisoners and consider them in all of their flawed human complexity. To do that, pull up a chair and join our most unconventional dinner party. Bon appétit!

POISON PRIMER

BEFORE YOU TAKE THAT FIRST BITE OR SIP, LET'S SPEND A MOMENT CONSIDER-ing what poison is, its history, and what particular havoc it can wreak on the body. (Have you lost your appetite yet?) Poison is more than a nondescript powder spilling out of a bejeweled ring or a mysterious liquid lingering in a glass vial. There are many plant toxins as well as animal toxins that can be delivered in the form of a bite or sting. There are also inorganic, or nonliving, poisons that can come from a chemistry lab, as well as metals and elements residing in the Earth's crust.

The amount of poison that might be lethal to one individual might not be for someone else. A number of factors can influence this, including the type of exposure, how quickly they were able to vomit or purge the poison, and their age and health. Also, poison rarely acts right away, like it does in the movies; it can take hours for its effects to become noticeable. Some intent on murder have needed a couple of tries to get the dosage right (or wrong, depending on which side of the vial of poison you're standing on).

Poisoners have relied on two different approaches when deciding how to murder their victims: Acute poisoning is when a large dose of poison is given to someone all at once, often leading to a sudden and violent death. Chronic poisoning is a process by which small amounts of poison are administered to the victim slowly, over a period of time, allowing it to accumulate in their body. The second approach more closely mimics the progression of common diseases, as a poisoned person might get sick, then perhaps recover a little, and then become

increasingly ill or incapacitated over time. If the death seemed natural enough it was less likely to be investigated, which made it more likely for the poisoner to get away with murder.

Once they reach the bloodstream, poisons affect the body on chemical and molecular levels to disrupt its normal functions. Some target the nervous system, some the organs, and others the blood. To poison someone is to commit biochemical warfare against an individual.

TOXIC TIMELINE

Writings from ancient India, China, and Mesopotamia all reflect knowledge of plant poisons.

Alchemy was practiced throughout much of the ancient world, and is often considered to be the precursor to chemistry. Alchemists sought to turn base metals into gold and create an elixir of immortality.

AROUND 3000 BCE: Menes, the founder of ancient Egypt's First Dynasty, is believed to have studied poisonous plants.

AROUND 1500 BCE: The Ebers Papyrus, one of ancient Egypt's oldest surviving medical documents, includes information on the recognized poisons of the time.

AROUND 850 BCE: Homer wrote of poisoned arrows used as weapons in *The Odyssey* and *The Iliad*.

399 BCE: Greek philosopher Socrates was accused of corrupting the youth of Athens and refusing to recognize the gods of the state. He was sentenced to death by poisoning with hemlock.

AROUND 100 BCE: Chinese legend has it that Shen Nong or "Divine Farmer" created the *Shen Nong Ben Cao Jing*, a book describing medical plants and toxic substances.

AROUND 100 BCE: King Mithridates VI of Pontus (modern-day northeastern Turkey) was said to be fixated on avoiding assassination by poison and developed a technique by which he ingested small amounts of toxins daily in order to build up a tolerance or immunity. According to Pliny the Elder, he created what was believed to be a universal antidote called *mithridate* or *mithridatium*.

82 BCE: Poisoning became so rampant a problem in ancient Rome that the general and dictator Sulla passed laws making buying, selling, or preparing poison illegal.

ABOUT CE 800: Arab alchemist Jabir ibn Hayyan is often credited with first isolating arsenic.

1198: Jewish scholar and philosopher Maimonides wrote the *Treatise on Poisons and Their Antidotes.*

1250: Albertus Magnus, also known as Albert the Great, was a German Dominican bishop, philosopher, and alchemist; he is also often credited with the discovery of elemental arsenic.

1300s: The witch trials began in Europe and would continue

for another three and a half centuries, spreading to America as well. Many of those accused were women who had skills as herbalists and healers with knowledge of plants and poisons.

1310: In Venice, a tribunal called the Council of Ten was formed and tasked with the security of the public. To maintain power and order, the council was known to enact mysterious state-sanctioned poisonings. The council was not disbanded until 1797.

1492: Rodrigo Borgia was elected pope. Along with his son Cesare and daughter Lucrezia, the Borgias would all be accused of poisoning their rivals with a special poison of their own called "la cantarella."

1493 TO 1541: Theophrastus Bombastus von Hohenheim, better known as Paracelsus, was a Swiss physician and alchemist who is credited with introducing the field of chemistry into the study of medicine. He famously said that "the dose makes the poison."

1531: King Henry VIII of England declared murder by poison to be an act of treason carrying a punishment of being boiled alive.

1533: Italian Catherine de' Medici was married to the second son of the king of France. Many claimed she brought the Italian art of poisoning with her to the French court.

1603: Queen Elizabeth I of England died, perhaps as a result of blood poisoning from decades of wearing lead-based cosmetics.

1679: King Louis XIV of France reestablished a special tribunal called the Chambre Ardente (literally, "fiery chamber"), originally established in the sixteenth century to root out heretics, to investigate the fears of black magic and poisoning that had overtaken his country and court. The Affair of the Poisons, as it would later be known, led to the arrests of more than three hundred people and the execution of thirty-six, among them members of the aristocracy.

1760s: Life insurance policies were introduced in the United States and the idea spread to other countries. Collection of life insurance payouts would become a major impetus for poisoning crimes.

1775: Carl Wilhelm Scheele invented an artificial colorant with a striking bright green hue that he called Scheele's green. This arsenic-based dye was used in everything from wallpaper to fabric, candles, and toys.

1786: Dr. Thomas Fowler published a study on the effectiveness of a solution he developed that contained 1 percent potassium arsenite. Fowler's Solution would continue to be prescribed as a general cure-all for nearly two hundred years.

1814: Mathieu Orfila, a Spanish-born toxicologist and chemist working in Paris, published the first book exclusively devoted to toxicology. He is considered to be the father of modern toxicology.

1818: Strychnine was discovered by two French scientists: Joseph Bienamé Caventou and Pierre-Joseph Pelletier in the Saint-Ignatius' beans (*S. ignatii*).

1836: Chemist James Marsh developed a reliable test to detect arsenic in a body or tissues. The forensic proof collected by the Marsh test could be used in court.

1837 TO 1901: The Victorian era is considered by some to be the "golden age" of poisoning crimes. During this time arsenic was so prevalent that it could be bought as easily as a loaf of bread.

1851: The Arsenic Act was passed in the United Kingdom to place legal restrictions on the previously unregulated sale of arsenic.

1868: The Pharmacy Act was passed in the United Kingdom to ensure that only pharmacists and druggists could purchase poisons and dangerous drugs.

1874: Dr. Robert C. Kedzie produced *Shadows from the Walls of Death*, a book that he sent to libraries across Michigan to warn of the dangers of the poisonous arsenic in the wallpaper of American homes.

1918: Dr. Charles Norris was appointed New York City's first Chief Medical Examiner. He then hired Dr. Alexander Gettler, who served as the Toxicology Laboratory's director. Gettler has been called "the father of forensic toxicology in America."

1938: In the United States, the Food, Drug, and Cosmetic Act passed. The new law brought cosmetics and medical devices under FDA control.

1975: The American Board of Forensic Toxicology was created.

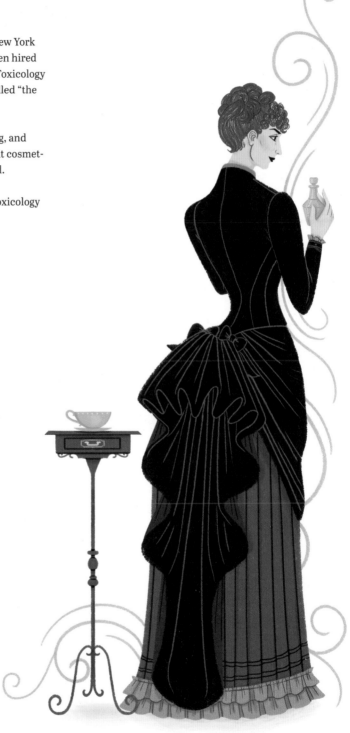

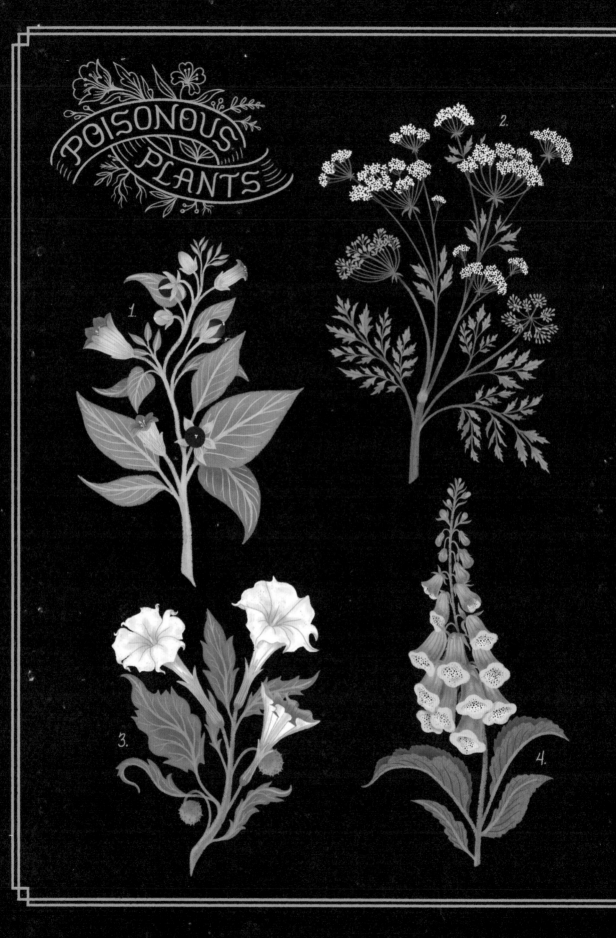

POISONOUS PLANTS

1.

2.

3.

4.

POISONOUS PLANTS

A pleasant stroll through the garden becomes a little bit more sinister when you realize how many plants could kill you. Think of all of those fairy tales that warn you to stay out of the woods. Things humans don't understand live within the forest, things outside of human control—powerful, unbridled nature. We have always been fascinated by plants and what we can make and get from them: wood for our homes, fibers for our clothes, nourishment for our bodies, and poisons for those who get in our way.

Plants are poisonous for their own protection. They have evolved to have different deterrents to avoid being eaten by insects, animals, and humans. Every rose has its thorns, mostly to keep you away from it! It's a sobering reminder as we seek out organic and all-natural products to use that just because something is natural does not automatically mean it is safe.

Many of the poisonous plants listed below are also noted for having medicinal value when administered by a professional in small and controlled doses. Some plants are toxic only if you eat them or parts of them, while others impart their toxicity with a mere touch. If you have ever experienced the itchy discomfort of poison ivy or poison oak, you have experienced a taste of the power of plants.

1. DEADLY NIGHTSHADE

(Atropa belladonna)
aka Devil's Cherries

Part of the Solanaceae family, which also includes tomatoes and eggplants, belladonna is one of the oldest known botanical poisons. It blooms bell-shaped purple flowers and small, bright green berries that change to black in color and taste deceptively sweet. Belladonna means "beautiful lady" in Italian and may refer to the Renaissance practice of women using the juice of the plant in their eyes to dilate their pupils, making them appear large and shining. In safe amounts, the atropine produced by belladonna is still used today by ophthalmologists to dilate the pupils during an eye exam. Every part of the belladonna plant is toxic, and just touching it can cause

blisters or rashes. It also contains other tropane alkaloids—organic substances that often have physiological effects on humans. Even a small amount can cause extreme dryness in the mouth, blurred vision, a fast heartbeat, delirium, hallucinations, convulsions, and death.

2. POISON HEMLOCK

(Conium maculatum)
aka Devil's Porridge and Poison Parsley

A member of the carrot family, hemlock, which features little clusters of white flowers, can grow up to ten feet tall on hollow stems marked with purple blotches. It is noted for having a bad or "mousy" odor. Hemlock resembles other harmless plants like parsley and Queen Anne's lace. But do not be deceived by its similarity to those friendly

look-alikes: Every part of the plant contains toxic alkaloid chemicals. This poison acts slowly and causes the gradual paralysis of the central nervous system, which begins in the extremities and ends when the lungs are paralyzed, causing death by asphyxiation. Hemlock poisoning was used to carry out state executions in ancient Greece, and, as noted in the toxic timeline, is associated with the death of philosopher, playwright, poet, and general rabble-rouser, Socrates.

3. Thornapple
(Datura stramonium)
aka Jimsonweed and Devil's Trumpet

Another member of the nightshade family, this plant is also called moonflower because of its trumpet-shaped white and purple blossoms that open at night. The alien-looking, egg-like seed capsules are covered in spiky thorns, ergo its common name, Thornapple. The entire plant is poisonous, but the toxicity is most concentrated in the seeds. The alkaloids in the seeds are known to cause hallucinations and seizures. An overdose can lead to the failure of the autonomic nervous system, which controls heartbeat and breathing, leading to coma and death.

4. Foxglove
(Digitalis purpurea)
aka Witches' Gloves and Dead Man's Bells

Enchanting foxgloves are identifiable by their cascading layers of bell-shaped flowers on tall stalks. The blossoms are typically purple but can also be white, pink, or yellow. Other fanciful nicknames include goblin's gloves, fairy caps, and lady's-thimbles. It was discovered that the plant contains cardiac glycosides known as digitalis, which were helpful in treating heart conditions and maintaining cardiac stability. It is still used in some heart medications today. Take heed that every part of the plant is toxic, especially the leaves. Symptoms of poisoning include nausea, vomiting, irregular heartbeat, visual disturbances, tremors, delirium, and death.

5. Castor Bean
(Ricinus communis)
aka Castor-Oil Plant

This large shrub or small tree is very striking, with glossy star-shaped leaves that can be any variation of green, red, or purple. It can grow up to forty feet in height and has strange, spiky seed pods. These seed pods are referred to as castor beans, though they are not really beans. This is where castor oil, which has many commercial uses, comes from. Only the seeds of this plant are poisonous, but boy are they ever: They contain ricin, one of the most toxic substances that we know of. If the seeds are chewed and swallowed, they release a toxin six thousand times more poisonous than cyanide. The consequences would include abdominal pain, vomiting, and bloody diarrhea, followed by dehydration, seizures, and finally organ failure, leading to death.

6. Opium Poppy
(Papaver somniferum)
aka Breadseed Poppy

Poppies might make you think of the iconic scene in *The Wizard of Oz* where the characters fall deeply asleep in a field of bright red flowers. The author of the story, L. Frank Baum, would have known about the poppy's use throughout history as a painkiller and sleep aid because it is the source of opium. Poppies have large petals that can be white, pink, purple, or red and leaves that are a soft green-gray with small hairs interspersed. When the flesh of the unripe seed

pods is scored with a knife, they release a milky sap from which opium is produced. Opium is a narcotic that is also the source of heroin and morphine. Such substances are very addictive and at high risk for being abused. Opium creates a feeling of calm and euphoria, but it also depresses the respiratory system, which can cause coma and lead to death.

7. WOLFSBANE
(Aconitum napellus)
aka Aconite, Monkshood, Devil's Helmet, Women's Bane, and Queen of Poisons

This plant is part of the Ranunculaceae (or buttercup) family. The spires of blooms are usually blue or purple, and they look like the flower is wearing a helmet or hood, which gives the plant several of its nicknames. The term *wolfsbane* comes from its early use on scraps of meat to poison wolves. More fantastically, it may also have been thought to be an effective weapon or repellent against mythic werewolves. It contains several alkaloids, but the most dangerous one is aconitine, which affects both the heart and the nerves. Soon after initial contact with the plant, one can experience numbness or a tingling sensation of the mouth and face, followed by vomiting, diarrhea, dizziness, and difficulty breathing. Ultimately this can progress to paralysis of the respiratory system, causing death by asphyxiation or heart rhythm abnormalities that can also cause death.

8. MANDRAKE
(Mandragora officinarum)
aka Satan's Apple

Mandrakes are part of the Solanaceae family, and aboveground they are short and leafy, with clusters of small flowers as well as fruits that resemble tomatoes, but the most fascinating part of a mandrake is what dwells below the surface of the earth. The mandrake is iconic for its oddly shaped, sometimes bifurcated root that is said to resemble a human body. There is a lot of lore about these plants, but the most memorable story is that when pulled from the earth, mandrakes emit an otherworldly scream that will kill anyone who has the misfortune of hearing it. While the mandrake won't really scream, a person who abuses it might. The plant possesses several powerful tropane alkaloids that damage the nervous system. It can cause dizziness, rapid heartbeat, and hallucinations and can lead to coma and death.

(NOT PICTURED)
STRYCHNINE
(Strychnos nux-vomica)
aka Poison Nut

Within the gray disk-shaped seeds of this tree, native to India and Southern Asia, is one of the most violent poisons on record. When isolated from the seed, strychnine looks like a white crystalline substance, which was once popularly used as a cheap rat poison. Strychnine has an intensely bitter taste and wastes no time getting to work inflicting great suffering. After ingesting a small amount, a victim will begin to experience violent muscle spasms that can force the body into an unnatural backward arch, leaving only their head and heels touching the floor. The tightened muscles include those of the face, which are often twisted into an eerie, sardonic grin. While this is going on, the victim remains conscious and aware of their plight the entire time. After experiencing these torturous waves of convulsions, they usually succumb to asphyxiation.

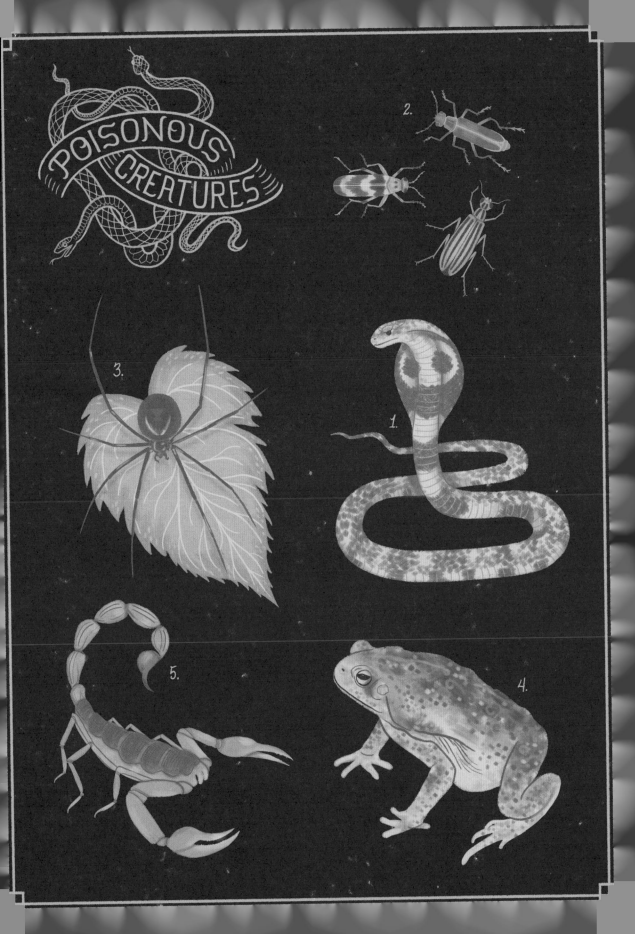

POISONOUS AND VENOMOUS ANIMALS

Animal poisons are called zootoxins, and there are more than two hundred thousand venomous creatures currently known to science. I won't devote too much time to them, because they are not commonly implicated in homicides—it's difficult to get snakes to do your bidding—but you will see that a few of these creatures do slither their way into the stories to come.

The word *poisonous* is often used to describe animals who impart their toxicity in a passive way, such as a frog whose skin is toxic to those who touch or eat it. *Venom,* on the other hand, is reserved for substances imparted actively through bites and stings. Animals rely on these toxins for a number of different purposes, including self-defense and attack (not dissimilarly from people who use poison), as well as digestion of food. And while scorpions and spiders can seem awfully scary, don't forget that humans are the most dangerous animal of all.

1. KING COBRA
(Ophiophagus hannah)

King cobras are so called not because they have a regal air about them, but because they kill and eat other cobras. Native to Asia, they are often yellow, green, brown, or black when fully grown. Reaching up to eighteen feet in length, the king cobra is the world's largest venomous snake. In spite of their fearsome appearance, they rarely strike unless provoked. A cobra bite is painful, and the venom is injected directly into its victim's bloodstream through the snake's fangs, which act like hypodermic needles. This neurotoxin goes to work within minutes and strategically strikes the central nervous system, paralyzing nerves that control the lungs and the heart.

2. BLISTER BEETLES
(Meloidae family)
aka Spanish Fly

These small insects get their name from the toxic bodily fluid they secrete called cantharidin, which causes burns and blisters on the skin. Cantharides, made from the dried, pulverized bodies of blister beetles, have been in use as a drug for more than two thousand years. You may have heard of cantharides by its more common name, Spanish fly, which is commonly touted for its aphrodisiac properties. (That name is a bit of a misnomer, as the creature is neither a fly nor specifically from Spain. In fact, blister beetles can be found in many places throughout the world.) When ingested it blisters everything all the way down the digestive and urinary tract. If taken in sufficient quantities, it can also cause some

very unsexy symptoms, including stomach pain, kidney failure, heart and breathing problems, and ultimately coma and death.

3. Black Widow Spider
(Latrodectus genus)

The black widow is among the most venomous spiders in North America. The adult female is visually defined by her bulbous, shiny black abdomen featuring an iconic red or orange hourglass-shaped marking. She has long spindly legs, eight eyes, and fangs equipped with neurotoxic venom. She was given her name because it was observed that the females eat the males after mating, but this is not universally true. Pragmatically, she will only do this if she is very hungry, which seems understandable. The term *black widow* has also come to describe female murderers who serially kill husbands or lovers for personal gain. A bite from a black widow might induce pain at the site, as well as vomiting, cramps, dizziness, sweating, difficulty breathing, and muscle spasms.

4. Cane Toad
(Rhinella marina)
aka Bufo Toad and Giant Toad

These toads are large, warty amphibians that are native to Central and South America. However, they were introduced to several other countries in the 1930s and '40s as a means of controlling agricultural pests. They are now among the world's worst invasive species. They have a gland that produces a poison called bufotoxin, which they release when they feel threatened. They are poisonous at all stages of life, even as eggs and tadpoles. The toxin is strong enough to kill pets that try to eat them and cause skin irritation and burning eyes in humans who make the mistake of handling them.

5. Indian Red Scorpion
(Hottentotta tamulus)

Native to India as well as parts of Nepal, Pakistan, and Sri Lanka, this is among the deadliest of all scorpions. They have eight legs, including two pincers, and a tail with a stinger that can inject venom into its prey or anyone who bothers it. The Indian red scorpion is fairly small, between 2 and 3½ inches. The venom targets the cardiovascular and pulmonary systems and can cause numbness and tingling, difficulty breathing, muscle twitching, and an accelerated heartbeat.

Poisonous Elements and Chemicals

Some of the most infamous poisons that appear in criminal homicides are the heavy metals (which are not nearly as punk rock as they sound). These come from elements found in the Earth's crust and have been used for a variety of purposes since antiquity. The periodic table contains 118 chemical elements; while many are necessary for sustaining life, others have a much darker side.

These are among some of the most nefarious poisons because many can have a cumulative effect and build up in the body over time. They also cause symptoms not unlike many that accompany common illnesses and ailments, making them difficult to detect. Many people have experienced poisoning from these elements through accidental or workplace exposure. In addition to these naturally occurring substances, science has also provided us with other forms of chemical poisons (because there weren't enough options already!).

1. Mercury

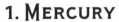

Mercury is a naturally occurring metallic element found in the Earth's crust, but it also appears in the water, soil, and air. It remains liquid at room temperature, forming smooth, ethereal silver globules, which led to it being called "quicksilver." Mercury exists in several different forms, including elemental or metallic mercury, which you might find in glass thermometers and dental fillings, as well as in organic and inorganic versions. Symptoms of mercury poisoning can include a lot of nasty mouth-centric symptoms, such as excessive salivation, inflamed lips and gums, tooth loss, and foul breath, as well as damage to the kidneys. Excessive exposure can also cause mood swings, paranoia, and mental instability, which eighteenth- and nineteenth-century hatters, exposed to mercury in the hat-making process, experienced at alarming rates, hence the expression "mad as a hatter!"

2. Lead

Lead is a malleable gray metal that is naturally found in the Earth's crust. Many civilizations found it useful for everything from plumbing to pottery and paints, and it was used generously by the ancient Romans. In fact, it has been theorized that rampant lead poisoning was one reason for the downfall of the mighty empire. Lead exposure has a cumulative effect and can build up to dangerous levels in the body over time. It primarily affects the brain, liver, kidneys, and bones and can remain stored in bones and teeth for more than thirty years. Lead disrupts the formation of the blood, the nervous system, the kidneys, and—most critically—the brain. People respond unpredictably to lead exposure, but symptoms can include everything from mild headaches and sleeplessness to hallucinations, blindness, coma, seizures, and death.

3. THALLIUM

A soft, bluish-white metal, thallium is one of the most toxic metals and lethal poisons that we know of. It effectively mimics potassium and affects parts of the body that rely on it, such as the brain, nerves, and muscles. Thallium is similar to lead in that it is a cumulative poison that attacks the central nervous system, and similar to arsenic in that it is odorless, colorless, and tasteless. Victims first experience gastrointestinal symptoms, such as pain, nausea, vomiting, and diarrhea. Next come the neurological symptoms, which can include muscle weakness, tingling, numbness, and pain in the extremities, as well as paralysis. A notable symptom of thallium poisoning is hair loss, which occurs roughly three weeks after exposure. There can also be delirium, seizures, blindness, coma, and ultimately death from circulatory collapse and respiratory failure.

4. CYANIDE

Cyanide occurs naturally in bitter almonds, apple seeds, and peach pits, but the chemical compound was discovered in 1782 by Swedish chemist Carl Scheele, who isolated it from the pigment Prussian blue. Cyanide prevents the body's cells from using oxygen, essentially starving them of this necessary ingredient for human life. As a result, it acts on the organs most dependent on oxygen, the heart and brain. If a large dose of cyanide is administered, death may occur so quickly that there might not be any time for symptoms to manifest. At lower doses, effects include nausea, vomiting, dizziness, headache, confusion, weakness, convulsions, respiratory failure, coma, and death. Cyanide may give off the smell of bitter almonds, although only half of the population is able to smell it.

5. ARSENIC

All other poisons aside, there is only one vial in the poisoner's cabinet that holds the indisputable title "King of Poisons": arsenic, the infamous element that is practically synonymous with poison itself. It will play a prevalent role in many of the stories to follow, as well as in different eruptions of poison panics throughout history. In 1855 the London newspaper the *Leader* rather eerily asked its readers, "If you feel a deadly sensation within and grow gradually weaker, how do you know you are not poisoned? If your hands tingle, do you not fancy it is arsenic?"

Number thirty-three on the periodic table, and the twentieth most common element in the Earth's crust, the organic form of arsenic is actually relatively harmless. It is only when arsenic is combined with other elements to form specific compounds that it becomes poisonous. This might make you feel a little better about the fact that arsenic is in just about everything—including you! A 1977 study from the National Research Council Committee on Medical and Biological Effects of Environmental Pollutants found that arsenic is naturally present in rocks, soil, water, and, in small amounts, our own bodies.

Arsenic sulfides were known to many ancient cultures, including the Romans, Indians, and Chinese, as sources of vivid pigments, medicines, and poisons. What most people are referring to when they talk about arsenic is arsenic trioxide, or white arsenic. White arsenic does not occur naturally but rather is the by-product of smelting ores that possess arsenic as an impurity, such as copper, lead, tin, and gold. When heated, the arsenic would turn into a gaseous form of white smoke and combine with oxygen, forming

arsenic trioxide, which was then collected and sold in a powdered or crystalline form.

It is this version of arsenic that would become the ideal poison for murder plots over the centuries and supposedly was the favored method of murder for the powerful Medici and Borgia families of Renaissance Europe. It was colloquially called "inheritance powder" for its ability to hasten the death of a well-off relative, and it would become the singular substance that led to the Victorian era being known as the golden age of poisoning.

Several key factors serendipitously aligned for arsenic to become the perfect poison. In nineteenth-century Britain, arsenic was widely available at every druggist shop and grocery store in the form of flypaper and rat poison. It was the cheapest of all such poisons available, costing only pennies, making it uniquely accessible, even democratic. It wasn't until the middle of the century that laws were passed preventing the sale of arsenic to children and ensuring that sellers kept a register of whom they sold poisons to. Importantly for the poisoner, arsenic has no telltale odor or revealing taste to give it away. If it tastes like anything, it may be a little sweet, making it easy to blend into food and drink. And the pièce de résistance: the symptoms of poisoning by arsenic were largely indistinguishable from those caused by numerous common diseases of the time, such as gastroenteritis, cholera, and dysentery.

Arsenic is considered an irritant poison, which doesn't seem like a strong enough word to describe what it does. Generally, within an hour of acute arsenic poisoning a victim experiences severe stomach pain, as well as violent vomiting and watery diarrhea leading to dehydration. The arsenic then quickly finds its way into the bloodstream, where it can create symptoms of

shock, yielding a weak, rapid pulse and cold, clammy skin. Within a short time the person could slip into a coma and experience heart failure and death.

Acute poisoning was a little flashy for the poisoner hoping to pass off a death as natural, so many favored the more subtle, chronic approach. In addition to stomach pain, vomiting, and diarrhea, the victim might complain of a burning sensation in the mouth and throat and extreme thirst. These symptoms are reflective of many kinds of common ailments, and even a medical professional would be hard-pressed to jump to the conclusion of poisoning. This steady building of symptoms and withering of vitality over time created circumstances where death would seem natural and forestall any investigation.

But if anyone did take the time to probe a little further, arsenic certainly leaves its marks on the body and clues for the examiner. An observant physician or coroner might notice changes to the skin, such as thickening on the palms of the hands and soles of the feet, as well as Aldrich-Mees lines (horizontal white lines) on the fingernails. Arsenic permeates all the body's tissues and settles into bone, hair, and nails, where it can be detected in a postmortem examination for many years to come.

As James Whorton explains in *The Arsenic Century: How Victorian Britain Was Poisoned at Home, Work, and Play*, the nineteenth century was literally awash with arsenic. It was in fruit and vegetables, meats and confections, candles, beer, children's toys, garments, and wallpaper. A pigment developed in 1775 by Carl Scheele, called Scheele's green, was immensely popular during this period. The ravishing, brightly hued pigment, made using copper arsenite, was used to color just about everything. In Lucinda

Hawksley's stunning book on the subject, *Bitten by Witch Fever: Wallpaper & Arsenic in the Victorian Home*, she features a number of examples of wallpaper designs from the British National Archives made with arsenical pigments. It's easy to understand why the public was so enthralled by them despite the danger.

The fashion industry was no exception to the craze for vivid colors created with arsenic. In *Fashion Victims: The Dangers of Dress Past and Present* by Alison Matthews David, the author explains that a green ball gown from this time period made from twenty yards of fabric dyed with arsenical pigments would have contained a whopping nine hundred grains of arsenic. ("Grains" were often used as a unit of measurement in this period. It was based on the weight of a grain of wheat, which was equivalent to about 65 milligrams.) On the subject of this fatal fabric, the *British Medical Journal* opined, "Well may the fascinating wearer of it be called a killing creature. She actually carries in her skirts poison enough to slay the whole of the admirers she may meet with in half a dozen ball-rooms."

The Victorians had a complex relationship with arsenic: They simultaneously thought it to be good, bad, and benign. They loved to use it in medications, cosmetics, and richly colored pigments, and they appreciated how it kept flies and bedbugs out of wallpapered rooms (because they died—a real "canary in the coal mine" moment). But arsenic was always dangerous, and once it became ubiquitous—abundant in people's lives and homes—it was perhaps inevitable that it would be used as a weapon.

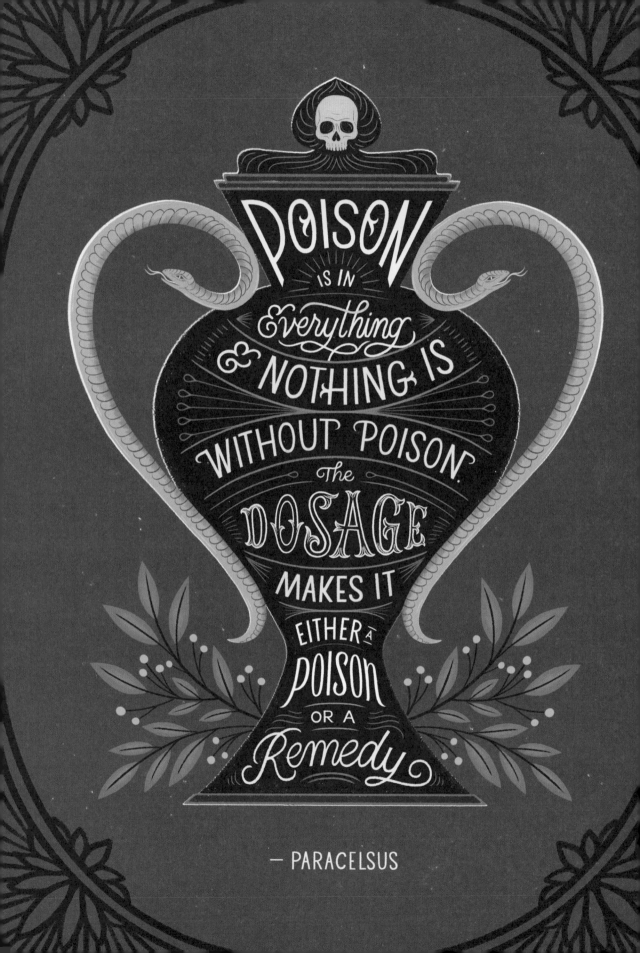

CHAPTER ONE
PROFESSIONAL POISONERS

MARKETS EXIST BECAUSE OF THE LAW OF SUPPLY AND DEMAND, AND PLENTY of people have wanted poison. Professional poisoners have been there to answer the call—imagine those business cards! The women in this chapter got into the business of murder for different reasons. Some may have used their skills to help others in need, but most of them were in it because poison was profitable. Because of their unique insights and empathy for their customers, many of these professional poisoners attracted other women as their clientele.

Often trained as healers and herbalists, these women understood how to use plants to help as well as to harm. That duality is the nature of many of these plants—and arguably some of the women who used them too. In ancient Greek the word *pharmakon* meant both drug and poison, reflecting the complexity that the same substance can in fact be both. The word *venom* may have originally derived from *Venus* and referred specifically to a love potion. This meaning later evolved to include remedy, potion, and invariably poison. But these women, for all their knowledge of botany and healing, were not called doctors, apothecaries, or scientists. They had no access to the formal instruction that would have bestowed those titles. Instead, they were called witches and poisoners.

A skilled, successful, and self-sufficient woman has long been known to make some people (mostly men) nervous. In Europe around the 1300s, attitudes

started to change toward these sorts of wisewomen and healers. The Catholic Church and the government, which were practically the same thing, started to portray them as threatening and in league with the Devil. And in the 1400s, when Europe was overtaken with misogynist hysteria, the witch hunts and trials began. They spread rapidly across continents. In the American witch trials in Salem, around 80 percent of accused witches were women. They were usually people the community didn't like or understand. Accusations of witchcraft were leveled at many of the women in this chapter.

Generally, the poisonings these women were associated with were symptoms of much larger societal problems. But instead of acknowledging and correcting the problem that led to the poisonings, most societies opted to find and punish the women. The individuals discussed here were smart, capable, and enterprising, which often meant that they were perceived as dangerous.

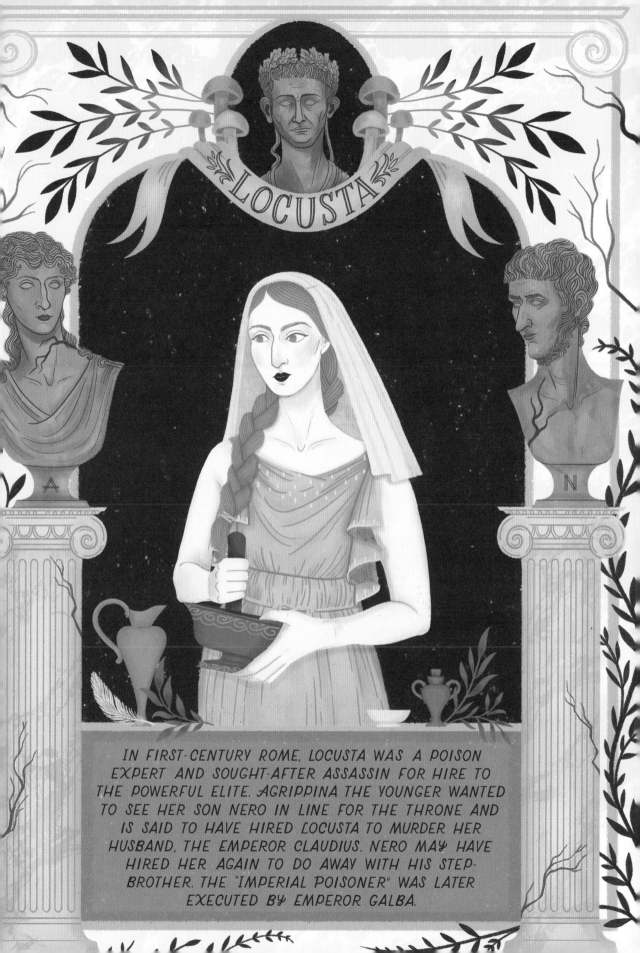

LOCUSTA

IN FIRST-CENTURY ROME, LOCUSTA WAS A POISON EXPERT AND SOUGHT-AFTER ASSASSIN FOR HIRE TO THE POWERFUL ELITE. AGRIPPINA THE YOUNGER WANTED TO SEE HER SON NERO IN LINE FOR THE THRONE AND IS SAID TO HAVE HIRED LOCUSTA TO MURDER HER HUSBAND, THE EMPEROR CLAUDIUS. NERO MAY HAVE HIRED HER AGAIN TO DO AWAY WITH HIS STEP-BROTHER. THE "IMPERIAL POISONER" WAS LATER EXECUTED BY EMPEROR GALBA.

If you happened to find yourself in ancient Rome with a profound knowledge of plants—how to elicit their toxic effects and administer them discreetly—you could make a killing. That kind of skill, savvy, and subtlety was perfectly packaged in a woman called Locusta, who became one of the most sought-after poisoners of the day. She was an intelligent botanist and a clever assassin. She was a weapon who could be bought by the powerful players in Roman politics. Would she have used her skills and knowledge of plants to be a healer if there weren't so many people willing to pay for poison? In her book *The Human Predator: A Historical Chronicle of Serial Murder and Forensic Investigation*, Katherine Ramsland describes Locusta as a "necro-entrepreneur."

She became known rather literally as "Locusta the Poisoner." She was born in the first century in Gaul, an area that encompassed France as well as parts of Belgium, Germany, and Italy, but not much is known about her background or early life. What we know of Locusta's story comes from *The Annals* by ancient historian Tacitus, as well as accounts by his contemporaries, Suetonius and Cassius Dio. It's clear that she possessed an impressive knowledge of botany, likely passed down to her through generations and supplemented with what she learned from studying plants near her home. When she arrived in Rome she entered into a veritable soap opera of family intrigue, power struggles, and dark alliances, with everyone vying for proximity to power.

During the Julio-Claudian dynasty (27 BCE–CE 68) poison was a very popular way to take care of problems. In his collection of poems *The Satires,* the author Juvenal sarcastically noted that poisoning for personal gain had become a sort of status symbol during the first century CE. Everyone who was anyone was doing it. As they say, when in Rome!

Although she is often described as a serial killer, Locusta was really more of an assassin for hire who was paid for her services by wealthy patrons. She was caught and jailed twice, but both times her high-profile benefactors bailed her out. Upon her third arrest, she received an unexpected visitor: Julia Agrippina, aka Agrippina the Younger. She had a little job that required Locusta's unique talents. She wanted to kill her husband, the emperor Claudius. Locusta wanted to get out of jail, so she took the job.

The empress Agrippina the Younger was known to be beautiful, ambitious, cunning, and ruthless. She was once exiled for plotting against her brother Caligula (yes, *that* Caligula), but she was allowed to return after his death. Agrippina had been married twice before she became empress, and it was speculated that she poisoned at least one of those husbands. She had a son named Lucius, whom she desperately wanted to see in line to become Roman emperor.

She rose to power after Emperor Claudius executed his third wife, Messalina, and went on the market for a new bride. In an unsettling move, he married Agrippina, who was also his niece. He had to pass an unsavory new law allowing incestuous marriages, which his fellow Romans frowned upon. (In case you

were thinking, "It was a different time and people were OK with that," well, they weren't.) Agrippina quickly set about getting rid of anyone who was loyal to Messalina before her. The final step in her plan was to persuade Claudius to adopt her son and name him as successor over his own biological son, Britannicus.

Would you believe that Claudius was starting to have second thoughts and found himself suddenly suspicious of his ambitious wife/niece? In this fragile moment, with Claudius changing his mind when she was so close to ensuring power for herself and for her son, Agrippina went to visit Locusta.

According to the legend, the plan they devised was rather brilliant. Agrippina would get her husband jolly and drunk, while Locusta would poison a dish of the emperor's favorite meal, mushrooms. Importantly, she would also distract the servant charged with tasting the emperor's food to check for poison. (He only had one job!) Claudius ravenously devoured the mushrooms, and it wasn't long before he began to complain of terrible stomach pains.

The doctor was sent for. This is where Locusta's brilliance as a master poisoner really shone: She knew the doctor would call for a feather to tickle Claudius's throat to induce him to vomit, so Locusta had preemptively soaked the feather in more poison. Claudius died, of course, and Lucius ascended the throne under a new name: Nero.

The two women would not remain friends forever, bound by a dark secret. Agrippina quickly turned on her conspirator, accusing Locusta of murdering her husband—and sentencing her to death. The new emperor, Nero, however, suspected Locusta might be useful in the future and decided to keep her around. Nero was nervous. His stepbrother Britannicus was still out there and could claim a legitimate right to the throne. According to Suetonius, the rotted apple doesn't fall far from the tree: Following in his mother's footsteps, Nero asked for Locusta's help in poisoning his stepbrother.

The legend continues that Nero invited Britannicus to a dinner party, and Britannicus foolishly accepted. At the time it was customary

to drink wine cut with hot water. Britannicus's wine was too hot and he called for some cool water. The taster who was present tested the wine but neglected to test the water that was mixed in with it, which—you guessed it—Locusta had poisoned. Britannicus began to writhe and convulse, but Nero reassured the concerned dinner guests that his stepbrother had epilepsy, and a spell like this was not uncommon. Britannicus was taken away and died shortly after.

Nero was elated at his success and promptly rewarded the dutiful Locusta with money, property, and the fanciful new title of imperial poisoner. He also gave her immunity from execution during his lifetime and helped her set up a school to teach the dark art of poisoning to others so they could learn the trade from a master. Locusta had gone from being a Gaulish peasant to one of the most powerful players in Roman politics. (You could say she had some gall!)

Emperor Galba, who succeeded Nero, stripped Locusta of her imperial protections and sentenced her to death. There is a disturbing legend about her execution involving death by trained giraffe, but she likely would have been chained and dragged through the streets before being executed by more traditional means. By the time of her death Locusta had not only left an indelible mark on Roman history, but she had also taught a new generation of poisoners the craft. She used her skills and knowledge to make a name and career for herself, but she was playing a very dangerous game. The higher they rise, the harder they fall—and Agrippina and Nero dragged Locusta down with them.

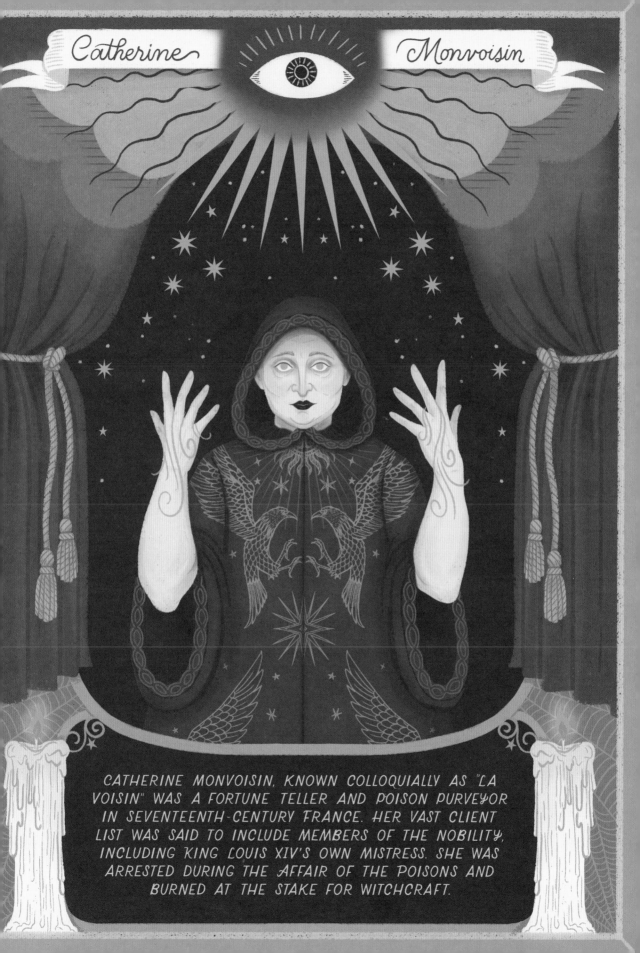

Catherine Monvoisin

CATHERINE MONVOISIN, KNOWN COLLOQUIALLY AS "LA VOISIN" WAS A FORTUNE TELLER AND POISON PURVEYOR IN SEVENTEENTH-CENTURY FRANCE. HER VAST CLIENT LIST WAS SAID TO INCLUDE MEMBERS OF THE NOBILITY, INCLUDING KING LOUIS XIV'S OWN MISTRESS. SHE WAS ARRESTED DURING THE AFFAIR OF THE POISONS AND BURNED AT THE STAKE FOR WITCHCRAFT.

Another self-made woman who responded to the demand for poison was Catherine Deshayes, a Frenchwoman who claimed that God had given her the gift of divination. Since childhood, she said, she had been able to read a person's face or palm and see their future. Maybe she genuinely believed she had a divine gift, or perhaps she was just a good listener who knew what people wanted to hear. Either way, she made good use of her unique set of skills.

As a teenager in the 1650s, Catherine married a jeweler and silk merchant named Antoine Monvoisin and had several children. When her husband's business went bankrupt (too bad she didn't see *that* coming), Catherine Monvoisin made the most of her affinity for clairvoyance and set up shop as a fortune teller in Paris. She also worked as a midwife and illicit abortionist.

In spite of her occult powers, Catherine was devoutly Catholic. In the early days of her fortune-telling practice, she would tell clients that their wishes would come true if the Lord willed it and urge them to pray to specific saints. As time went on she discovered that her patrons wanted more than prayers; she allegedly started to sell them love potions, aphrodisiacs, and poisons. Her potions were said to include such unappetizing ingredients as bones of toads, blood, and the dust of human remains.

Catherine understood the importance of atmosphere and imbued her events with theatricality. She set the scene to create an environment where guests could really believe they were in touch with something mystical. She is said to have donned a fabulous red velvet robe embroidered with golden eagles when she entertained her clients in a small room hidden in the back of her home's garden. The woman knew how to put on a show!

Before long Catherine coined a nickname for herself that was a punny take on her last name, Monvoisin. She called herself "La Voisin," which translates to "the neighbor." You know, the way most friendly neighbors are there to lend a cup of sugar or a thimbleful of the dust of human remains. Her reputation grew, and soon her clientele included some of Paris's wealthy elite. La Voisin became quite a successful businesswoman, earning more than enough to support her large family from her work as a sorceress and fortune teller.

Meanwhile, at Versailles, the court of Louis XIV was wracked with scandal over a spate of poisonings among their own. The recent trial and execution of Madame de Brinvilliers, an aristocrat and poisoner (we will come back to her later), had just taken France by storm. The fear and hysteria were so rampant that many natural deaths were assumed to be poisonings, and blame was quickly thrown around. This scandal would later become known as the Affair of the Poisons.

In 1679 King Louis XIV sought to snuff out this poisoning epidemic by calling together the Chambre Ardente (literally, "fiery chamber"), a tribunal to investigate a suspected underground poisoning ring among the city's fortune tellers and alchemists. He appointed Gabriel

Nicolas de La Reynie, the lieutenant general of the Paris police, to oversee the proceedings. His suspicions that fortune tellers like La Voisin were providing poisons was right on the money. But Louis may not have realized just how many members of his own court would be implicated in his investigation. The fiery chamber was about to get very hot indeed.

La Voisin's highest-profile alleged client would take the poisoning scandal into the king's own bedroom. It was customary at the time for European kings to have a *maîtresse-en-titre*, or "official mistress," in addition to a wife. And Louis would have many official and unofficial mistresses during his reign. Many aspired to this coveted position and the privileges it entailed, which pitted women against each other for the king's attention and favor. One such ambitious woman, a member of the queen's own household, was Madame de Montespan.

Montespan was alleged to have sought out the services of La Voisin for love potions and aphrodisiacs to win Louis's affection away from his first official mistress, Louise de La Vallière. (In case you were curious, an aphrodisiac from La Voisin would include such sexy ingredients as bat blood, iron filings, menstrual blood, and sperm.) Before long Madame de Montespan got her wish and was declared King Louis XIV's official mistress. She could boast having more apartments in Versailles than the queen herself!

Over the thirteen years she was official mistress, Madame de Montespan bore the king seven children, in addition to the two she had with her husband. The numerous pregnancies had an effect on her figure, of course, and there were numerous remarks about her blossoming weight and increasingly short temper. The king's eye began to wander to a captivating new arrival at court. Seventeen-year-old Angélique

de Fontanges was described by a courtier as "beautiful as an angel and as stupid as a basket." Not only did she lack Madame de Montespan's wit, but this new rival was half her age. The older woman fumed when the king gave Fontanges the title of Duchess, something he had never done for her.

After complications from a miscarriage, Angélique became increasingly ill and never recovered. Primi Visconti, a notable writer of the time, quipped she would die "a martyr to the king's pleasures." But Angélique thought she had been poisoned, and so did everyone at court. When she died tragically at only nineteen, Madame de Montespan looked to be the obvious culprit.

Around this time a woman named Marie Bosse, a rival poisoner to La Voisin, was arrested after she drunkenly boasted at a dinner party that so many were paying her for poison, she could afford to retire. The person she happened to say this to was a lawyer, and he informed the police. Bosse (hopefully her nickname was simply *Boss*) quickly gave up La Voisin's name to divert attention away from herself. La Voisin was arrested as she was leaving mass in 1679. When her home was searched, they found "grimoires or black books [primers for satanists and necromancers, the ABCs of abracadabra], sacerdotal vestments and paraphernalia, a cross, incense, black tapers; a mysterious oven in a garden pavilion, redolent of evil, noxious fumes; fragments of human infants' bones in the ashes." La Reynie interrogated her, along with many of her associates.

In her book *The Affair of the Poisons: Murder, Infanticide, and Satanism at the Court of Louis XIV*, Anne Somerset devotes much time to the testimonies of those arrested as part of the Chambre Ardente investigation. When speaking about poison, La Voisin eventually told La Reynie, "Paris is full of this kind of thing and

there is an infinite number of people engaged in this evil trade." She went on to say, "A great number of persons of every sort of rank and condition addressed themselves to her to seek the death of or to find the means to kill many people."

La Voisin was found guilty of witchcraft at her trial and sentenced to burn at the stake. But her story does not end there. Her twenty-one-year-old daughter, Marie Marguerite Monvoisin, would weave the story for which her mother would become most infamous. Marie was also arrested and interrogated by La Reynie, and she asserted that Madame de Montespan was a frequent client of her mother's. Whenever she had an issue with the king she would seek out La Voisin's love potions and remedies.

She also made the bold claim that Madame de Montespan had come to her mother to perform black masses, which she conducted with the help of a defrocked priest. These ceremonies involved the displaying of the female supplicant's naked body as the altar, prayers to Satan, and, allegedly, the sacrifice of a human infant, whose blood would be poured into a chalice on the woman's stomach. Marie claimed Madame de Montespan had taken part in this dark ceremony in order to keep the king's love.

There was another facet to Marie's tale that made the police investigator's blood run cold. She claimed that when the king became enchanted by the young basket-brained beauty, Angélique de la Fontanges, Montespan had been overcome with jealousy and sought revenge.

Marie claimed that Montespan wanted the girl and the king dead, and offered La Voisin a large sum of money to accomplish it.

The supposed murder plot involved presenting the young newcomer with the gift of poisoned fabric and poisoned gloves. To take care of the king, La Voisin would hand deliver a petition soaked in poison on one of the days when the king made himself available to hear grievances directly from the people. On the day La Voisin arrived with her poisonous petition, there were more aggrieved citizens than usual, and she never had the chance to give him her fatal complaint. When she arrived back home, she asked her daughter to burn the petition; she would try again another day. Luckily for King Louis, La Voisin was arrested before she could make another attempt.

La Reynie would never be able to confirm whether any of this was true, but its mere suggestion was enough. Any whiff that the king's own mistress could be involved in this seedy poison plot would result in scandal and embarrassment for the king and country. Upon this revelation, Louis abruptly put an end to the investigation and ordered that all of the related documents be sealed and locked away. It had all gotten too close to home for him. He was playing with fire.

In the three years the Chambre Ardente was active, it issued 319 arrest warrants, took nearly two hundred people into custody, executed thirty-six individuals, and banished another seventeen. Louis xiv did everything in his power to keep the allegations against his former lover a secret, and Madame de Montespan eventually left court to live out the rest of her days in a convent, where the only neighbors she kept were pious nuns, and the masses she attended were strictly of the Catholic variety.

The infamous La Voisin was a paradox. She was a devout Catholic who dabbled in the occult. She mingled among both the lower and upper classes. She claimed she could see the future but walked right into a trap. Her power and success eventually led to her downfall, but she was also part of a much larger organization of poison providers who had been at work for centuries.

GIULIA TOFANA

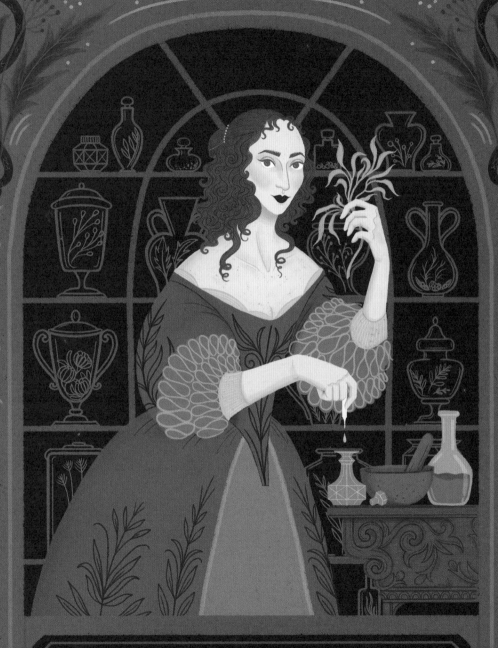

GIULIA TOFANA BECAME A FOLK HERO AMONG
WOMEN IN SEVENTEENTH-CENTURY ITALY. IT IS
BELIEVED THAT SHE PACKAGED AND SOLD HER
NAMESAKE POISON "AQUA TOFANA" IN THE GUISE
OF BEING PERFUME OR HEALING OIL TO WOMEN IN
ABUSIVE RELATIONSHIPS. SHE WAS LATER CAPTURED
AND TORTURED WHEN SHE ALLEGEDLY CONFESSED
TO KILLING SIX HUNDRED MEN WITH HER POISON.

There was no divorce in patriarchal Catholic Renaissance Italy, where the only way out of a bad or abusive marriage was death. Giulia Tofana, who was born in the late sixteenth century, held the key to safety, freedom, and widowhood, and that key was a small glass vial full of her unique brand of poison, Aqua Tofana. The formula has been lost to history, but it is thought to have been a combination of belladonna, arsenic, and lead that was odorless, colorless, tasteless, and virtually undetectable. It also acted slowly, mimicking a natural disease, making it the perfect poison. It has become legendary, as has its creator, who became a folk hero among the women in her community.

In 1890—hundreds of years after Tofana lived—*Chambers Journal* described Aqua Tofana at length:

> Administered in wine or tea or some other liquid by the flattering traitress, [it] produced but a scarcely noticeable effect; the husband became a little out of sorts, felt weak and languid, so little indisposed that he would scarcely call in a medical man. . . . After the second dose of poison, this weakness and languor became more pronounced. . . . The beautiful Medea who expressed so much anxiety for her husband's indisposition would scarcely be an object of suspicion, and perhaps would prepare her husband's food, as prescribed by the doctor, with her own fair hands. In this way the third drop would be administered, and would prostrate even the most vigorous man.

Not much is known for certain about Giulia's origins, and there are several different versions of her story. It may have been that Giulia learned the special combination of ingredients from her mother, who was executed for murdering her own abusive husband. If this origin story is to be believed, it explains why Giulia felt such sympathy for women trapped in dangerous marriages. Perhaps she identified with them and made it her mission to help them. Giulia was also said to have studied with apothecaries, so she may well have invented her namesake poison herself.

In the first half of the seventeenth century, Giulia opened a store in Naples where she sold cosmetics and perfumes. It was the perfect front for selling poison, which she disguised in glass vials with images of saints on them that looked exactly like bottled cosmetics or the healing oil known as Manna of St. Nicholas. A woman could hide the small glass bottle in plain sight, surrounded by similar containers on her vanity or dressing table; only she would know which one was the poison.

Giulia Tofana's business later moved to Rome, where Gironima Spana, a young woman thought to be her daughter, joined the family business. It has been suggested that Giulia was the leader of a gang of wisewomen selling

History of Potions, Powders, and Murderous Practitioners, a woman had given her husband a bowl of poisoned soup to eat when, in a moment of panic, she quickly snatched the bowl away from him. The man, confused, demanded to know what was going on and forced a confession from his wife. He brought her to the papal authorities in Rome, where she buckled and told all. After fifty years in the business, this single bowl of soup would prove to be Giulia's undoing.

The authorities went after Giulia. She sought sanctuary in a church until a nasty rumor began to circulate that she had poisoned the city's water supply. Spurred on by these accusations, an angry mob stormed the church and delivered her into the hands of the papal authorities. She was questioned under torture and confessed that her poison had been used to murder more than six hundred men. (But to be fair, one ought to take any confession given under torture with a grain of salt.)

In the 1650s Giulia was sentenced to death along with her daughter and her other female assistants. Historian Mike Dash explores several possible endings for Tofana in his article "Aqua Tofana: Slow-Poisoning and Husband-Killing in 17th century Italy": "In one especially detailed account, Tofana was dragged bodily from her sanctuary and strangled, after which 'her body was thrown at night into the area of the convent from which she had been taken.'" Other accounts claim that she was never captured and died in her own bed.

The legend—and fear—of Aqua Tofana would long outlive Giulia herself. In 1791, more than a hundred years after Tofana's death, the dying composer Wolfgang Amadeus Mozart was convinced he had been poisoned. He is reported to have said, "I feel definitely that I will not last much longer; I am sure that I have

poisons. She depended on a referral system for her poison clients. A customer who had already successfully poisoned her husband with Aqua Tofana would have to vouch for a new customer to ensure their discretion. The most popular version of the legend claims that this system worked to keep Giulia in the poison business and out of prison for fifty years!

Unfortunately for Giulia, one of her clients eventually had a crisis of conscience. As Ben Hubbard describes in his book *Poison: The*

been poisoned. I cannot rid myself of this idea . . . Someone has given me acqua tofana and calculated the precise time of my death." Modern historians have no reason to believe that Mozart was poisoned, but this speaks to the enduring power of Giulia Tofana and her namesake poison.

The authorities may have been able to kill Giulia, but they did nothing to change the circumstances that led women to seek out her poisonous services in the first place; husbands were permitted to abuse and mistreat their wives with impunity. It's no wonder that there was a market for Giulia's services. She was truly more than a serial poisoner: She was an entrepreneur, a source of comfort, and a provider of vigilante justice—a true "Renaissance woman."

Tofana's work protecting women from mistreatment was far from finished, and hundreds of years later, in a different country, another woman would take up the mantle. Ana Drakšin was known as Baba Anujka, the Serbo-Croatian version of "Grandma Annie" (adorable). She was also known as the Witch of Vladimirovac and "the world's oldest serial killer." She is thought to have provided the poison for between 50 and 150 deaths before being caught and sentenced when she was around ninety years old.

Ana was born in Romania either in 1836 or 1838, the daughter of a rich cattleman. According to a newspaper article from August 1929, published before her trial in the New York newspaper the *Angola Record*, Baba Anujka attended a private school and spoke five languages. She had an affinity for chemistry, medicine, and botany. In her youth she fell for an Austrian military officer who left her with a broken heart and a case of syphilis. After this she withdrew from society to focus on her scientific studies.

In her teens she moved to Yugoslavia, married an older landowner, and gave birth to eleven children. Tragically, only one of her children would survive until adulthood. When her husband died after twenty years of marriage, Ana once again retreated into her solitude and her experiments.

She transformed a wing of her home into her personal chemistry laboratory. People in town sought out her services as a healer to help solve their medical and emotional problems.

She is often described as a misanthrope, but that might not be fair. She had a hard life herself, and she did offer help to the people who came to her. Ana had a tincture for everything: love potions, health tonics, and, most famously, something she called "magic water."

Anna offered this "magic water" as a remedy to women who wished to be rid of their husbands. It is said that she would ask her customer, "How heavy is that problem?" This was her subtle way of inquiring about the intended victim's weight so she would know how much poison to dispense. The magic water was thought to have contained either plant poisons or arsenic.

She made a good living this way for decades. When helping people with problems is your business, your customers are never in short supply. Everybody wants something. And Baba Anujka was a fair businesswoman, pricing her potions on a sliding scale based on what individuals could afford. She was arrested in 1928 in connection with supplying poison for murders. Six newly widowed women were tried with her. Ana's defense in court was that it was not her fault if others misused her tinctures or overdosed on them.

An article from the *Brooklyn Daily Eagle* in 1929 noted the similarities between Baba Anujka and Giulia Tofana hundreds of years before her. "[Baba Anujka] had long been known to the police as an herbalist and 'wise woman,' and harmless. Now they think they have her fast in a net of evidence as an extensive poisoner, who used poisons derived from

herbs, thereby differing from Tofana, who used arsenic compounds, as probably did Locusta, Rome's female poisoner of husbands in the first century A.D. . . . A strong force of police fetched Anna from her miserable cottage at midnight, because she is venerated by the peasants, who would have defended her."

While this account suggests that local peasants would have protected her, others claim the townspeople thought Ana had supernatural powers and feared her as a witch. They thought her tinctures worked not because of chemistry, but because of magic. A spectacular newspaper headline from the time read "Aged Woman in Jugoslav Poison Plot. Score of Wealthy Husbands Cleverly Disposed of by Relatives. 'Witch' Supplies Peasant Women with 'Magic Water' for a Price." Imagine seeing that trending on Twitter!

Baba Anujka is the opposite of what we picture when we think of a murderer. She was an elderly woman—the epitome of the eastern European grandmother, complete with a babushka and deep smile lines. She was sentenced to fifteen years in prison but released after eight because of her advanced years. Perhaps thanks to her tonics, Baba Anujka lived to the ripe old age of one hundred years old. It's easy to see the lineage, a kind of kinship, connecting Locusta to Tofana to Baba Anujka, all members of a secret society of women who understood poisons and distributed them to those in need—for a price.

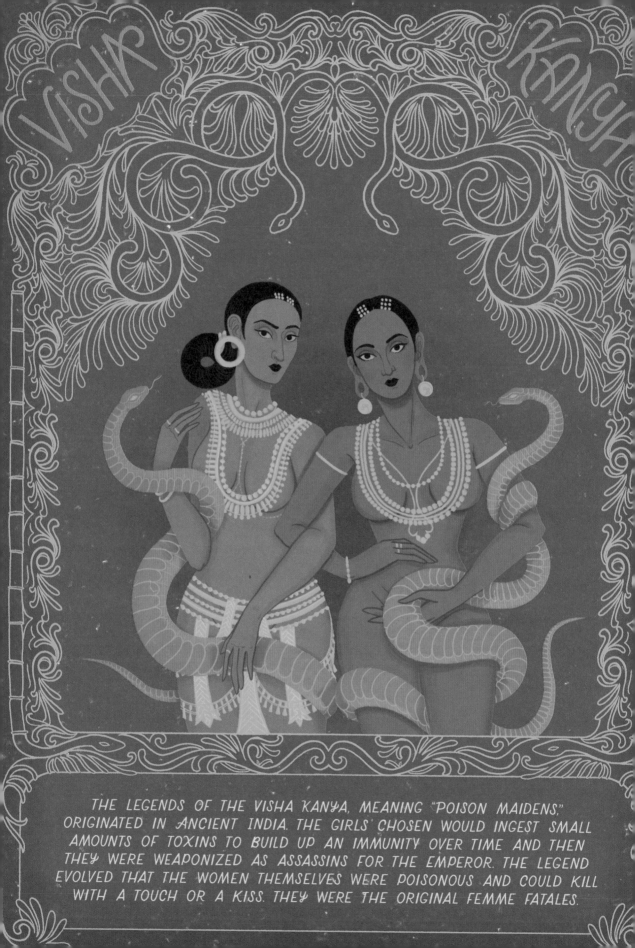

VISHA KANYA

THE LEGENDS OF THE VISHA KANYA, MEANING "POISON MAIDENS," ORIGINATED IN ANCIENT INDIA. THE GIRLS' CHOSEN WOULD INGEST SMALL AMOUNTS OF TOXINS TO BUILD UP AN IMMUNITY OVER TIME AND THEN THEY WERE WEAPONIZED AS ASSASSINS FOR THE EMPEROR. THE LEGEND EVOLVED THAT THE WOMEN THEMSELVES WERE POISONOUS AND COULD KILL WITH A TOUCH OR A KISS. THEY WERE THE ORIGINAL FEMME FATALES.

In ancient India there were tales of beautiful young women who were themselves poisonous. They were called Visha Kanya, which translates from Sanskrit to mean "poison girl" or "poison damsel." These poison girls were reputedly weaponized in service of the first Maurya emperor, Chandragupta, as his covert assassins. Around 300 BCE a man named Chanakya, a philosopher and advisor to the emperor, wrote about Visha Kanya in the *Arthashastra*, a text about how to run an empire. He spoke about the importance of spies and assassins to maintain power and keep order. Women, who are so often overlooked, could make great spies, and beautiful women are always welcomed wherever they go.

In his book *Poison-Damsels and Other Essays in Folklore and Anthropology*, author Norman Penzer explores several different references to Visha Kanya in ancient Sanskrit literature and plays, such as the Mudrārākasa, which describes the formation of the Maurya Empire around 321 BCE. The trope of these poison damsels, or "venomous virgins," appears in texts and legends from ancient India and later makes its way to medieval Europe.

The girls were chosen to be Visha Kanya based on astrology. The legend claims that from a young age, this select group of girls would be fed small amounts of multiple poisons daily to build an immunity to those poisons over time. This technique was called mithridatism, after King Mithridates VI of Pontus (more on him later).

Over time the legend of the Visha Kanya evolved, and the women who were originally seen as able to withstand the effects of poison became known for being fatally toxic themselves. The lore was that a simple touch or kiss from such a woman—not to mention more scandalous behavior—could poison and kill a man. This is described in *Aṣṭāṅga Samgraha of Vāgbhaṭa*: "A girl who has been exposed to poison from birth, and who has thus been made poisonous herself. She kills a lover just by her touch or her breath. Flowers and blossoms wilt when they come into contact with her head. The bugs in her bed, the lice in her clothes, and anyone who washes in the same water as her, all die. With this in mind, you should keep as far away from her as possible."

The Roots of Ayurveda: Selections from Sanskrit Medical Writings, edited by Dominik Wujastyk, contains a less subtle warning: "If she touches you, her sweat can kill. If you make love to her, your penis drops off like a ripe fruit from its stalk." In this same text it is explained that the legend of the venomous virgins was so widespread that Aristotle supposedly wrote a letter warning his student, Alexander the Great, to be wary of lavish gifts from Indian kings, reminding him of his last, almost fatal, encounter with a poison maiden. The danger and sexuality of these women is explicitly linked, as evidenced by their depiction in ancient art and sculpture. Visha Kanya are typically shown as bare-breasted, voluptuous figures with snakes winding around their bodies and between their legs.

Tracing the story of the Visha Kanya, it is hard to discern what is fact and what is superstition or myth, but the concept and image of

the venomous vixen endures. The archetype of the beautiful and dangerous woman luring men to their downfall is present in folklore from many different cultures, and it remains prevalent in stories today. (Comic book fans might think of the infamous Poison Ivy, for example.)

The trope of a femme fatale using her powers of seduction for evil or for personal gain has seeped into the stories of many of the poisoners in this book, who were judged by history and culture based on their gender, appearance, and suspected motives. The Visha Kanya, the poison maidens, were a perfect representation of patriarchal fear of women's sexuality and guile.

ALL OF THE WOMEN FEATURED IN THIS CHAPTER WERE PROFESSIONALS WHO excelled at what they did. Giulia Tofana had a long career helping women who had nowhere else to turn. Her business was a direct response to the lack of agency afforded to women in abusive relationships during the Renaissance period. But paying for poison wasn't solely the recourse of the helpless, poor, or downtrodden: It was also often employed by the higher classes, like the aristocratic clientele who sought out Locusta and La Voisin. These women were smart, capable botanists and chemists, like Baba Anujka. They were trained, like the Visha Kanya. They were used as weapons. They were brave. Professional poisoning is a risky profession, and many of its practitioners were caught and violently punished in the end.

It can't be denied that these businesswomen, scientists, sorceresses, and agents of chaos defied the rules that dictated what women could be. Every woman in this chapter ran her own business, made her own money, and supported herself with her skills in eras when women typically did not (or were not permitted to) do so. Their methods were effective and well researched, as replicable as the best science experiments. They were trusted implicitly by their customers, whose secrecy and discretion they relied on in turn.

Not all of those in pursuit of poison sought out professional assistance, however; some women opted to employ a more direct—if messier—DIY approach to their problems.

She NOURISHES THE POISON IN HER VEINS AND IS CONSUMED BY A SECRET FIRE

— VIRGIL

CHAPTER TWO

ESCAPE AND DEFIANCE

FOR SOME WOMEN TRAPPED IN DANGEROUS OR DIRE CIRCUMSTANCES, POISON has represented an unlikely source of hope and a path to freedom. In the introduction to *Women Criminals: An Encyclopedia of People and Issues,* Vickie Jensen and Kristyan M. Kouri report that women account for less than 10 percent of reported homicide offenders. Of this small percentage, they say, many homicides committed by women appear to be done in self-defense against domestic abuse—something Giulia Tofana and Baba Anujka knew all too well.

Although the details vary from place to place, social structures all over the world—and throughout recorded history—tend to disenfranchise women and grant power to men. This has led to circumstances where women have very little agency, and where their abuse and mistreatment is often tolerated or overlooked by the (male) powers that be. This unjust state of affairs can also drive some women to seek extralegal forms of retaliation.

In her book *Women's Bodies as Battlefield: Christian Theology and the Global War on Women,* Susan Brooks Thistlethwaite reminds us that for much of history, men were the only people protected by the law. In ancient Rome, for example, Laws of Chastisement condoned the beating of wives by their husbands. And, in the Middle Ages, a theological manual in circulation claimed that a husband could "castigate his wife and beat her for correction."

The women in this chapter used poison as a means to escape or to express defiance. In circumstances where it seemed like there was no hope, poison became an out, a chance for a better life. When women felt like no one was listening to them, poison spoke in a very loud and clear voice—a resounding "f--- you" to a system that left them without other options. Poison helped them reclaim their agency. But it also left a body count. So, was poisoning an act of empowerment—or just plain-old, no-good murder?

Would these women have killed if they had other recourse in the societies in which they lived? If they could have divorced a violent spouse, left a (forgive the expression) *toxic* relationship, or accumulated financial resources of their own? A mix of socioeconomic classes are represented in this chapter, from enslaved women to queens, which speaks to the fact that women have felt trapped by circumstances at every level of society. These women resorted to poison to escape specific unbearable circumstances and make their voices heard. It was an easy, appealing, and highly effective option to take care of a problem—a means to an end, if you will—and it sent a very clear, powerful message.

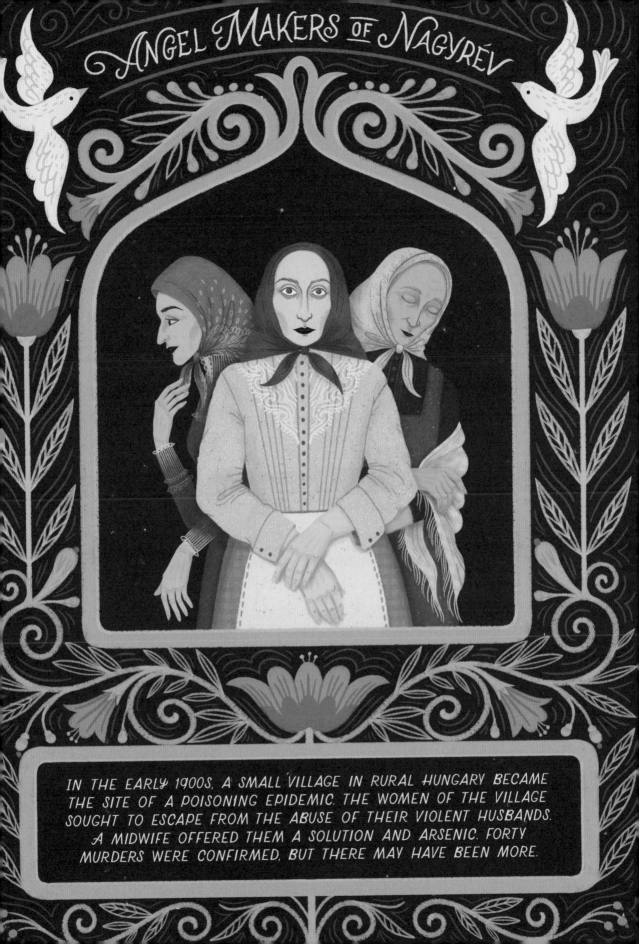

ANGEL MAKERS OF NAGYRÉV

IN THE EARLY 1900S, A SMALL VILLAGE IN RURAL HUNGARY BECAME THE SITE OF A POISONING EPIDEMIC. THE WOMEN OF THE VILLAGE SOUGHT TO ESCAPE FROM THE ABUSE OF THEIR VIOLENT HUSBANDS. A MIDWIFE OFFERED THEM A SOLUTION AND ARSENIC. FORTY MURDERS WERE CONFIRMED, BUT THERE MAY HAVE BEEN MORE.

In the early years of the twentieth century, a small, rural village in central Hungary became the site of a massive poisoning epidemic. At its heart was an unlikely group of middle-aged and elderly peasant women. In photos from the trial they are dressed entirely in black, kerchiefs tied around their faces, with somber, downcast expressions—like gothic nesting dolls. These women were accused of using arsenic to poison the husbands and other relatives of local women in a spree that lasted about twenty years and resulted in at least forty murders, although some sources speculate that the number of their victims was actually closer to three hundred. We may never know how many poisonings were committed by the Angel Makers of Nagyrév, but we do know something of the circumstances that led to their spate of killings.

Nagyrév was not an easy place to live. The remote village, which had no doctor of its own, was an agrarian community of peasants who struggled to make ends meet. Marriages were typically arranged and divorce was considered unacceptable. Alcoholism was rampant among the men of the village, and many would take out their frustrations on their wives and children with physical abuse. Women were expected to accept their lot while also acting as caregivers for their children and elderly parents and in-laws. Poverty, familial burdens, abuse, and desperation were all swirling around in a dangerous storm in the souls of the women of Nagyrév.

When Zsuzsanna Fazekas, a skilled healer and midwife, arrived in Nagyrév she was very welcome in the small town, which had no other local medical expert. She was different from the other women in the village. She was divorced and was said to have smoked a pipe, drank with the men in the local tavern, and carried arsenic in her pocket, which she would show off. She was well liked and, importantly, well trusted by the women in the village. Auntie Zsuzsie (as she came to be affectionately called) charged her clients on a sliding scale and accepted food items as payment. She performed abortions, for which she was arrested nine times, but she was always released by sympathetic judges.

With the outbreak of World War I in 1914, the women of Nagyrév experienced a new reality: a life mostly devoid of husbands and fathers. Many of the men were drafted to fight for Austria-Hungary, which enabled the women to take control of their finances, families, and lives for the first time. It was challenging to farm, make a living, and care for children and elderly relatives by themselves, but they were also emboldened by their newfound freedom. When the men returned from the battlefront, they found their wives unwilling to return to the status quo ante.

The poisonings began as whispers between women, commiserating with their neighbors and confiding in the midwife. They discovered that they could take flypaper—used to ensnare and kill pesky house flies—and boil it in water. The arsenic in the flypaper would rise to the top of the pot and could be skimmed off and poured into a small vial. Zsuzsanna Fazekas was the primary distributor of arsenic. When she heard the women's complaints about their husbands,

she is believed to have said something along the lines of, "Why put up with them?" And then the men started dropping like, well, flies.

One of the Angel Makers, Rozália Takács, would later admit to poisoning her husband, whom she would describe as "an alcoholic beast" in her court testimony. She also helped her friend Sára Beke when she claimed that her husband was physically abusive. Rozália brought her a vial of "medicine" to give him in small doses, and he was dead three days later. Rozália was also implicated in a couple of other poisonings, including that of another neighbor's abusive alcoholic husband, a war veteran who had threatened to kill her and her child.

As is the case in any small village, everyone knew everyone else—and certain women were more than eager to help out their community. An elderly woman named Julianna Lipka helped a woman by the name of Mária Köteles get access to poison. Mária feared her alcoholic and abusive husband, so Julianna brought some arsenic to hide in his brandy. After his death Mária took up with her late husband's best friend. Julianna, being the helpful, neighborly type, was implicated in at least six cases of poisoning, including assisting Mária Pápai in removing her husband Lajos. Witnesses testified that he had been seen beating her with a chain. When the poison only made him ill but didn't kill him, Mária went to Zsuzsanna for help finishing the job. In court Mária said, "I do not feel guilty at all; my husband was a very bad man, who beat and tortured me. Since he died, I have found my peace." Many of the women did not see their actions as murder, but as survival.

Husbands were not the only victims of the Angel Makers of Nagyrév. Some other relatives found themselves eating poisoned soup too. Sometimes it was elderly in-laws and parents who had become too much of a burden to care for, or who were cruel to the women who were their caregivers. Things had escalated. What

started as a drastic but perhaps understandable way out of abusive circumstances became a too-easy solution to less life-threatening problems too.

In June 1929, an anonymous letter published in a local newspaper, the *Szolnok Gazette*, accused the women of Nagyrév of getting away with murder for decades. The newspapers and authorities had received letters like this before, but they had always dismissed them as rumors. This time they took the accusation seriously and launched an investigation.

Early on, fingers pointed them to the midwife, Zsuzsanna Fazekas. After a few days of questioning she was released and went immediately to the homes of some of the other women involved. Now she was the one who needed help to raise money for a legal defense. She had delivered their babies, performed illegal abortions for them, given advice, and helped them out in their hour of need. But everyone was terrified of the police investigation and the threat it posed to them, so they turned their backs on her.

When she saw the police returning to her home the next morning, the woman who had doled out arsenic so easily to others drank her own poison. Zsuzsanna died before the police could get her medical attention, taking many secrets to her grave. The townspeople began to turn on each other. Thirty-five people were indicted, all but one of them women. Sadly, two of the women hanged themselves by their headscarves while in prison. The police exhumed fifty bodies from the cemetery and conducted tests for arsenic. Of those, about forty were found to have arsenic present.

In his book *Tiszazug: A Social History of a Murder Epidemic*, Béla Bodó examines the social and cultural circumstances surrounding the murders and the trials in Nagyrév. He describes how the regional newspapers painted a portrait of the women as backward peasants, no better than animals. The middle-class courtroom spectators and journalists seemed to revel in their superiority over these savage and uneducated women. Onlookers jeered and hoped for the harshest sentences possible, blaming the crimes on the peasant women's selfish, cruel characters rather than their poverty, abuse, and desperation. The Angel Makers may have escaped their violent husbands, but they couldn't escape the unforgiving public. One thoughtful journalist reported that the defendants "... caused the greatest disappointment. Instead of witches, demons, and crafty murderers we see only kind, poor, old, and broken women on the benches.... Everything is in vain, because the public mood is also against the accused."

Because so many of the suspected poisonings had happened years or even decades earlier, many cases were hard to prove. Some of the women were acquitted for lack of evidence. Seven women received death sentences for their involvement in the poisonings, and an additional six were sentenced to heavy prison terms. After further review by the highest court, only four of the seven death sentences were carried out. After the trials, the women gathered outside the courthouse and were heard making the eerie, high-pitched wailing cry typically heard at funerals.

Was Nagyrév an anomaly? A bizarre town brimming with homicidal housewives? No, but it did have all the ingredients necessary to create a perfectly poisonous paprikash. This story and its characters shine a light on the toll of human suffering. Desperate people often feel compelled to take desperate measures.

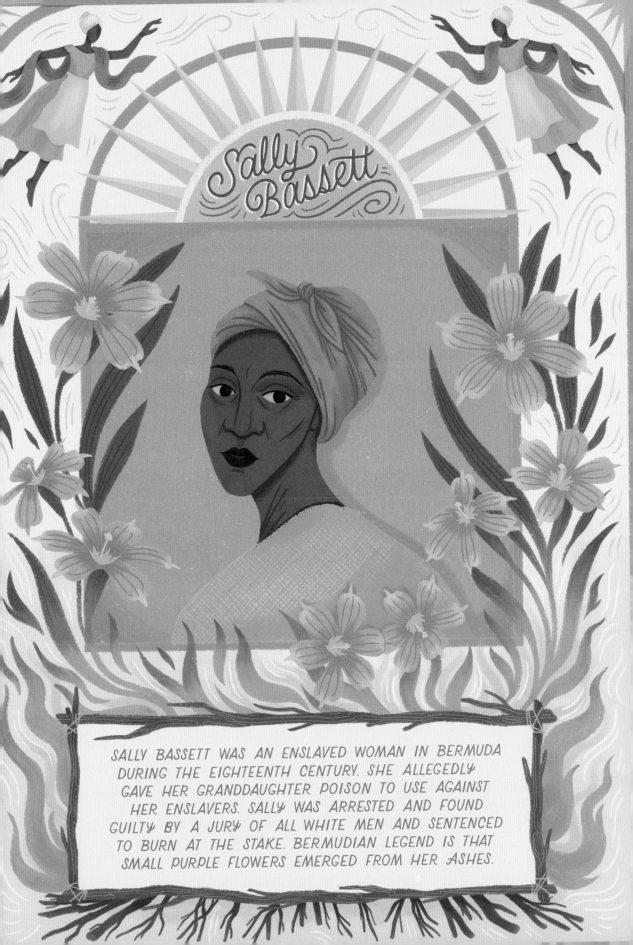

Sally Bassett

SALLY BASSETT WAS AN ENSLAVED WOMAN IN BERMUDA DURING THE EIGHTEENTH CENTURY. SHE ALLEGEDLY GAVE HER GRANDDAUGHTER POISON TO USE AGAINST HER ENSLAVERS. SALLY WAS ARRESTED AND FOUND GUILTY BY A JURY OF ALL WHITE MEN AND SENTENCED TO BURN AT THE STAKE. BERMUDIAN LEGEND IS THAT SMALL PURPLE FLOWERS EMERGED FROM HER ASHES.

About three hundred years before the Angel Makers of Nagyrév, a woman in Bermuda would understand the power of poison against her oppressors and harness it in an act of bold defiance. In the early modern Caribbean during the eighteenth century, a poison panic erupted among wealthy white plantation owners, who were suspicious of the people of African descent they had enslaved. It's unclear whether these poisonings were real or imagined, but the paranoia would peak when a member of the elite suddenly became ill and died. In these situations, often a scapegoat was identified, blamed, and violently punished. An enslaved person in the household would have easy access to food and drink, as well as plenty of motivation to seek retribution for the cruelty of slavery.

Many of the enslaved women in the island colonies of the Western hemisphere were skilled healers. Their medical knowledge came from West and Central African traditions, which they taught to one another. Some, however, felt uneasy in possession of this knowledge, aware that their skills could make them the target of unfounded suspicions. The fear and tension felt by Bermudians at this time is best captured in the story of accused poisoner and enslaved woman Sarah Bassett, who also went by the name Sally.

Sally was one of many enslaved people—most of them women—to be accused of poisoning during this time. In fact, according to Kathleen Crowther in her article "Poison and Protest: Sarah Bassett and Enslaved Women Poisoners in the Early Modern Caribbean," poisoning was one of the accusations most commonly leveled against enslaved people. As a result, laws were passed forbidding access to and use of poison by enslaved people.

Dear reader, I hope I shouldn't have to remind you of the atrocities committed against people who were forced into slavery. Stripped of their humanity and treated as property, millions of human beings toiled and labored for those who profited from their suffering. Their lives were not their own. Their children were not their own. Their bodies were not their own. Abuse and violence toward them were common and supported by law. There was no way to escape.

Today many see Sally as a hero and freedom fighter who challenged the injustices of slavery. Some believe she was falsely accused, while others see her as nothing more than a convicted criminal. Sally embodied many qualities that inspired discomfort in white enslavers: She was older; she was a woman; she was of mixed race; she was enslaved; and, because of her work as a healer, she was associated with medicine, witchcraft, and poison. She could be dangerous. To this day, her legacy runs deep in the folklore of Bermuda, where her story continues to ignite racial tensions.

In Sally's time, Bermuda was a colony of Great Britain (today it is a self-governing British territory). There are no records of Sally's birth, and much of her personal history is unknown. We do know that she was enslaved by a blacksmith named Francis Dickinson and upon his

passing, around 1726, she was inherited by his children along with the rest of his "property." By this time Sally was older, a grandmother in her sixties, and past her usefulness in the eyes of the plantation owners. In spite of this, she was allowed to continue her healing practice.

Sally's first run-in with the law occurred in 1712. She was found guilty of poisoning livestock that belonged to two white men and was sentenced to be publicly whipped more than one hundred times. This cruel punishment would have left deep, painful scars on her body and spirit. Years later, Sally's granddaughter Beck was enslaved to a family named the Fosters. Sally would eventually confess that sometime before Christmas in 1729 she gave Beck two bags containing different types of poison, one white powder, the other red. She provided very clear instructions on how the toxins should be used: One bag of poison was to be left by the kitchen and inhaled, and the other one was to be sprinkled into the food.

The Fosters soon became very ill. It's unclear exactly what the motive for the poisoning was. Some theorize that it was retribution for something terrible that happened to Beck at the hands of her enslavers. Others speculate that Sally, now deemed useless by the same system that had oppressed and exploited her throughout her life, sought retaliation through her granddaughter.

When Beck did not become sick like everyone else in the house, she was arrested. Likely to save her own life, she confessed that her grandmother had given her the toxins. Beck testified that the poisons were made of ratsbane (arsenic trioxide), manchineel (a poisonous tropical plant), and "white toade." Interestingly, the white toad whose skin has toxic properties is not indigenous to Bermuda. In his article "'Horrid Villainy': Sarah Bassett and the Poisoning Conspiracies in Bermuda, 1727–30," Clarence Maxwell suggests that Sally may have had to request this special ingredient

from one of the enslaved Black mariners who would have been traveling to West Africa or South America, where the toad could be found.

Sally was arrested and tried, and ten white citizens testified against her. In court, Sally was accused not only of attempted poisoning but also of being an agent of the Devil. This European witch hunt rhetoric was employed throughout her trial. A jury of twelve white men found her guilty and continued, "We value her at one pound, four shillings and six pence." The judge sentenced her to be burned at the stake like a witch. For the record, by the eighteenth century this was no longer a popular method of execution, showing that the court really wanted to drive home their conclusion that Sally was an agent of Satan. Beck was exonerated.

The day of her execution in 1730 has become enshrined in Bermudian legend. Sally was sixty-eight years old. While making her way to her public execution at Crow Lane she is said to have told onlookers, "No use you hurrying, folks, there'll be no fun 'til I get there!" The day was stiflingly hot—to this day, the phrase "It's a real Sally Bassett day" is used in Bermuda to describe very hot weather. Legend has it that from her ashes sprouted small purple flowers called Bermudiana, which are now the national flower of Bermuda.

In 2008 the government of Bermuda erected a ten-foot-tall bronze statue of Sally, the territory's first monument to an enslaved person. The sculpture, created by a local artist and titled *Spirit of Freedom*, depicts Sally tied to the stake, feet levitating above the fire, with her eyes lifted toward the heavens. Some historians now believe that news of Sally and the poisoning helped inspire slave rebellions throughout the West Indies.

While Sally couldn't escape slavery, she could take defiant action against enslavers. She had been publicly whipped and told she was without value. Sally had been oppressed all her life, and had watched her granddaughter succumb to the same cruelties. But she had power within her. She must have understood that she could get caught and be punished, but she took the risk anyway.

CLEOPATRA

FEW HAVE ASCENDED TO THE ICONIC STATUS HELD BY CLEOPATRA, EGYPT'S FINAL PHARAOH. WHEN HER ENEMIES WERE CLOSING IN, SHE CHOSE TO TAKE HER OWN LIFE RATHER THAN BE CAPTURED AND HUMILIATED BY THE ROMANS. WHILE THE ENDURING STORY IS THAT SHE DIED BY VENOMOUS SNAKEBITE, SOME SCHOLARS BELIEVE THAT IT WAS MORE LIKELY THAT SHE DRANK POISON.

While Sally Bassett remains largely unknown outside of Bermuda, another woman who used poison to express her defiance is among the most famous figures in all of history. The legend of Cleopatra is so alluring that even now, more than two thousand years after her death, we are still talking about her. She lives in our cultural imagination as a striking beauty and cunning seductress who took down two of Rome's most powerful men (picture the movie version: Elizabeth Taylor in her prime, dripping in blue eyeshadow and tight-fitting gold costumes). Her life, and especially the story of her death—a venomous snakebite to the breast—has inspired countless artists, poets, playwrights, and other creatives. Though the imagery makes for great art, it doesn't make great sense. As many contemporary historians have pointed out, the snake theory doesn't really hold up. The cause of her death was more likely poison.

It's important to remember that many of the accounts we look to for the story of Cleopatra's life were composed, often hundreds of years after her death, by Greek and Roman men who hated her. They got to spin the narrative, showing the male Roman characters in a favorable light and demonizing the powerful eastern queen as a "wicked temptress." The Cleopatra we think we know is one who was crafted into a villain by historians such as Plutarch, Cassius Dio, Suetonius, and Pliny the Elder.

Cleopatra was the last queen of Egypt, a member of the Ptolemaic dynasty, which reigned for nearly three hundred years. She was of Macedonian-Greek heritage, not Egyptian. In her rich biography *Cleopatra: A Life*, Stacy Schiff describes her: "A commanding woman, versed in politics, diplomacy, and governance; fluent in nine languages; silver-tongued and charismatic, Cleopatra nonetheless seems the joint creation of Roman propagandists and Hollywood directors." To keep power in the family, it was common for royal relatives to marry each other, including brothers and sisters. It was also standard operating procedure to murder one's siblings to clear the path to the throne—imagine those family dinners!

After the death of their father in 51 BCE, Cleopatra and her younger brother Ptolemy XIII were married and expected to rule as co-regents. Cleopatra was eighteen and her brother was only ten—so it was weird on a couple of levels. The siblings did not see eye to eye on leadership for their country. And, although the standard at the time was for a female ruler to have a male consort, Cleopatra wanted to rule alone.

The siblings fought one another in open civil war. Ptolemy XIII had his sister exiled to Syria when Julius Caesar came from Rome for a visit. The legend is that Cleopatra was smuggled back into her own palace in Alexandria, hidden inside a rolled-up carpet and delivered directly into Caesar's chambers. Plutarch tells us she was brought into the palace inside a large sack of hemp or leather. There she met Caesar and supposedly seduced him with her cunning feminine wiles . . . *or* perhaps she genuinely impressed him with her charisma, intelligence,

and charm. When men do it, it's called strategy; when women do it, it's called scheming.

Cleopatra would emerge from their liaison with a powerful Roman ally, and pregnant with Caesar's child. She named the child, a son, Caesarion, or "little Caesar." Caesar, firmly on Cleopatra's side, declared war on Ptolemy XIII and emerged victorious. She watched her brother drown in the Nile River. Afterward she was appointed co-regent with another of her younger brothers, Ptolemy XIV, but it is speculated that she poisoned him in 44 BCE so she could rule Egypt alone. Her three-year-old son now counted as her male consort.

That same year, Caesar was murdered by the Roman senate. His right-hand man, Mark Antony, was expected to be next in command. However, in Caesar's will, the late emperor formally adopted his nephew Octavian and named him his heir. Tensions between the two men ran high as they both sought to claim Caesar's power. Ultimately, they agreed that Antony would oversee the eastern sphere of the empire, which included Egypt. Antony summoned Cleopatra to meet him, and so began one of the greatest love stories of the ages. Cleopatra and Antony had three children together—first a set of twins (a boy and a girl), and then another son.

For a brief time everything was golden for Cleopatra and Antony and they dreamt of the empire their children would inherit. But Octavian's military successes were piling up and his vendetta against Mark Antony was deepening. He accused Antony of being corrupted by the East and blinded by Cleopatra. Playing on the fears of his countrymen, he warned that Antony would give Rome over to Egyptian control. His words hit their mark, and the senate stripped Antony of all authority. Octavian used Cleopatra and xenophobia as a smokescreen to wage war against his personal rival. The conflict came to a head at the Battle

of Actium, when Antony's troops abandoned him and defected to Octavian's side. It became increasingly clear that the lovers would not win this war.

Cleopatra fled the frontline with Charmian, her lady-in-waiting; and Iras, her hairdresser—because, priorities—and took refuge in a grand two-story mausoleum she had built for her death. Mark Antony heard a rumor that Cleopatra was dead and fell upon his own sword, stabbing himself in the abdomen, which was considered a noble end for a Roman commander. He didn't die immediately and was brought to the mausoleum where, bleeding out, he asked the women for wine—again, priorities—before dying in Cleopatra's arms.

With Antony gone, Cleopatra attempted to negotiate with Octavian. Her top priority was to protect her children and preserve the Ptolemaic lineage. Octavian wanted to keep her comfortable, happy, and alive. It was important that he bring back home the defeated Egyptian queen. Cleopatra would have known that he intended to parade her as a captive through the streets of Rome, a fate she deemed worse than death. He granted her request to bury Mark Antony as she saw fit. She then sent him one final request, to be buried beside her lover. When Octavian read this, he understood what she was planning to do and raced to the mausoleum.

The story that endures (thanks, Shakespeare) is that she was brought a basket of figs with an asp, a kind of Egyptian cobra, smuggled inside. Cleopatra then held the serpent to her breast to inject herself with its venom in an act of suicide. Octavian's guards burst in to find her lying on a golden couch, looking peaceful dressed in all her royal finery, stone dead, her attendants dying beside her.

According to Plutarch, Cleopatra was a poison expert who had meticulously studied

poisons and venomous animals, noting their effects. He claimed that she tested these toxins on prisoners, conducting research to determine which poisons led to the most and least painful deaths. If there is any truth to this, then she certainly would not have chosen to die by snakebite. Of all the options, it's one of the worst. It's not a pretty death, as venom often causes convulsions, paralysis, and contorted facial features, as well as swelling, vomiting, and diarrhea—the opposite of the peaceful image of the queen that Octavian reported having seen.

And snakebites are not always fatal. Cleopatra was too meticulous a planner to leave something this important up to chance. There are a number of other flaws with the snakebite theory, as François Retief and Louise Cilliers point out in their article "The Death of Cleopatra": "It would have taken a large snake, or more than one, to kill three adults so speedily, and this does not tally with the story of the basket of figs." The asp was a symbol of royalty to the Egyptians, so it makes more sense as a literary device, added for effect, than as a practical choice.

It is far more likely that Cleopatra and her handmaidens would have drunk a poisonous cocktail, likely containing hemlock, wolfsbane, and opium. This would explain the speedy effect, the deaths of all three women, and the lack of evidence on their bodies that a snakebite would have left behind. There are also theories that Cleopatra pricked herself with a poisoned hair pin or smeared poisoned ointment on her skin. The truth is, we will never really know.

At the time of her death, Cleopatra was thirty-nine years old. She had ruled Egypt for twenty-two years and was viewed by her

people as both a queen and a goddess. She was a shrewd politician who was deeply invested in the success of the country and her family's dynasty. She had two of the most powerful men of the era as her lovers and was mother to four children by them. While her eldest son was murdered and the other two simply disappeared from the historical record, Cleopatra had a daughter who married a king whom she ruled alongside until her death at age 35. But Cleopatra herself was to be the last pharaoh of Egypt. Her story was written by men who served the conquering empire and had their own reasons to transform the capable leader into a depraved "whore queen."

Cleopatra's last act was one that reflected her defiance and strong will. She is the only person in this book to use poison to die by suicide. It's important not to glorify that action, but to share her story and why she might have made that dark choice. She refused to be captured by Octavian, who planned to parade her through Rome in a gilded cage to humiliate her. Cleopatra looked to poison to escape her impending defeat and take control of the situation on her own terms.

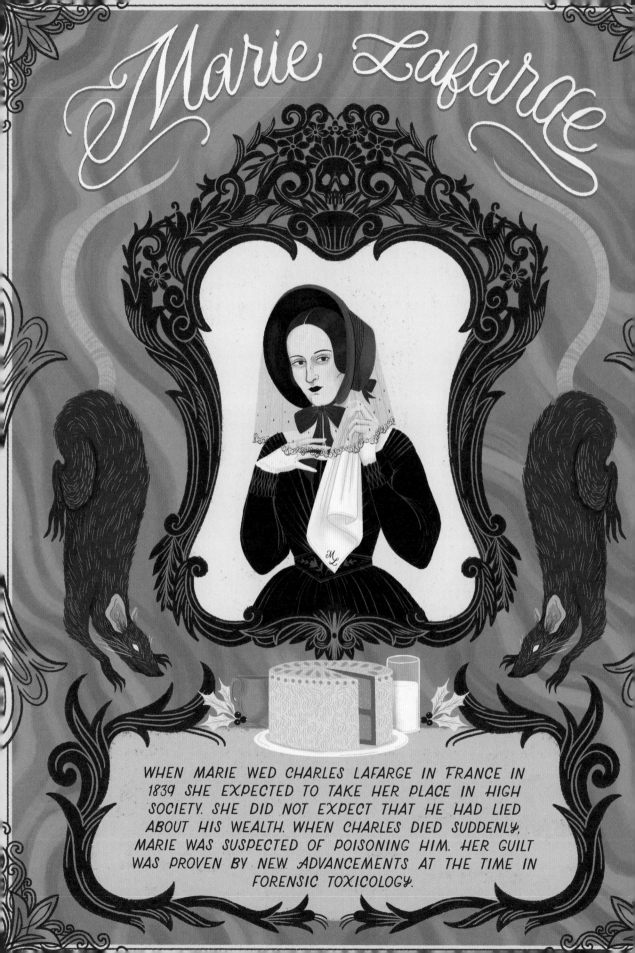

Marie Lafarge

WHEN MARIE WED CHARLES LAFARGE IN FRANCE IN 1839 SHE EXPECTED TO TAKE HER PLACE IN HIGH SOCIETY. SHE DID NOT EXPECT THAT HE HAD LIED ABOUT HIS WEALTH. WHEN CHARLES DIED SUDDENLY, MARIE WAS SUSPECTED OF POISONING HIM. HER GUILT WAS PROVEN BY NEW ADVANCEMENTS AT THE TIME IN FORENSIC TOXICOLOGY.

Historically, one of the reasons many poisoners got away with the dastardly deed was because it was often very hard to prove that a death occurred by poison and not some natural cause. Would-be criminals took advantage of this fact and made arsenic the most popular poison of its day. In the nineteenth century arsenic was hailed as the "king of poisons," though for our purposes let's call it the "queen of poisons." Forensic science needed to catch up to wily criminals. Before we talk about convicted poisoner Marie Lafarge, let's consider the science that brought her down.

In 1832 the British chemist James Marsh was summoned to be an expert witness in the murder trial of John Bodle. Bodle was accused of poisoning his family's coffee, leading to the death of his wealthy grandfather—who, apparently, was stingy and disliked. Marsh conducted the standard test at the time to detect arsenic in the grandfather's tissues. If there was indeed arsenic to be found, a chemical reaction would occur, manifesting as a yellow residue. Marsh saw the telltale yellow color appear, so he stated in court that his test had proved the presence of arsenic. But there was a problem. Between conducting the test and sharing the results in court, the yellow residue had faded and there was nothing to show the jury to prove the test had worked. The scientist's word wasn't enough—the people needed to see it to believe it—so they found Bodle innocent of murder.

Years later John Bodle freely admitted his guilt, and Marsh resolved to invent a better test for arsenic. He constructed an apparatus using several glass beakers and tubes. Zinc and sulfuric acid would be mixed with the potentially poisoned sample, which would produce arsine gas if arsenic was present. The gas would then be ignited, causing oxidation. If a ceramic bowl was then held to the flame, a silvery deposit would appear to prove the presence of arsenic. This test was so precise that even minute amounts of arsenic could be detected.

Known as the Marsh test, it became the standard for proving the presence of arsenic in a body, and remained so until the 1970s. José Ramón Bertomeu-Sánchez writes in his article "Managing Uncertainty in the Academy and the Courtroom: Normal Arsenic and Nineteenth-Century Toxicology," ". . . the Marsh test soon became the 'chief terror of poisoners,' uncovering crimes that previously would have gone undetected and eventually leading to a significant decline in the use of arsenic for murder." Marsh's test would become most famously associated with the court case of a French woman he never met, but who would likely curse his name forever.

Marie Capelle was born into an aristocratic family in Paris in 1816. Her father, an artillery officer who had been a member of Napoleon's imperial guard, died in a hunting accident when she was twelve. Her mother quickly remarried, but she too passed away in Marie's teen years. Orphaned, Marie was sent to live with her aunt. Though they did not get along, her aunt ensured that Marie was still sent to the finest schools, where she mixed with other

young ladies of the aristocracy. She watched her schoolmates marry well and move up in society, so Marie expected the same glamorous fate for herself. She cared a great deal about wealth, status, and how others perceived her.

By the time Marie was twenty-three, she was still unmarried—and thus a liability to her family—and nearing spinsterhood by the standards of the day. It's important here to reiterate how critical it was for a woman to be married in Victorian society. Marriage to a man was seen as the fulfillment of a woman's purpose and her most natural accomplishment. In her article "'So Few Prizes and So Many Blanks': Marriage and Feminism in Later Nineteenth-Century England," Philippa Levine reminds us that "for the woman who did not marry, whether by choice or by chance, spinsterhood marked her as one of society's unfortunates, cast aside from the common lot of the sex."

Marie's uncle secretly sought the services of a marriage broker. He insisted upon high standards for any potential prospect for his well-to-do niece. To be considered, a gentleman must have an impressive level of income and be able to provide a certain quality of life. The marriage broker found a suitable match in twenty-eight-year-old Charles Pouch Lafarge. Lafarge owned a grand estate and managed a successful iron foundry on his property (or so he claimed). A meeting was arranged so Charles could meet Marie at the opera one night (a sort of surprise blind date with her and her family—everyone's favorite kind of romantic outing).

After their (planned) surprise meeting, Marie's relatives told her that Charles had fallen in love with her at first sight, and what a catch he was! Marie was less impressed, thinking the heavy, awkward man was ill-mannered and beneath her. She soon changed her tune when she heard about his château, successful business, and presumed piles of cash.

Before we judge Marie too harshly and think she was petty, which she may well have been, it's important to remember that in her world, finding a "good match" that would reinforce her social status was her primary objective in life. Nothing was more important to her. Charles and Marie were married in 1839, and three days later they moved into his château: Le Glandier, in the Limousine region of France.

Marie was expecting a fairy tale. What she got was more like her worst nightmare. It turned out that Charles may have misrepresented himself to the marriage broker—the historical equivalent of exaggerating on his dating profile. Tl;dr, he was bankrupt and had married Marie for her dowry. The château was dilapidated, had no modern conveniences, and was infested with rats. Oh, and the iron foundry was in shambles.

Her first night there Marie locked herself in a room and penned a letter to her new husband, which she slid under the door. She begged to be released from the marriage and threatened to take her own life with arsenic. Charles urged her to give their new relationship a little time. He promised to get the house in order and make the foundry profitable, and until he had done so, he would not seek his "marital privileges."

This managed to coax Marie out of the room and her glum mood. As time went on, things seemed to improve. Her new husband soon went away on a business trip to Paris, and Marie dotingly sent him letters, as well as some cake. After eating it, Charles became seriously ill (Oh no, I trusted cake!). Thinking perhaps that the confection had spoiled, he threw the rest away. When he returned he still was feeling off, and Marie rushed in to nurse him. The meal she made for him only made his condition worse.

Marie and his mother did everything they could think of. It didn't help poor, sick Charles that the sound of the rats scuttling around in the walls was affecting his sleep. So, Marie set out to acquire some arsenic—for the rats, of course. Marie was seen by family members adding a white powder to her husband's food and drink. She explained it was gum arabic, which was thought to help with digestive maladies. Some accounts describe Marie keeping the powder in a precious malachite box.

The family became increasingly suspicious of Charles's new wife and eventually banned her from the sickroom and urged Charles to take nothing she offered him. But it was too late; Charles Lafarge died on January 14, 1840. Because of the suspicious circumstances surrounding his death, Charles's stomach was removed for tests before he was buried, and Marie was arrested.

The news quickly became a media sensation, with reports emerging daily to feed the hungry public. This story had it all: a young bride, money, deception, *cake*, and alleged murder most foul. Marie's innocence or guilt was the most hotly debated topic of the day. Marie played to the media attention. She dressed in black mourning clothes and weepily carried smelling salts in court. In the book *The*

Inheritor's Powder: A Tale of Arsenic, Murder, and the New Forensic Science, Sandra Hempel describes the attempts by Marie's defense attorney to play up her genteel upbringing as grounds that she was not capable of murder, citing in court ". . . the excellence of her piano-playing, her delightful voice, her competence in more than one science, her reading and translation of Goethe, her fluency in several languages and composing of Italian verse." As if committing murder and playing the piano were mutually exclusive skills.

Charles's stomach was found to contain arsenic, as were the remnants of Marie's home-made chicken broth, which Charles's family had given to investigators for testing. Marie fainted in court when she heard this. The decision was made to do further testing, this time using the newly available, more accurate Marsh test. Charles was exhumed and the test was performed in view of the public by local physicians. They found no arsenic—an unexpected twist.

Now the prosecution and defense were in a heated battle of science. The prosecution did not accept the new results and called for famous French toxicologist Mathieu Orfila to perform the test instead. When Orfila performed the Marsh test—correctly, this time—it proved the

presence of arsenic in Charles Lafarge's body. The jury swiftly found Marie guilty of murder. She was sentenced to life in prison and incarcerated for eleven years. After contracting tuberculosis, she was released from prison and died six months later in 1852.

In some ways, Marie's conviction was the result of bad timing—for Marie. The implementation of the Marsh test for arsenic coincided perfectly with her murder trial, and she may have gotten away with the crime if she had acted a little bit sooner. In fact, Marie Lafarge is often cited as the first person convicted of murder because of direct forensic toxicological evidence. Advancements in forensic toxicology from this point on would provide the proof in the proverbial pudding needed to convict many poisoners.

Marie was misled, lured into marriage under false pretenses, caught up in society's expectations for young women. She was deeply unhappy, and looking for a way out, and it took her very little time to decide on murder as her best option. As Lisa Downing writes in her article "Murder in the Feminine: Marie Lafarge and the Sexualization of the Nineteenth-Century Criminal Woman," "The woman who killed her husband from the very seat of the prescribed feminine domain of domesticity threatened the social order from within."

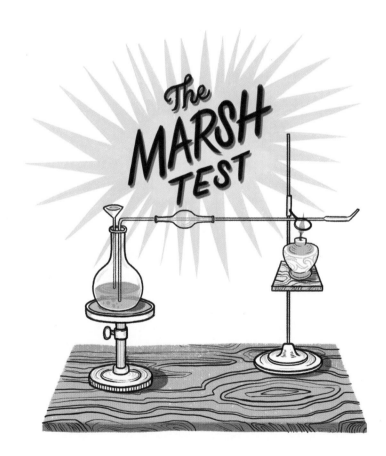

FOR THESE WOMEN, POISON PRESENTED A SOLUTION TO A PROBLEM THEY could find no other way to solve. We can only imagine how dark the circumstance must have been for them to even consider this their best or only choice. The Angel Makers of Nagyrév sought to free themselves from abusive husbands. The press called the murders a poisoning epidemic, but journalists ignored the epidemic of abuse that spurred the women to such desperate action. Sally Bassett's poisoning attempt was also a response to an oppressive and cruel system. Marie Lafarge was tricked into marriage, but perhaps she was really deceived by a much grander system that boiled down her self-worth to that union. She used arsenic to escape her marriage, but she couldn't escape society's limited expectations for women. Even Cleopatra, a powerful queen, turned to poison when her back was against a wall rather than yielding to defeat and humiliation. It was a terrible choice to make, but it was still a choice.

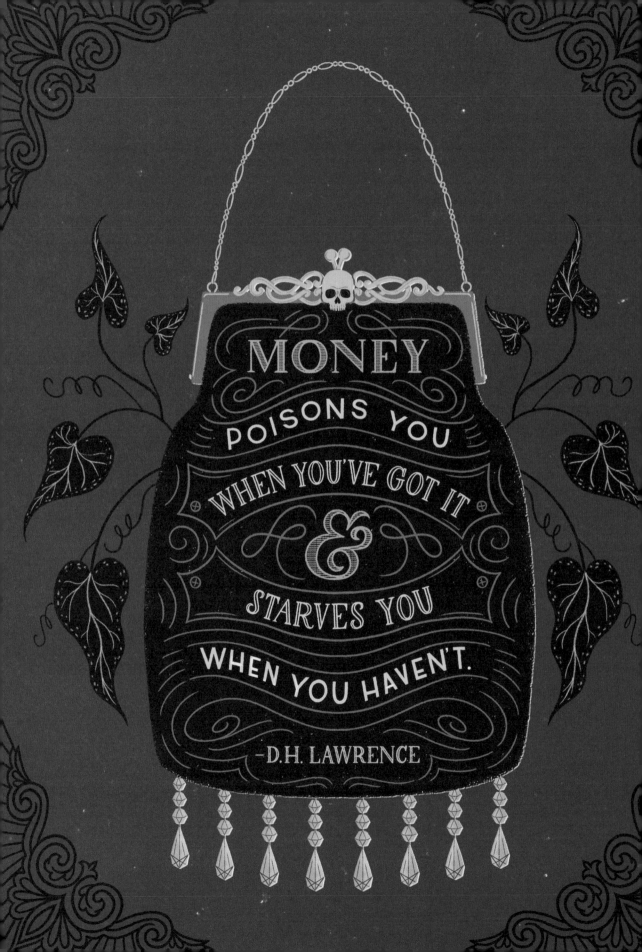

Chapter Three

Money and Greed

HISTORICALLY, ARSENIC WAS KNOWN AS "INHERITANCE POWDER" FOR THE macabre reason that it could hasten the death of a lingering relative in order to cash in. Imagine the infomercial: "Got a greedy grandpa hoarding their own hard-earned money? Snuff 'em out fast with Inheritance Powder! Just a small dose at dinner, and you'll come out a winner!"

The effects of arsenic poisoning could look like a natural illness, especially in the elderly or the infirm. But collecting an inheritance was just one way an ambitious poisoner might gain financially. Life insurance policies became very popular in the Victorian era, placing a bull's-eye with a big dollar sign on the backs of unwitting friends and family members.

Money is an evergreen motive for murder, and a fairly gender-neutral one at that. Any seasoned homicide investigator trying to crack a case might ponder who stands to benefit financially from a suspicious death. Women have been in the precarious position of being dependent on men to support them financially in societies that did not permit them to earn money for themselves. They experienced the same monetary strains as anyone else, but they had very little control over their fiscal futures. Battling poverty, the necessity of feeding several hungry mouths, and having no means to improve her situation could compel a woman to desperate action. This is not to excuse or justify these crimes, of course—most people deal with financial instability without turning to poison.

At any rate, the life insurance industry was booming. Anyone who had been made the beneficiary of someone else's policy suddenly had a potential motive for murder. The insurance industry wasn't really regulated in the United States

and Great Britain until toward the end of the nineteenth century, which meant it was open season; just about anyone could take out a life insurance policy on just about anyone else. This system worked so well that some greedy murderers repeated their trick multiple times on different people. Some couldn't resist the allure of more money, especially when funds from the last policy ran dry.

Many of the women discussed here became infamous for murdering for money until they were finally caught. This became such a popular trope in the media of the time that nicknames were sometimes given to these female killers, like the darkly glamorous term *black widow*. An article by Scott Bonn for the *Psychology Today* website explains that "the black widow serial killer is a woman who murders three or more husbands or lovers for financial or material gain over the course of her criminal career." Female serial murderers are also sometimes referred to as "Lady Bluebeard" or "Mrs. Bluebeard," a reference to a French fairy tale about a wealthy nobleman who keeps remarrying because all of his wives seem to disappear. (Spoiler alert: It's because he murders them.)

Some of these poisoners were crafty scam artists. They took advantage of their own good looks and charm to earn the trust of insurable parties. Others sought out lonely men and lured them with promises of companionship and romance. A good lie works because it's what someone wants to hear. Some of these poisoners took advantage of working in the traditionally feminine occupations of caregiving and nursing. The sick, elderly, and young inherently trust the person taking care of them, making them easy targets for savvy insurance scammers and other financial predators. The combination of easy access to cheap poison like arsenic, enduring poverty with little chance to escape it, and the lure of money, comfort, and control could tempt a good woman to do bad things.

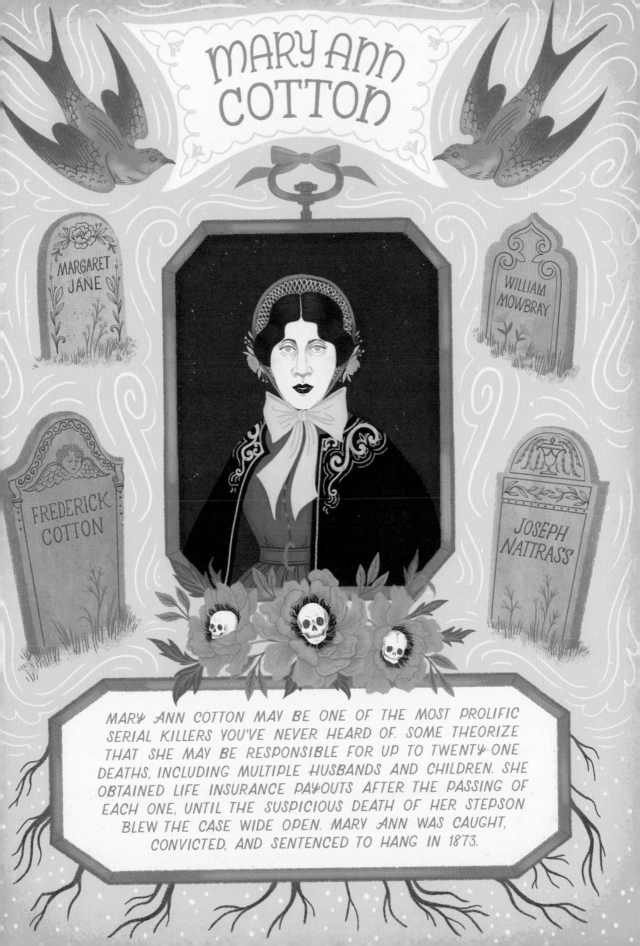

MARY ANN COTTON

MARGARET JANE

WILLIAM MOWBRAY

FREDERICK COTTON

JOSEPH NATTRASS

MARY ANN COTTON MAY BE ONE OF THE MOST PROLIFIC SERIAL KILLERS YOU'VE NEVER HEARD OF. SOME THEORIZE THAT SHE MAY BE RESPONSIBLE FOR UP TO TWENTY-ONE DEATHS, INCLUDING MULTIPLE HUSBANDS AND CHILDREN. SHE OBTAINED LIFE INSURANCE PAYOUTS AFTER THE PASSING OF EACH ONE, UNTIL THE SUSPICIOUS DEATH OF HER STEPSON BLEW THE CASE WIDE OPEN. MARY ANN WAS CAUGHT, CONVICTED, AND SENTENCED TO HANG IN 1873.

Looking past the romantic top hats and sweeping floor-length gowns, the Victorian era was a dangerous one for most people, especially children, who are smaller and more vulnerable than adults. At the time, little was understood about sanitation and the spread of germs, which contributed to the rapid spread of disease. Even the Victorians' homes were unsafe, from arsenical pigments in the wallpaper to exploding toilets (the result of methane seeping in). In 1850 the average life expectancy was about forty years old, and roughly 27 percent of children didn't live past the age of five. There was a grim reality behind all those pretty petticoats, decorated bonnets, and dramatic corsets.

Mary Ann Robson's childhood, like that of so many other Victorians, was marked by death. She was born in the north of England in 1832. When she was just ten years old, her father fell to his death while working in a coal mine. His body was unceremoniously returned to the family home in a sack stamped "Property of the South Hetton Coal Company." Mary Ann's childhood came to an abrupt halt, and she went to work to help her struggling family. After training as a nurse she took several odd jobs to earn money, including that of a nursemaid for a well-to-do family, where she caught her first glimpse of how money could buy comfort. In his biography of her, *Mary Ann Cotton, Dark Angel: Britain's First Female Serial Killer*, Martin Connolly describes this momentous realization: "... this would become the lifestyle that

Mary Ann aspired to and her journey from here would always be in search of a husband who could deliver it." In her young mind, a husband equaled money, which equaled comfort, which equaled happiness: It was basic arithmetic.

At twenty she married William Mowbray, a coal miner like her father, and moved with him to the south. They quickly had several children whom we know nothing about; they were never formally registered and seem to have had tragically short lives. The couple then moved back to the northeast of England with only one living child, a daughter named Margaret Jane, and soon had another named Isabella. Sadly, Margaret Jane died after the move, but within a year Mary Ann had another daughter whom she also named Margaret Jane. She later gave birth to a son, who also passed away as a baby. But what initially seemed to be a series of tragedies would soon evolve into an alarming pattern.

According to one theory, Mary Ann took up with a lover, a man named Joseph Nattrass, during this time, but there is no evidence of that. He will, however, return later in the story. After twelve years of marriage, William Mowbray died of typhus fever and Mary Ann collected the life insurance payout for thirty-five pounds, as well as small amounts for the deaths of the children. She took her two daughters—the second Margaret Jane and Isabella—and moved to the coast. Margaret Jane passed away shortly after the move, and Mary Anne sent her only living child, Isabella, to stay with her mother. Then Mary Ann picked

up yet again and moved to take a job at an infirmary. Her frequent moves to different towns made it harder for neighbors to notice the pattern of disappearing family members. (Naming multiple babies Margaret didn't help people keep track of them either.)

At her new job, in her new town, Mary Ann was praised for her nursing skills, and it was while working at the Old Sunderland Infirmary that she met her second husband: her patient, George Ward. (Don't get too attached to George.) He died within the year, also of typhus fever, and Mary Ann got another life insurance payout. (Later, in court, it would be mentioned that nursing gave her access to an array of poisons.)

Next, Mary Ann saw an ad for a housekeeper placed by one James Robison, a wealthy widower with five children and a fine house, and she knew just the gal for the job. Shortly after Mary Ann arrived, the children started dying. She was there to comfort James in his grief, and she became pregnant soon after. In her book *Lady Killers*, Tori Telfer writes, "Mary Ann used pregnancy to secure marriage, but she wasn't especially interested in raising the children."

Mary Ann received word that her mother was ill, but it was an inconvenient time to leave her new love interest. She left the Robison home to care for her ailing mother, but she returned shortly when her mother promptly and conveniently died. Newspapers would make much of this later, that her mother only lived nine days after the arrival of Mary Ann, who helped herself to a number of linens and other items before leaving. She also brought her daughter Isabella back home with her.

This would prove unfortunate for nine-year-old Isabella, because upon Mary Ann's return, the young girl and two more of the Robinson children soon died of "gastric fever."

All three had life insurance policies taken out on them. At the trial, James Robinson stated, "I am convinced that my children were poisoned. . . . They were healthy and strong, and only ill a few days before they died. Any time she gave them anything they vomited, and were sick and purged." If he really was concerned about this pattern he supposedly noticed, he didn't let it stop him from marrying Mary Ann in August of 1867.

In November she gave birth to a daughter who only survived until February—another in a long line of Margarets. But not to worry, Mary Ann was soon pregnant again, with a son they named George. James foolishly entrusted his new bride with his finances, and he soon discovered she had been stealing from him and racking up debts. His son confessed that she had made him take objects from the home and sell them at a pawn shop for her. Furious, James took what was left of his family and

moved in with his sister, leaving his wife to her own devices. He would be the only man to survive being married to Mary Ann.

By now Joseph Nattrass's wife had died, and it's possible Mary Ann resumed her affair with him around this time. Meanwhile, her friend Margaret Cotton reached out and introduced Mary Ann to her grieving brother, Frederick. He was a widower who had also lost two of his four children. Margaret Cotton had been helping to care for the children when she suddenly passed away. Mary Ann is often accused of her murder, but other accounts state that she passed before Mary Ann arrived. However, Mary Ann quickly swooped in to console Frederick and help out around the house. Her particular style of comforting resulted in yet another pregnancy.

She married Frederick Cotton in 1870 and took his name. Of course, this marriage was not legal because she was still technically married to Robinson, but poor Frederick didn't know that. At her trial, bigamy was the only crime she would confess to. The Cotton family settled in West Auckland, but Frederick soon became ill, and he died within two weeks. The cause of death on his death certificate was typhus fever and hepatitis. He was thirty-nine.

At this point Joseph Nattrass moved in with Mary Ann as a lodger. If he had been her longtime lover, she may have been anxious to do away with any obstacles to rekindling their romance—namely, her stepchildren. Frederick Cotton junior soon died of gastric fever, and Robert Robson Cotton, her recent baby, died of "teething with convulsions" within the same month. Mary Ann collected small amounts of life insurance money on the three Cottons.

If Mary Ann had been seeking a path to Nattrass, something must have changed. Nattrass, who intended to marry her, died

soon after the Cotton baby. In fact, visitors to Nattrass's sickbed commented on the baby's creepy coffin in his room. Mary Ann knew Nattrass didn't have long to live, so she waited to bury the baby until her lover died, so she could bury them at the same time and save some money. The gossip around town was that Mary Ann had her sights set higher than Nattrass and that she had taken up with an excise officer, who would have been a better catch. In some accounts he is referred to as John Quick Manning and in others as John Mann. This fellow was thought to be the father of Mary Ann's last baby.

There was just one little Cotton child left standing between Mary Ann and her newest would-be husband. She complained to many that the boy, Charles Edward, was a burden, and caring for him was preventing her from taking in more lodgers. Mary Ann tried to have him committed to a workhouse, but that request was denied. Thomas Riley was the head of the Parish Relief and workhouse in West Auckland. Knowing she had been a nurse, he visited Mary Ann to ask if she would help tend to a smallpox patient. She explained she couldn't because of Charles Edward. At the trial Riley testified that Mary Ann darkly told him, "It may not make much matter; she would not be troubled long; he would go like all the rest of the Cotton family."

Riley never forgot those chilling words, and a few days later, as he was walking past her home, Mary Ann called out to say the boy had died. Thomas Riley took his suspicions to the police. Mary Ann wanted to get his death certificate so she could collect the life insurance, but she was prevented by a summons for a coroner's inquest. The local doctor performed a hasty autopsy in her home, on the table, and confirmed the death was natural. However, when he performed more rigorous tests on

"Mary Ann Cotton
She's DEAD and she's ROTTEN.
Laying in bed with her eyes WIDE OPEN.
Sing, sing, oh what should I sing?
Mary Ann Cotton she's TIED UP with string.
Where, where? Up in the air.
Selling BLACK PUDDINGS a penny a pair."

Charles Edward's stomach contents the next day, his tests did reveal the presence of arsenic. Mary Ann was then arrested for poisoning her stepson.

The press managed to piece together the body count, capitalizing on the sensational story that one woman had mysteriously lost so many people: three husbands, one mother, eleven children, and a friend. Charles Edward's body was exhumed, and samples were sent to the area's foremost expert in poisons. The bodies of the other Cotton family members as well as Joseph Nattrass were also exhumed, and they also tested positive for arsenic.

Mary Ann was arrested and gave birth to her thirteenth child while in prison—one final Margaret. She was given up for adoption and, after being separated from her mother, lived to be eighty-one years old. Mary Ann's defense argued that she was a loving mother and nurse incapable of what she was being accused of. They suggested that Charles Edward may have been poisoned by inhaling the fumes from the arsenical pigments in the wallpaper in the home—not an implausible argument—or from accidentally ingesting arsenic, but the jury swiftly found Mary Ann guilty of his murder. This was the only murder she was tried for, though she is believed to be responsible for as many as twenty-one. She was sentenced to hang.

In his book, Martin Connolly is uniquely sympathetic to Mary Ann. He notes that all the evidence against her was circumstantial. When police searched her home, no arsenic was found, and no witness could attest to having seen her give anyone poison. The other deaths were mentioned in the murder trial for Charles Edward, which surely influenced the jury. There were a number of reasons she may not have received the fairest trial. Perhaps it's also worth noting that while Mary Ann Cotton often seemed to use pregnancy to her advantage, birth control options at the time were few and far between. This is no excuse for offing your progeny, but it's easy to imagine

that a constant stream of pregnancies and births might take a toll on a woman's physical and mental health. It may never be known how many of the deaths attributed to her were actually the result of natural causes and which ones she hurried along. Public opinion had turned against the woman dubbed "The Black Widow," "The West Auckland Poisoner," and "The Dark Angel," but Mary Ann Cotton proclaimed her innocence until the very end.

Her last request was for a cup of tea, which was ironic because it is believed she poisoned many of her victims by slipping arsenic into their tea. In 1873 she was publicly hanged at age forty. However, it seemed the hangman botched the job and the rope was too short. The executioner had to press down on her shoulders to strangle her, and it took a full three minutes before she succumbed. A woman who never seemed to care much for children, she would live on as the villain in a creepy children's rhyme for many years to come. Otherwise, her name remains relatively unknown, despite the fact she was arguably a prolific serial killer.

Mary Ann's story is dark and confounding. If the allegations against her have any truth to them, then she was unimaginably mercenary, using pregnancy to secure husbands and disposing of her children as they became burdensome. She represents something deviant, diabolical, and "unfeminine." She is the opposite of the Victorian ideal of womanhood—not a nurturer, but a murderer. Stories like Mary Ann's would have a profound impact on the public and the fear of poison in the hands of the fairer sex.

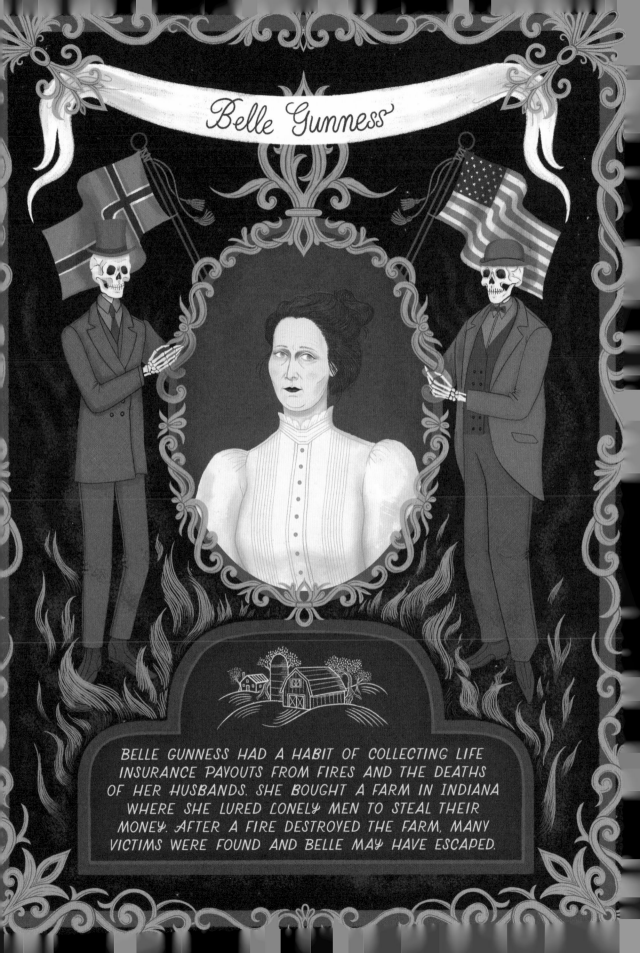

Belle Gunness

BELLE GUNNESS HAD A HABIT OF COLLECTING LIFE INSURANCE PAYOUTS FROM FIRES AND THE DEATHS OF HER HUSBANDS. SHE BOUGHT A FARM IN INDIANA WHERE SHE LURED LONELY MEN TO STEAL THEIR MONEY. AFTER A FIRE DESTROYED THE FARM, MANY VICTIMS WERE FOUND AND BELLE MAY HAVE ESCAPED.

The unbelievable story of Belle Gunness has everything you could want in a crime mystery (and many things you probably don't!): arson, piles of amorous love letters, Scandinavian cuisine, strychnine poison, a headless corpse, money sewn into underwear, and multiple murders. Belle would go by many names in the press, including Hell's Belle, Hell's Princess, the Indiana Ogress, and Madam Bluebeard (which all sound like cool rock bands or motorcycle gangs), but she was born into poverty in Norway in 1859 as Brynhild Paulsdatter Størset.

She followed her older sister and immigrated to the United States in 1881, where she started calling herself Belle. Living in Chicago, she worked menial jobs to pay the bills, but she always envisioned a grander future for herself. Her sister, Nellie Larson, would later say of her, "My sister was insane on the subject of money. . . . She would do anything to get it. . . . She never seemed to care for a man for his own self, only the money or luxury he was able to give her."

Money would motivate most of Belle's choices, including her romantic ones. She is usually described as having piercing blue eyes, standing anywhere from around five feet seven to almost six feet tall (as the legends about her grew, so did she), and weighing about 280 pounds—these features will be very important later. It is generally understood that she was tall and strong: The word "formidable" is thrown around a lot in connection with Belle.

One of her contemporaries described her as a "fat, heavy-featured woman with a big head covered with a mop of mud-colored hair, small eyes, huge hands and arms, and a gross body supported by feet grotesquely small." In spite of this unflattering description, Belle never had any trouble finding suitors.

She met and married fellow Norwegian immigrant Mads Ditlev Anton Sorenson, and the two opened a candy store, but, alas, they weren't living the sweet life just yet. Their business was failing when it mysteriously caught fire. The two sold the shop and bought a house with the insurance payout. Another fire broke out in this house as well, but luckily (or, likely, intentionally) all of the damaged items were heavily insured. Belle was also known to adopt and foster children, as Harold Schechter explains in his account of her life, *Hell's Princess: The Mystery of Belle Gunness, Butcher of Men*. One such child was a neighbor's daughter, named Jennie Olsen, who lived with Belle and Mads at the time.

On July 30, 1900, Mads came home from work complaining of a terrible headache. Belle later told the doctor that she had given him some quinine powder while he laid down. When she went to check on him later, he was dead. The doctor cited the cause of death as natural, though he would later admit that the symptoms were not dissimilar from those of strychnine poisoning. What are the odds that her husband died on the one day that two different life insurance policies overlapped? Belle

was able to collect on both, for a total of five thousand dollars, like she had won the darkest version of the lottery.

She used the money to purchase a thirteen-room farmhouse on forty-eight acres of land in scenic La Porte, Indiana, where she moved with her children. Her next marriage would be to another fellow Norwegian, Peter Gunness. He was a widower with two children, though his baby daughter would die a week after their wedding while in Belle's care. If Mads's death seemed uncanny, Peter's was certainly weirder. Just eight months after Peter and Belle's wedding, little Jennie called on the neighbors for help when Peter was found facedown with a massive gash in the back of his head and a broken nose. Belle wove a story about a tragic accident in which her second husband had fallen in the kitchen, scalding himself with a bowl of hot brine, and had then been struck in the head by a meat grinder that fell from a high shelf. Though bizarre and suspicious, Peter's death was ruled an accident. Many people in town whispered about foul play, including Belle's little daughter Myrtle, from her marriage to Mads, who supposedly confided in a schoolmate, "My mamma killed my papa. She hit him with a meat cleaver and he died. Don't tell a soul."

Belle would start hiring different farmhands to help her with the many duties of managing a farm. These men often became more to her than hired help—many of them boasted that she would marry them, and they would then become the proprietor of her beautiful farm—but they had a funny habit of suddenly vanishing. Belle always had a way to explain away their disappearances. One young farmhand became enamored of her now sixteen-year-old, Jennie. Belle told everyone that Jennie would be going off to college

in California. She was never seen or heard from again.

Belle was once again a wealthy widow, with a farm to run, in search of a husband. She placed an ad in some of the Norwegian-language papers in the area that read: "Personal—comely widow who owns a large farm in one of the finest districts in La Porte County, Indiana, desires to make the acquaintance of a gentleman equally well provided, with view of joining fortunes. No replies by letter considered unless sender is willing to follow answer with personal visit. Triflers need not apply."

Belle's postman said she received about ten letters a day in response to her ad. She would write back to the lonely men and tell them all the same thing: to liquefy their assets and come visit her soon with their life savings in cash sewn into their underwear. She also warned them not to tell anyone where they were going. She promised these lonely immigrant men comforts from their homeland that they missed, like Norwegian language and cuisine, as well as companionship, wealth, a beautiful farm, and all of Belle.

Visitors began to cycle through the farm as frequently as every other week, but no one ever saw them leave. And they always left all of their belongings behind. Belle devoted a room in the farmhouse to all their "abandoned" trunks and clothes. She was often seen wearing their coats or shoes while she tended to her pigs. One of Belle's men was Andrew Helgelien. He was almost fifty years old, a Norwegian wheat farmer from South Dakota. The two are thought to have exchanged almost eighty letters, in which Belle showered him with praise and promises of domestic bliss. She wrote to him, "My heart beats in wild rapture for you. My Andrew, I love you. Come prepared to stay forever." And she meant it, literally.

When he finally arrived in La Porte, they were seen going to the bank together to collect all of Andrew's money. After she got his life savings in her hot little hands, Andrew was never seen again—alive. Her latest hired hand, Ray Lamphere, was quite smitten with Belle and bitterly envious of her many suitors, especially Helgelien. It's possible that Ray saw something of what happened to Helgelien and knew too much. Things between them turned sour and Belle accused Ray of harassing her. She had him arrested multiple times for trespassing and tried to have him declared insane. Eventually Belle moved on and hired a new helper named Joe Maxson.

When Andrew didn't return home in a week like he had said he would, his brother became worried and discovered dozens of letters from Belle documenting their whirlwind romance. He resolved to investigate for himself. Things were starting to unravel. Belle went around town telling everyone that Ray had lost it and was threatening to set fire to her home with her inside it. She visited her lawyer to finalize her will, then went to the store and purchased an interesting assortment of items: cake, candy, and toys for the children—and two gallons of kerosene.

The very next day, the morning of April 27, 1908, Joe Maxson awoke with a start to find his bedroom in the Gunness farmhouse filled with smoke. He tried desperately to find and evacuate Mrs. Gunness and the children—Myrtle, age eleven, Lucy, age nine, and Philip, age five—but he was unable to find them. Maxson fled from the burning building to call for help. When the raging fire was eventually extinguished, four corpses were discovered, not in their bedrooms, but lying neatly stacked on top of each other in the cellar. Three small bodies and one that belonged to an adult woman—who, one would presume, must have been Belle Gunness. But there was a problem. The woman's corpse was missing a critical piece for identification: Her head was nowhere to be found.

From the beginning there were doubts that the body belonged to Belle Gunness. Doctors estimated this woman they found was about

five foot three—even accounting for the missing head, significantly shorter than Belle. The corpse also weighed a measly seventy-five pounds. Granted, much of the body had been burned away, but could so little of the formidable Belle really have remained?

The community, fueled by reports from the press, was agog with theories about the mysterious and tragic event. Rumors quickly swirled that Ray had set the fire like Belle had feared, and slowly an even more sinister theory emerged: that Belle had started the fire herself. Was the woman's headless body a decoy planted by Belle to fake her own death so she could escape? Ray was arrested. He seemed to know about the fire, but not that the family had perished in it.

Andrew Helgelien's brother, Asle, arrived in La Porte to try and find his missing sibling. He saw what had become of the Gunness farm and joined the men in digging at the site for more evidence. The men noticed a soft patch of earth at one of the "rubbish holes" Joe had dug at Belle's insistence. There they discovered a dismembered human body buried in a gunnysack, which Asle recognized as his brother. They called for the sheriff, and that day the men found five additional bodies buried in pieces throughout Belle's hog lot. Curious onlookers gathered to watch as the grisly discoveries came to light. Jennie's teenage body was found among the dead. She had never gone to California. Nine more bodies were uncovered the next day. They were all treated the exact same way, cut into pieces, covered in quicklime, and stuffed in gunnysacks. Many of them were the suitors who had responded to Belle's matrimonial ad— she had just adored them to bits.

A postmortem exam was carried out on the charred remains. The stomachs of the victims of the fire were tested and found to contain arsenic and strychnine. Andrew Helgelien's stomach was also found to contain the toxic mixture. The theory of Belle's modus operandi emerged: She lured men to her with promises of love, stole their life savings, and, when she had no more use for them, she used poison to weaken them, struck them with a cleaver or hammer, and then dismembered and buried them on her property. We may never know Belle's true body count. It has been speculated to be about twenty-eight.

In *The Truth about Belle Gunness: The True Story of Notorious Serial Killer Hell's Belle*, Lillian de la Torre goes into great detail about the trial of Ray Lamphere. His defense hinged on the notion that Ray could not be tried for Belle's murder because she was not dead, but actually alive and on the lam. The argument continued that the people in the house were killed with poison and then the fire was set to cover it up. His defense lawyer argued, "Mrs. Gunness was one of the most notorious of women criminals. . . . We will show that she had a clear motive in burning down her house and poisoning her children on that memorable night. We will show that this was the crisis in her life of crime, and that she was afraid that any hour her career of crime might be uncovered."

Ultimately Ray Lamphere was found guilty of arson, but not of murder, and he was sentenced to twenty-one years in the state penitentiary. On his deathbed he allegedly confessed to being Belle's accomplice and helping her escape. He believed she was still alive and very rich. Claims of seeing Belle after the fire continued to surface in the years after her supposed death, but nothing was ever confirmed.

Belle is unusual among women poisoners in a few ways. Most use poison to avoid the messier means of murder, like stabbing or strangling, but Belle was strong and clearly

not averse to violent acts. It's also not clear why she used both arsenic *and* strychnine poison on her victims. Surely one would have been plenty, and to poison them and then bludgeon them seems like overkill. Most female poisoners do not dismember or bury their victims. They tend to want to have as little to do with the dead body as possible, and they try to pass off the death as illness or other natural causes.

Belle Gunness's life is a contradiction. She was a motherly figure who seemed to genuinely love children and adopted many babies, but she also hacked people to pieces. The term didn't exist in her time, but she would later be understood to be a psychopath. Her newspaper advertisement seeking to meet strange men shares a troubling resemblance to today's internet phishing and dating scams. To this day Belle and her murder farm remain the stuff of mystery and nightmares. She was the belle of her own twisted ball, until it all went up in smoke.

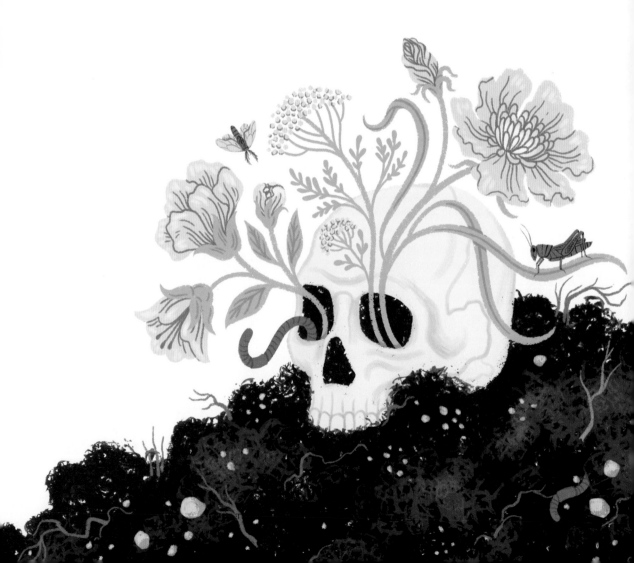

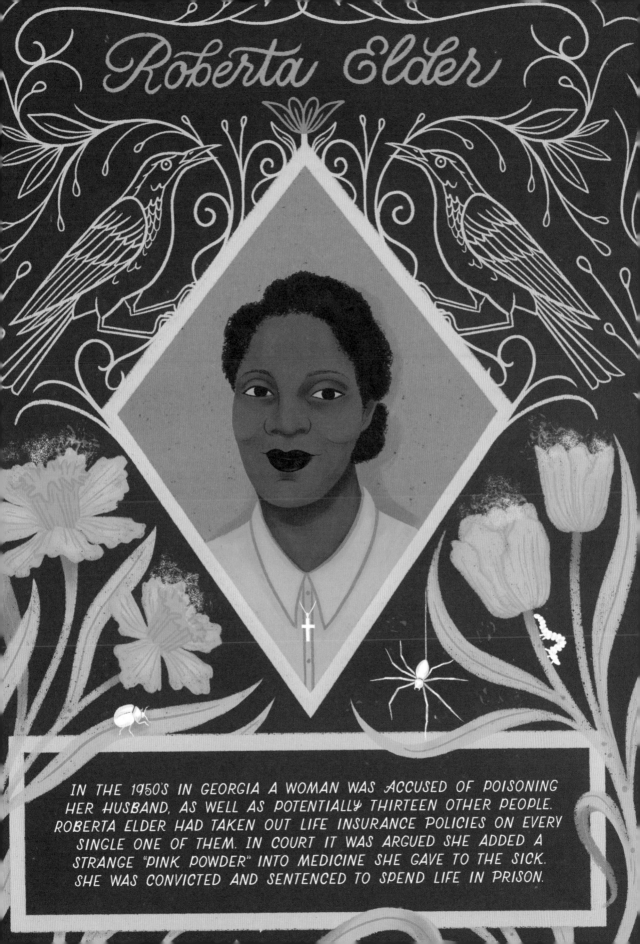

Roberta Elder

IN THE 1950'S IN GEORGIA A WOMAN WAS ACCUSED OF POISONING
HER HUSBAND, AS WELL AS POTENTIALLY THIRTEEN OTHER PEOPLE.
ROBERTA ELDER HAD TAKEN OUT LIFE INSURANCE POLICIES ON EVERY
SINGLE ONE OF THEM. IN COURT IT WAS ARGUED SHE ADDED A
STRANGE "PINK POWDER" INTO MEDICINE SHE GAVE TO THE SICK.
SHE WAS CONVICTED AND SENTENCED TO SPEND LIFE IN PRISON.

When a woman is accused of murder, especially of the serial poisoning variety, it often becomes a full-blown media frenzy, with newspapers publishing everything they can about the sensational story to feed the public's dark fascination. We enter ethically murky waters when criminals evolve into quasi celebrities. However, an examination of whose stories are highlighted by the press and take hold in our collective memories says a lot about deep implicit biases in our society. The stories of people who are rich and white tend to dominate our headlines, while those of people from marginalized backgrounds fall by the wayside. This inequity is reflected in the captivating but little-known story of Roberta Elder.

Roberta was a middle-aged Black woman in Atlanta, Georgia, who was accused of poisoning multiple family members in the mid-1950s. The only sources to be found about her life are newspaper articles from the time of her inquest and trial. The mainstream white press failed to cover her story, but African American newspapers from around the country, including the *Pittsburgh Courier*, the *Atlanta Daily World*, and the *Chicago Defender,* ran it.

The news coverage began after the sudden passing of Roberta's husband, Reverend William M. Elder, a Baptist minister and part-time carpenter. The two had married in 1950, creating a blended family with their children from previous relationships. After having been married only two years, the reverend became ill while at work on a construction site after eating a snack brought from home, an innocuous combination of "bananas and cheese."

The *Pittsburgh Courier* published a four-part series about Roberta, written by William A. Fowlkes, titled "Atlanta's 'Mrs. Bluebeard': The Strange Case of Roberta Elder!" In it, the author mentions that one of Reverend Elder's fellow workmen came to visit him while he was sick in bed and commented, "Well, I didn't know bananas and cheese would hurt you." (If this book teaches you anything, I hope it is the realization that anything can be poison, and bananas are no exception. Not that death by banana is easy to do. According to Catherine Collins, a dietitian at St George's Hospital in London for the BBC, "You would probably need around 400 bananas a day to build up the kind of potassium levels that would cause your heart to stop beating . . ." Now, if those bananas were deliberately adulterated with poison, that's another story entirely.)

Reverend Elder died in August of 1952, but the family physician paused before signing the death certificate. He noted some symptoms that struck him as out of the ordinary. It looked like the reverend's skin had started to "shift" and peel, and there were also sores on his body. He realized he had seen these same symptoms before: on the body of Annie Pearl Elder, the reverend's nine-year-old daughter who had died the previous year, and on her sister, Fannie Mae Elder, just fifteen, who had died within months of the younger Elder. At the time, he cited the

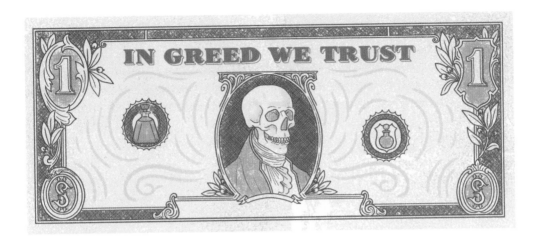

IN GREED WE TRUST

cause of death for both girls as pneumonia, but the shifting skin had shifted his opinion, and now he was having second thoughts. The doctor brought his concerns to the coroner.

The coroner called for an inquest, and tests revealed the presence of nearly three grains of arsenic in Reverend Elder's body. According to Fowlkes, ". . . subsequent court orders resulted in the bodies of two of the Rev. Mr. Elder's young children being exhumed from the lonely 'garden of death' Mrs. Elder had 'planted.'" Arsenic was also found in the sisters' hair and tissue. Roberta Elder was charged with all three of the murders, but she would only go to trial for that of her husband. It came to light that all three family members had life insurance policies taken out on them, with Roberta named as the sole beneficiary.

Detective J. E. Helms uncovered a litany of suspicious deaths from Roberta's past that may have begun as early as 1938. According to the four-part series in the *Pittsburgh Courier*, "They found thirteen possible victims, from two weeks old to 93 years of age. Most of them had died of pneumonia, uremic and/or 'food

poisoning.' Most of them were insured with policies worth from $50 to $500. Most of them died a year or slightly more after being insured." Different articles claim that there were eleven to seventeen possible victims in about a fourteen-year span. If this is true, Roberta Elder may be one of the most prolific serial poisoners you have never heard of.

While only the three aforementioned bodies were tested for arsenic, the many other suspicious deaths associated with Roberta betray a startling pattern. All of the suspected victims had lived in the same home as Roberta, and she was the beneficiary on each of their life insurance policies. According to a list published by the *Pittsburg Courier*, among those suspicious deaths were those of her first common-law husband, John Woodward, who died at age thirty-six in 1938; James W. Thurmond, her thirteen-year-old son, who died in 1939; her two-year-old grandson, Jimmy Lee Crane Hunter; one-year-old James Garfield Crane; and three-year-old Gloria Evans, who all passed away between 1941 and 1944; two babies who were just weeks old, Willie Mae Thurmond

and Lillie Lou Thurmond; Roberta's own mother, Collie Brown; and ninety-three-year-old Nora Scott Harris. It was an occupational hazard just to live under the same roof as Roberta.

At the inquest and trial, her demeanor was described as cold and expressionless. Fowlkes wrote, "With as much indifference as a cornered opossum, Mrs. Elder merely shrugged her shoulders when deputies escorted her from the courtroom." The theory emerged that Mrs. Elder had given all three of the now-deceased members of the Elder family medicine from the same bottle of milk of magnesia. The bottle from the Elder home was taken, tested, and proved to contain arsenic. This would be a particularly diabolical vehicle for poison, in the guise of medicine. The family members would get sick after eating food laced with arsenic and then get treated with "medicine" that only made them sicker. And Roberta would get to look like a caring, attentive motherly figure.

Two of Reverend Elder's surviving children took the stand at their stepmother's trial. Dorothy Elder claimed she had been sick with symptoms similar to those of the deceased and that Roberta had given her milk of magnesia, though "it made me worse." Willie Elder Jr. also explained that he stopped eating at the house after his father's death. An article from the *Atlanta Daily World* in 1953 quoted him as saying, "I thought if she poisoned them she might try to get me too."

Roberta denied knowing anything about arsenic, claiming she didn't even know what it looked like. Her stepdaughter Dorothy claimed she had seen something pink in a brown paper sack in the house. Roberta explained that it was poison used to kill insects on plants. The prosecution alleged it was this that she added to the medicine bottle. They added that she could have gotten the pink arsenical mixture from her brother-in-law's farm. Roberta never wavered in saying she had nothing to do with it.

Roberta Elder had been acting as the treasurer for a local fraternal organization called the Heroines of Jericho. Money had gone missing, and the organization was putting pressure on Roberta to account for and repay the missing funds. The prosecution cited this as a potential motive for the murders. Although all of the evidence against her was circumstantial, the (all-white) jury convicted Roberta Elder of the murder of her husband. She was sentenced to life in prison.

After her conviction, the rest of Roberta's story goes cold. There is no further mention of her in the newspapers. Roberta took out rather modest insurance claims on those around her, which likely prevented her from attracting too much suspicion. Though arsenic poisoning is often associated with gastrointestinal ailments, some of its symptoms can also be misconstrued as pneumonia, as arsenic poisoning can affect just about every part of the body, including the respiratory system. If her family's doctor hadn't spoken up and intervened, perhaps the three living Elder children would not have been around to take the stand. Maybe that was her plan all along.

Atlanta's Mrs. Bluebeard was accused of some grisly and heinous crimes, yet her name is often left off the list of infamous women poisoners. Black women are not usually considered a part of the canon of serial murderers. Although this isn't necessarily a club people are clamoring to join, it's worth reflecting on how there are more narratives than the same few we regularly see that highlight white criminals and white victims. Just because a story isn't told doesn't mean it didn't happen.

Anna Marie Hahn was a betting woman. She loved the rush of winning big. But no matter how much she won, she always wanted more. The thing about greed is that it never ends. No amount of money is ever enough, and the trappings of wealth never actually bring satisfaction. Greed would lead Anna Marie to become many things in her life: a gambler, a "nurse," a thief, a mother, and a murderer. Her riskiest bet of all was that she wouldn't get caught.

She was born in Bavaria, Germany, in 1906, the youngest of twelve children in a large and well-respected Catholic family. She became the subject of a local scandal when she got pregnant at nineteen while unmarried. Her son, Oskar, was born in May of 1925. No one believed Anna Marie's story that the father was a prominent Viennese cancer doctor who abandoned her. Shunned by her community, she left for America at her mother's suggestion.

Anna Marie wrote to an uncle in Cincinnati, Ohio, saying nothing of her predicament but telling him that she was looking for work. Her uncle agreed to loan her money for the voyage and house her when she arrived. It was decided that her son would stay in Germany with her parents for the time being. So, at age twenty-three Anna Marie bid goodbye to judgmental Bavaria and said hello to a fresh start in Ohio.

It didn't matter that Anna Marie never had terribly well-paying jobs; somehow, she filled her room with lovely trinkets well beyond her means. This befuddled her family and irked her

uncle, as she had not managed to repay his loan. Then she discovered gambling. After winning a bet at the horse races, she was hooked. Her gambling addiction would fuel all of her poor choices for years to come.

She was a young, pretty, blonde con artist, and the men of Cincinnati couldn't believe their luck when they caught her attention. She falsely claimed to be a trained nurse, though she had no medical training. She would promise to marry the men, make them home-cooked meals, and dote on them, all while asking for loans and gifts, which the men happily gave her. She was careful to pick lonely older men with no close relatives.

Her first mark was "Uncle Charlie," or Karl Osswald, a seventy-one-year-old widower. Convincing him that she was a nurse who could help care for him, she moved into the top floor of his home. She took Uncle Charlie for every penny she could get, while promising to marry him despite their nearly fifty-year age gap. He was over the moon. But it was just another lie.

Meanwhile, at a German dance Anna Marie met Philip Hahn, a telegrapher for Western Union. They married in 1930 and then traveled to Bavaria to retrieve Oskar, but the couple's relationship would always be rocky. Philip saw little of his wife, who was often out flirting with senior citizens to secure money and then gambling it away. Philip and Anna Marie bought a home and lost it, then started a bakery and delicatessen but lost that too. It was the height of the Great Depression after all. After experiencing a strange illness himself, Philip became increasingly afraid of his wife; the two of them would eventually become rather estranged, although some sources suggest he did support her at the trial.

When Karl Osswald discovered that his fiancée was already married and had a son, he initiated a lawsuit against her for breach of trust, but the smooth-talking scammer talked him down. He died in 1935, and Anna Marie collected a thousand dollars as the sole beneficiary of his pension death benefit. There was no other money to be gotten from Uncle Charlie. She had taken everything he had.

Her next pursuit was Ernst Koehler, a sixty-two-year-old man with a lovely home who was suffering from throat cancer, and whom she also offered to nurse. When he died, everyone assumed it had been from the cancer. About two weeks before his passing, Ernst had conveniently rewritten his will, leaving all of his possessions—including his house, car, and savings—to his dear, caring nurse, Anna Marie.

After this big score she next sidled up to George Heis, from whom she bought her coal. She started asking for little loans that eventually added up to the hefty sum of two thousand dollars. Heis had borrowed most of the money from the company that he worked for, which put him in a tricky spot. When he and the credit manager for the Consolidated Coal Company, Clarence Osborne, started to demand the money back, Anna Marie began borrowing the money from another older man to pay off her loan from George. George started to feel unwell and had difficulty walking after eating meals Anna served him. Suspicious and fearful, he threw her out.

In *The Good-Bye Door: The Incredible True Story of America's First Female Serial Killer to Die in the Chair*, Diana Franklin refers to an article from the International News Service from October 11, 1937, explaining, "The pressure Heis and Osborne put on Anna Marie to pay back the money she had borrowed accelerated 'the most gruesome premeditated poison murder plot in crime annals.'" She offered to be nurse and girlfriend to seventy-two-year-old

Albert Palmer. She got one thousand dollars from him in an effort to repay Heis, but she couldn't resist gambling some of the money away. Palmer gave her an ultimatum: Pay the money back or be his exclusive girlfriend. Anna Marie had no intention of doing either. He threatened her with legal action, and she responded with lethal action. He died at age seventy-two, totally penniless.

Her next clever idea was to trick seventy-eight-year-old Jacob Wagner into believing she was his long-lost niece from the old country. She had been randomly knocking on doors and asking people if any old men lived nearby. Somehow this worked and Wagner was head over heels. She "borrowed" his bank book and only returned it when he threatened to call the police. When he became violently ill with vomiting and diarrhea, two different doctors urged Anna Marie to take him to the hospital. Two weeks after she walked through his door, he died in agony.

Sixty-seven-year-old George Gsellman would be next to perish, after eating poisoned meat and gravy Anna Marie had served him. At her trial, it was revealed that pots left on his stovetop were tested and found to contain nearly eighteen grains of arsenic trioxide, enough to kill two dozen people! But these were small potatoes, so to speak; her next con would be her most elaborate one yet.

Anna Marie convinced cobbler Georg Obendoerfer to take a trip with her to Colorado Springs, promising that they would get married afterward. The sixty-seven-year-old grandfather gladly agreed to go with Anna Marie and her son. He boarded the train after dinner feeling extremely unwell. When they checked into a hotel along their route, all the employees took notice of the gravely ill older man with the young woman and child. Everyone would later

avoid his room because of the terrible smell emanating from it. Anna Marie kept switching hotels when the staff complained.

He wouldn't live to see their destination. Anna Marie dropped him off at a local hospital claiming not to know the sick man, and she took off with Oskar in tow. Before returning to Cincinnati, she swiped two diamond rings she had spotted in the hotel in Colorado Springs and hocked them in a pawn shop. It's the sparkly appeal of the diamonds that did her in. When she returned to Ohio, the police were waiting with a warrant for her arrest—not for serial murder, but for jewelry theft.

While she was away in Colorado, Ohio police had exhumed Jacob Wagner's body; the autopsy proved he had almost eight grains of arsenic in his organs (between one and three is enough to be fatal). A murder investigation was opened, and it didn't take long for detectives to connect their jewelry thief to a string of murders of older men by a woman claiming to be their caregiver. She was arrested and promptly became a media sensation.

Anna Marie staunchly maintained her innocence throughout her questioning and trial. When asked if she ever added poison to anyone's food, she replied, "Do I look like a woman who would do a thing like that? . . . It

was just my kindness that got me into all this trouble." (If "kindness" was a euphemism for arsenic, then yes.) She used her angelic appearance and her young son to pass herself off as an elegant and feminine woman, falsely accused of a cruel crime. She was tried only for the poisoning murder of Jacob Wagner, but the pattern of her association with other deceased men came out during the trial.

George Heis, now in a wheelchair from the effects of poisoning, testified against her as a "living victim." In his final statement, the lawyer for the prosecution made a powerful and theatrical plea for her conviction. He bellowed, "In the four corners of this courtroom there stand four dead men, Jacob Wagner! George Gsellman! Georg Obendoerfer! Albert Palmer! From the four corners of this room, bony fingers point at her and they say to you, 'That woman poisoned me! That woman made my last moment an agony! That woman tortured me with tortures of the damned!' . . . From the four corners of this room those old men say to you, 'Do your duty!'"

The jury found her guilty without a recommendation of mercy. They were particularly swayed by the fact that her purse, confiscated at the time of her arrest and presented as evidence, was full of arsenic. Anna Marie seemed incredulous at her fate and kept expecting a reprieve that never came. As she was taken to the electric chair, known as "Old Sparky" by the locals, she broke down, thrashed, and pleaded for help. Josie O'Bleness, one of the prison matrons, revealed that in "her last twenty-four hours, Anna Hahn changed from the poised, confident, proud, and even vain woman she had been continuously since she was first arrested into a little witch—a demon with a wild look in her eyes. When she knew the jig was up, she became the true Anna."

She was executed on December 7, 1938, and became the first woman in Ohio to die by electric chair. After her death, her handwritten confessions were released and printed in the newspapers. In them she finally admits to the poisonings, but she also claims, "It was another mind that made me do these things. I didn't do them. I don't know how I could have done the things I did in my life." To the bitter end, Anna Marie Hahn never took responsibility for her actions. She used her good looks and her young son to get people to trust her, and then exploited them for everything they had.

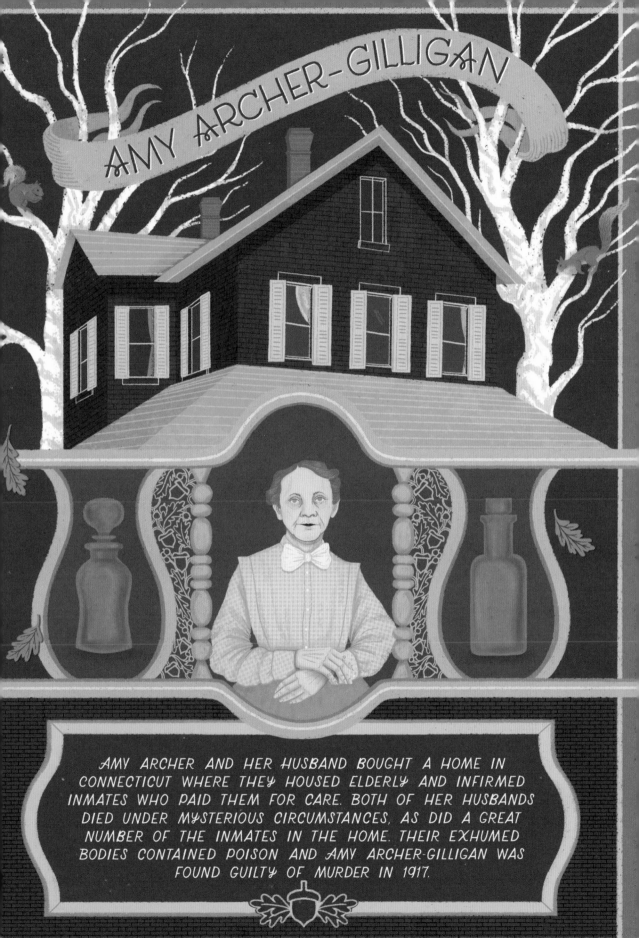

AMY ARCHER-GILLIGAN

AMY ARCHER AND HER HUSBAND BOUGHT A HOME IN CONNECTICUT WHERE THEY HOUSED ELDERLY AND INFIRMED INMATES WHO PAID THEM FOR CARE. BOTH OF HER HUSBANDS DIED UNDER MYSTERIOUS CIRCUMSTANCES, AS DID A GREAT NUMBER OF THE INMATES IN THE HOME. THEIR EXHUMED BODIES CONTAINED POISON AND AMY ARCHER-GILLIGAN WAS FOUND GUILTY OF MURDER IN 1917.

Hahn wasn't the only person to take advantage of vulnerable elderly people. According to the CDC there were about 15,600 nursing homes in the United States as of 2016, but in the early twentieth century retirement and nursing homes were a novel concept. Families typically took care of their elderly relatives themselves, as the only other option was sending them to the poorhouse.

Amy Archer-Gilligan saw lonely, abandoned elderly people as a great business opportunity. And she would have gotten away with her money-making murder scheme, too, if it weren't for a dogged newspaper reporter, a devoted sibling, careful police work, and the telltale signs of arsenic poisoning.

Little is known about her childhood except that she was born in Milton, Connecticut, in October of 1868. She may have even been born on Halloween—spooky! Amy Duggan married her first husband, James Archer, in 1897. They had one daughter, named Mary. In 1901 in Newington, Connecticut, a wealthy elderly man named John Seymour hired Amy to be his caregiver, while her husband helped around the grounds of Seymour's large home. In return, the Archers could stay with him rent-free. Like Anna Marie, Amy had falsely claimed she was a trained nurse to gain Seymour's trust.

This is where the Archers hatched their innovative business idea of running a home for the elderly in Seymour's house. It didn't seem to bother them that they were in no way qualified for such work. Elder care was the Wild West back then, and there were no laws yet regulating the care of senior citizens. Amy and James continued to care for elderly people in Seymour's home until his family sold it and the ambitious couple decided to buy and run their own place. The pair settled in Windsor, Connecticut, in a stately brick house on Prospect Street, which still stands to this day. They called it the Archer Home for the Elderly and Indigent Persons, but in a few short years newspaper headlines would dub this same home "The Murder Factory."

The Archers could house about twenty "inmates," who paid according to a unique payment policy. Potential inmates could choose between two options: Pay $7 a week, or a flat fee for $1,000 up front for the "life care plan," which guaranteed them housing, meals, and care for as long as they lived. If you were in decent health, it seemed like a great deal. If you couldn't afford the $1,000 payment all at once, Amy would gladly accept pensions and property, as well as revised wills and life insurance policies in her favor—she wasn't picky. Residents, thinking they were ensuring care for the rest of their lives, had no idea just how short those lives would be.

Amy is often described as small and grandmotherly herself—unfortunately for her, because she was only in her late thirties. Amy presented herself about town as a pious woman and was often seen with a Bible tucked under her arm, earning her the nickname "Sister Amy." She was well regarded in the community for her

service to the elderly. She would later say to the *Hartford Courant*, "This is Christian work and one that is very trying as we have to put up with lots of things on account of the peculiarities of the old people." Really, the old people had to put up with *her*. There were claims of abuse in the home, doled out by Amy, and a lawsuit that she was trying to keep quiet. Sister Amy also became a widow when her husband died suddenly in 1910.

M. William Phelps describes Amy's story in rich detail in his book *The Devil's Rooming House: The True Story of America's Deadliest Female Serial Killer*. In his book, he admits that if it weren't for all the murdering, Amy could have left a very different legacy as a woman entrepreneur and a pioneer in the budding business of elder care. But that's not how this story plays out. You see, there was an intrinsic flaw with the home's payment model. With everyone opting for the "care for life" plan, Amy only had money coming in when a new inmate arrived. This gave her a financial incentive to keep opening up new beds, and to get rid of inmates who had already paid up. If someone showed up willing to fork over $1,000 dollars and there wasn't a bed available—well, Amy would just have to make a bed available.

Phelps asserts that the hero of the tale is a plucky part-time newspaper reporter for the *Hartford Courant* named Carlan Goslee. He was the first to notice the unusually large number of deaths happening at the Archer home, and he began investigating.

One of the inmates was a man named Franklin Andrews. Later, reporter Joseph McNamara would write, "Fun-loving Andrews considered himself a youngster [at fifty-nine years of age] [compared] to the ancients that lumbered about the place." Franklin was happy to help out around the home and do chores for the matron, but he also wrote many letters to friends and family commenting on how many people seemed to come and go in the house. He stopped just short of making any accusations.

It was hard to notice at first. It was to be expected that some people in a home for the elderly and disabled would, at some point, pass away. Goslee, however, made the morbid discovery that ". . . the ratio of dead to living in the Archer home was six times higher than any other home in the state." In fact, Amy's death count was much higher than that at similar homes that housed considerably more inmates. Carlan Goslee also had the insight to check the local drugstore's poison register, where he discovered the staggering amount of arsenic Amy had purchased there. In fact, Amy rarely made the purchases herself, instead sending her residents on errands to pick up the poison she would later use to kill them.

Amy took special notice of a strong, capable middle-aged man among her inmates named Michael Gilligan. They were married shortly after they met in 1913, but their whirlwind romance concluded in the fifty-seven-year-old's untimely death a mere three months into their marriage. One evening Amy asked him to sign a new will making her his executor, and the very next day Michael was experiencing vomiting, diarrhea, and agonizing pain. Amy called the in-house physician she regularly used, but only when it was too late. The doctor cited his cause of death as an acute attack of indigestion.

The twice-widowed matron of the home wrote a letter asking Franklin Andrews for a loan of several hundred dollars. Around this same time, a wealthy elderly couple, Loren and Alice Gaudi, reached out to Amy inquiring if she had space available for them. And, of course, Amy always did. The only room in the Archer house that could accommodate the couple was

already occupied—by Franklin Andrews. One morning in late May 1914, Andrews helped Amy out by painting the fence around the property. Neighbors later commented on having seen him at work, apparently completely healthy. That's why it was so shocking when he became violently ill later that night. A burning sensation in his throat and stomach soon became a roaring pain, and the man, who had never complained of any stomach issues, was soon pale, and he vomited for two days.

When his sister, Nellie Pierce, arrived, she was too late. Andrews had died. Pierce was confused by the death certificate citing gastric ulcers as the cause of her healthy brother's demise. She also found the letter from Amy asking Andrews for money among his belongings. Pierce's gut told her that Andrews's gut wasn't the problem here, and she took her suspicions to the office of the *Hartford Courant*. Now the newspaper agreed it was time to inform Thomas Egan, the superintendent of the Connecticut state police.

The Gaudis then moved into Andrews's old room in the Archer home, but it wasn't long before Alice took ill with the same troubling symptoms as Michael Gilligan, Franklin Andrews, and many before them. It is believed that between 1908 and 1914, fifty-two deaths were recorded at the Archer home, and forty of those were deemed suspicious. Amy doubled down on her lies, indignant about the accusations arising from her community.

About two years after Franklin Andrews's death, the state ordered a secret exhumation of his body. Arthur Wolfe, the state's chief pathologist, was called to perform the task under the cover of night, so as not to alert Amy to their investigation. Dr. Wolfe tested samples he had collected of Andrews's internal organs, and the results came back positive for arsenic. This led

directly to Amy's arrest in May of 1916. Amy pled not guilty in response to the five counts of first-degree murder she was charged with for the deaths of Franklin Andrews, Alice Gaudi, Michael Gilligan, Charles Smith, and Maude Lynch. All of their bodies had been exhumed and showed evidence of arsenic poisoning, except for Lynch's, which showed strychnine—they say variety is the spice of life. Ultimately, she would only be tried for the murder of Franklin Andrews, as that was the case the state had the most evidence for.

The jury convicted Amy Archer-Gilligan of first-degree murder. She was sentenced to hang, but her lawyer appealed the sentence and she was granted a second trial on the grounds that information about the other suspicious deaths was included in what was supposed to be a trial for Franklin Andrews's murder alone. This time the defense tried to use an insanity plea and claimed Amy was a drug addict, out of her mind on morphine when the murders occurred. She was found guilty of second-degree murder and sentenced to life in prison.

After a few years in prison, Amy was eventually declared insane. An article in the *Hartford Courant* by Colin McEnroe in 2000

looked back on these crimes and the events surrounding them. McEnroe described her behavior: "She had previously been in the habit of talking at length on the telephone to herself and of playing funeral music on the piano on those very rare occasions when nobody had died recently, so this diagnosis was perhaps not a stretch." Amy would spend almost forty years in a mental hospital before she died in 1962. She was almost ninety years old and had received considerably better care than many of her inmates ever did. It's impossible to know the accurate total, but it's estimated that Amy may have murdered up to forty seniors in her elder home.

This case inspired new regulations and standards in the budding nursing home industry. It also inspired the playwright Joseph Kesselring, who in 1939 wrote the dark comedy *Arsenic and Old Lace*, in which two doting older women run a boarding house where they poison their lonely male guests with elderberry wine laced with arsenic. The play became a film starring Cary Grant. One critic for the *New York Sun* assured their readers, "You wouldn't believe that homicidal mania could be such great fun!"

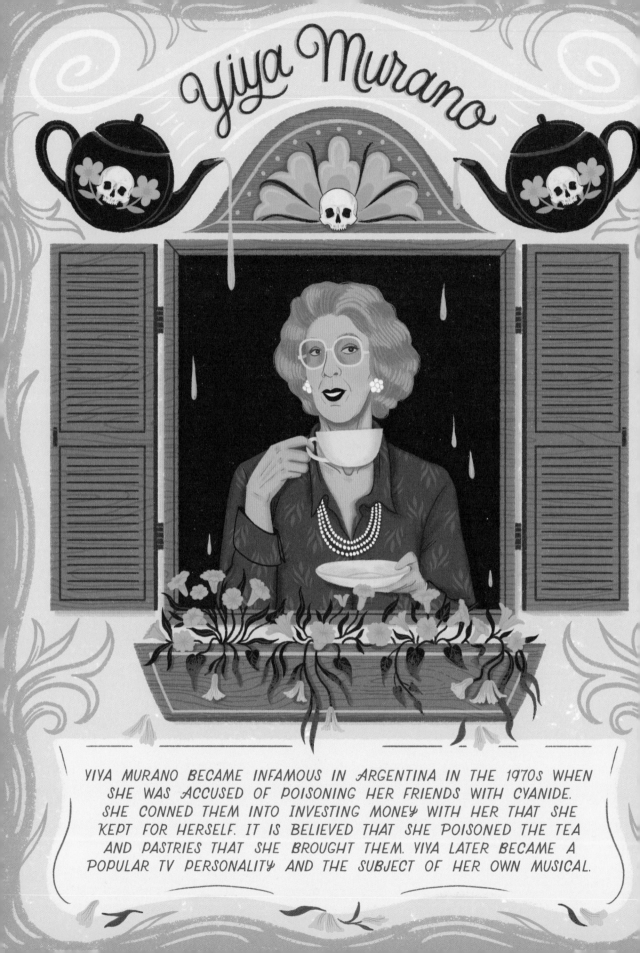

Yiya Murano

YIYA MURANO BECAME INFAMOUS IN ARGENTINA IN THE 1970s WHEN SHE WAS ACCUSED OF POISONING HER FRIENDS WITH CYANIDE. SHE CONNED THEM INTO INVESTING MONEY WITH HER THAT SHE KEPT FOR HERSELF. IT IS BELIEVED THAT SHE POISONED THE TEA AND PASTRIES THAT SHE BROUGHT THEM. YIYA LATER BECAME A POPULAR TV PERSONALITY AND THE SUBJECT OF HER OWN MUSICAL.

Speaking of theater—in 2016, a musical debuted in Argentina about the country's most notorious lady poisoner. It was full of black humor, murder, and the majesty of song. Featuring a talkative, cold, and narcissistic title character, *Yiya the Musical* quickly became a hit. The audience was very familiar with the infamous story. The musical follows an Argentinean woman who, in the late 1970s, convinced her friends to give her money to invest, which she then spent on herself. When the time came and her friends wanted their investment dividends, Yiya thought her best option was not to own up to the crime, but to get rid of her friends using tea and pastries laced with cyanide.

Yiya had a powerful and theatrical personality, so she may well have approved of the stage adaptation of her life. She did not, however, appreciate the tell-all memoir that her son, Martín Murano, wrote about her in the 1990s. The book, *Mi Madre, Yiya Murano*, tells the story that captivated the country through the eyes of her son, who was only a child when his mother was arrested on charges of fraud and murder, becoming a media sensation. Her full name was María de las Mercedes Bernardina Bolla Aponte de Murano, but she was known as Yiya to friends and family. Born in 1930, she would marry Antonio Murano, a lawyer who was fourteen years her senior, for the financial stability the marriage would provide. The couple settled in a small two-bedroom apartment in Monserrat, in the heart of Buenos Aires, Argentina.

Martín spends much of the book relating his mother's many extramarital affairs and expressing empathy for his father, who was so devoted to his wife that he was unable to see her many faults. He describes his mother as unloving toward him but very charismatic with others and desperate to impress. She was tall and blonde, and she had a penchant for expensive jewelry. She cared a lot about wealth, status, and how other people perceived her.

Yiya hatched a plan to scam some of her nearest and dearest into giving her money. She convinced them to invest with her by describing the high interest rate she was getting on returns for herself, claiming that she wanted to share her good fortune with her friends. They were very trusting of Yiya, who often came by with tea and sweets to chat about finances. Yiya baited her second cousin, Carmen Zulema (who went by "Mema"), by making good on a small initial investment, prompting her to give Yiya more money in the hope of seeing an even greater return. It is rumored that Yiya stole around three hundred thousand dollars from friends, neighbors, and relatives this way. She lived lavishly on their money while her friends enjoyed her attention and dreamt about their exciting financial futures. Of course, Yiya had to keep putting off their requests to get their money back from her and keep reassuring them that all was well.

It's hard to know what Yiya's end game was. The walls started to close in as her friends more emphatically demanded their money back. Yiya didn't have it, and she had

no intention of admitting her wrongdoing; she needed a way out. On February 10, 1979, Yiya made one of her typical visits to her neighbor and investor Nilda Adelina Gamba. Nilda started to feel unwell afterward, complaining of pain and nausea. Her doctor examined her and suspected it was a case of food poisoning from some fish she had eaten and promised she should start to feel better soon. Yiya generously offered to stay and care for her sick friend. Later that night Nilda began vomiting. She was in a coma by morning when Yiya called the doctor again. By the time the doctor arrived she was dead. The cause of death was deemed to be cardiac arrest.

Just a week after Nilda's death, tragedy struck again when another of Yiya's friends passed away suddenly. Lelia Formisano de Ayala, called "Chicha," was in mourning but was still intent on getting her money back from Yiya, who came over with tea, pastries, reassurances, and a plan. Knowing how much Chicha enjoyed going out, Yiya invited her and some other friends to the theater that evening (coincidentally, she would later become a character in a play herself). When they went to Chicha's apartment to pick her up, no one responded. After a couple of days, her neighbors voiced concerns about a terrible odor emanating from Chicha's apartment. The authorities found her dead, sitting in her armchair in front of the TV, which was still on, with some tea and half-eaten sweets beside her. This death, too, was deemed to have been cardiac arrest. No one seemed to notice the similarities to Nilda's death the week prior.

Yiya let about a month pass before she visited Mema. On March 24, 1979, Mema was found by neighbors on the floor in the hallway of her apartment building. She had been experiencing excruciating stomach pain and nausea

and had tried to get someone's attention to call for help. Her neighbors were there when Yiya showed up (and the doorman noted she arrived carrying a box of fine pastries). She kept asking if her cousin had said anything before she lost consciousness. She convinced the building manager to let her into Mema's apartment, claiming that she needed to see her address book so she could call relatives and inform them of what had happened. Inside she grabbed the book, some other papers, and supposedly a small bottle, then she left to accompany Mema in the ambulance. While medical professionals worked to save the woman's life, Yiya allegedly asked them if they felt an autopsy would be necessary—a strange question to ask about a woman who was still alive!

"My God, it's my third friend to die in a short time!" Yiya was heard to have exclaimed. A tragic coincidence, or everything going according to plan? It was Mema's daughter Diana who put the pieces together. She noticed that promissory notes were missing among her mother's possessions and realized that all three women who had died had had financial dealings with Yiya, who had visited them just before their deaths. She informed the police and a judge ordered the exhumation of the women's bodies. Yiya was right to worry about an autopsy. Proof was found in Mema's body of cyanide poisoning. In April, Yiya was arrested and sent to Ezeiza prison to await trial.

She would remain there until her trial began in July of 1982. Yiya always staunchly maintained her innocence. She was vindicated at her trial when the judge acquitted her of all charges, claiming there was too much reasonable doubt to convict her. As is often the case with poisoning, no one had ever witnessed Yiya administer anything. In addition to the homicide charges, the judge also dropped the

fraud charges because he alleged no one could prove that the women hadn't loaned or given the money to their friend voluntarily.

Her acquittal was quickly appealed, and in 1985 the National Criminal and Correctional Appeals Chamber of the Federal Capital found her guilty of fraud and murder, submitting a damning forty-page report detailing Yiya's deception, manipulation, avarice, and criminal action and asserting that she was a danger to society. Although they were never officially able to determine the vehicle for the cyanide, many believe it was in the dough of the pastries Yiya baked and brought to her friends. Her son, however, alleges in his book that Yiya confessed her guilt to him and claimed she hid the cyanide in the tea bags. Would you like some sugar with your cyanide?

Although she was sentenced to life in prison, Yiya benefited from a change in the law in the mid-1990s that allowed a prisoner to serve only two-thirds of their time. Her sentence was also commuted to twenty-five years by the Argentinean president, and Yiya was released after spending just over sixteen years in prison for the murder of three women. She returned to life as a free woman in 1997, at the age of sixty-eight. According to one account she sent the judges who granted her freedom boxes of chocolate in thanks, which one can only imagine they threw straight into the trash.

Yiya, however, did not fade quietly back into society. Instead, she became a celebrity and made many TV appearances. Most famously she appeared on a program where the host (bravely) ate some cake Yiya had made. Her husband had died while she was in prison, and she remarried. Later her stepdaughter would accuse her of poisoning some noodles she ate, though nothing came from the allegation. Her son, of course, wrote a book about her, and she was the subject of several television programs, as well as her own musical.

Yiya Murano, the "Poisoner of Monserrat," died in a retirement home in April 2014. She remains one of the most infamous female serial killers in Argentinean criminal history. She loved money more than she loved her friends, and was a calculating scam artist who took advantage of the people who trusted her. And while her tea and pastries became a dark joke, the truth is she used them as a murder weapon. In the end she swore, "I never invited anybody to eat."

THEY SAY MONEY IS THE ROOT OF ALL EVIL; WHOEVER "THEY" ARE, THEY'RE not wrong. Money motivated every woman in this chapter to poison the people around them. Sometimes the victims were husbands and children whose lives had been insured, as in the cases of Mary Ann Cotton and Roberta Elder. Sometimes they were lonely men, like those Belle Gunness and Anna Marie Hahn sought out. The victims were always vulnerable, like the inmates of Amy Archer-Gilligan's nursing home or the trusting friends of Yiya Murano. These women didn't care who they harmed, or how many they harmed, as their body counts spiraled out of control. If they hadn't been caught, it's likely they would have continued their murderous sprees. The actions of these black widows and Lady Bluebeards, whose crimes attracted a lot of attention and speculation, are one reason that we tend to associate poison with women. In legal courts as well as the court of public opinion, they would all pay the price for their avarice. Crime does pay, but not for long.

POISONING goes back as far as POLITICS goes back, POISON penetrates POWER

— John H. Trestrail III

CHAPTER FOUR
POWER AND POLITICS

SOME OF THE MOST SCANDALOUS AND SECRETIVE MURDERS IN HISTORY HAVE
been carried out for political reasons. Poison is the perfect solution to an incon-
venient obstacle to the throne or other positions of power. Just a few well-placed
drops can change the course of history, taking out one sovereign and installing
another. Of course, this meant it was dangerous to be the heir next in the line
of succession. Anyone could be a potential assassin: servants, cooks, enemies,
friends, and—most dangerous of all—family members. Almost every royal or
imperial court in history was swimming with poison—or at least with rumors of
it. Arsenic was not only known as the "king of poisons" because of how effective
and subtle it is, but it was also known as the "poison of kings" because of how
frequently monarchs met their demise this way.

King Mithridates VI of Pontus, a ruler in the first century BCE, was called
the "Poison King" because of his obsession with toxins. But he was right to be
paranoid; his father had been poisoned, and later his own mother tried to
assassinate him (thanks, Mom). He began a daily practice of ingesting small
amounts of various poisons in order to build up an immunity. The legend is
that he became singularly focused on learning about toxicology, testing poisons
and potential antidotes on condemned prisoners, and using this information
to develop an impressive universal antidote, which was called mithridatium (or
mithridate)—because he was humble that way. The recipe for the Poison King's
incredible antidote is lost to history, but according to Pliny the Elder's account,
it was composed of thirty-six different ingredients, which were ground together

and mixed with honey into a kind of superpill. The story continues that when he was captured by his Roman enemies, King Mithridates tried to take his own life using the poison he carried with him at all times, but his tolerance was too great, his immunity-building technique too effective, and the poison failed to kill him. He had to ask his bodyguard to stab him to finish the job.

Royal poisoning paranoia sparked many unique rituals and practices. Eleanor Herman covers these at length in her wondrous book *The Royal Art of Poison: Filthy Palaces, Fatal Cosmetics, Deadly Medicine, and Murder Most Foul.* You may know that many kings employed tasters to try the first nibble of the royal meal or sip of the imperial wine. You may not know that in King Henry VIII's case, this extended to having servants who tried on the monarch's clothes before he put them on to make sure they weren't coated with poison. Or that other servants had to touch and kiss the king's bedsheets or the cushion of his chair to make sure the royal bottom was protected from potential poison attacks. It was also believed that certain gemstones and even "unicorn horns" could detect poison, and they would react if they were in close proximity to it. Before the king or queen might take a bite of their meal, it would have been carefully poked and prodded, tasted, and tested with gems and horns before the monarchs enjoyed what was by then likely a cold and unappetizing bite.

While this might sound ridiculous to us, there is a long history of powerful leaders being removed by poison. You might recall Rome's Emperor Claudius from the first chapter, as well as Egypt's Ptolemy XIV, done in by his sister Cleopatra, from the second. In the article "Toxicology in the Borgias Period: The Mystery of *Cantarella* Poison," the authors claim that during the Renaissance, "Murder in political circles became so frequent that nobody believed in the natural death of popes, cardinals, and royalty." Gripped by fear, royals often had innocent servants executed for suspected poisonings. In the times before refrigeration, pasteurization, and the Food and Drug Administration, simple food poisoning rather than criminal activity may have been the cause of an upset royal tummy. And malaria, tuberculosis, and other diseases that present symptoms similar to those of deliberate poisoning could also strike down young, healthy adults.

Furthermore, women in positions of power are often judged more harshly than their male counterparts. The violence that many male sovereigns enacted to maintain order in their realms was viewed as decisive and necessary leadership, but when women took similar actions they were often dubbed wicked or mad. The following stories are united by a common thread: the sheer improbability that these women should come to hold the rare and coveted seat of power at all. They likely had to be twice as tough, guarded, and paranoid to hold onto their precarious positions.

LUCREZIA ✲ BORGIA

THE BORGIA FAMILY IS SYNONYMOUS WITH POLITICAL INTRIGUE, POWER, AND POISON. LUCREZIA WAS THE DAUGHTER OF POPE ALEXANDER VI WITH HIS MISTRESS. IT WAS RUMORED THAT SHE WORE A HOLLOW RING THAT CONTAINED POISON TO USE AGAINST HER ENEMIES. THOUGH THERE IS NO EVIDENCE THAT SHE EVER DID SO, THE LEGEND ABOUT HER LINGERS ON.

Few can live up to Lucrezia Borgia's legend of depravity. Accused of having incestuous relations with her father and brother, and sporting a magnificent ring on her finger with a hidden compartment that contained poison, Lucrezia was the illegitimate daughter of a pope, born into a scheming family said to callously murder their political rivals with their own special family brand of poison. (You know what they say: The family that slays together, stays together.) But of all their alleged misdeeds—incest, adultery, bribery, nepotism, murder—it is the stain of poison that we most associate with the Borgia name. The image of the conniving, golden-haired femme fatale subtly pouring poison into the wineglasses of her enemies makes for a captivating image that continues to fascinate us. Too bad it likely isn't true.

Believe it: There is no proof that the best-known woman poisoner in history ever poisoned anyone. In fact, historians' attitudes toward the Borgias really started to shift in the nineteenth century, when many acknowledged that the rumors about them were largely exaggerated and their behavior was pretty standard for powerful families of the time. Lucrezia's reputation underwent the biggest overhaul, from murderous vixen to hapless pawn in her family's political dealings. In her detailed biography, *Lucrezia Borgia: Life, Love, and Death in Renaissance Italy*, Sarah Bradford paints a portrait of her as an intelligent and capable leader who did the best she could within the strict limitations imposed upon women of the time. However, to really understand the Borgias,

we need to know both the truth and the wild rumors that their contemporaries believed.

It was said that the Borgias had their own unique brand of poison that they created and used called cantarella. It is described as a discreet powder with a sweet taste, easily disguised in food and wine. In *Toxicology in the Borgias Period: The Mystery of Cantarella Poison*, the authors explain that while the exact recipe for cantarella is unknown, it was believed to be a combination of arsenic mixed with "alkaloids of putrefaction" from decaying animal corpses. Some accounts claim it was a mixture of arsenic, copper, and phosphorus prepared in the decaying carcass of a pig or toad, then liquefied before being turned into a powder. Luckily for the aforementioned animals, there is no proof that the legendary poison was real. If the Borgias used poison, it was likely just plain old arsenic.

The Borgias (originally "de Borja") were a Catalan family from Valencia, Spain, who moved to Italy to seek their fortune. Before Lucrezia was born, her family was busy ascending the ranks of the Catholic Church. In fifteenth-century Europe, the pope had complete religious and secular authority, and whoever occupied the role held tremendous power. This was also a time when popes lived like rock stars and were known to indulge in many less-than-saintly behaviors—having mistresses and lovers, amassing wealth, and using their position to further their own ambitions. Alfonso de Borja established the family dynasty when he was elected pope under the name Callixtus III in 1455. Like many other powerful

men, he gave prestigious appointments to his kin, including his nephew Rodrigo, whom he made a cardinal at age twenty-five.

Rodrigo would go on to become the infamous Pope Alexander VI after—according to many accounts—he bought the position. He was known for being a shrewd politician who worshipped beauty, and he vied to increase his family's wealth and power. And he had a large family, fathering eight or nine children among his many mistresses. But the children he had by his favorite mistress, Vannozza dei Cattanei, he adored above all the others. Among them were his son Cesare and daughter Lucrezia, whom he loved fiercely. He relished planning illustrious futures for both of them.

Lucrezia was born in 1480, and her father, then a cardinal, wasted no time in putting his beloved and beautiful daughter to use, aiming to make political connections and enhance the family's position through her marriage. By the time she was twelve years old she had been betrothed twice, but both times her father broke off the arrangement when a more advantageous prospect came along. When he became pope in 1492, Alexander VI scrapped his previous matrimonial plans for his daughter and set his sights much higher. She was married at age thirteen to Giovanni Sforza, a widower twice her age, but the marriage did not last long because Alexander fancied they could still do better.

After almost four years, the pope had the marriage annulled on the grounds that it was never consummated due to Sforza's impotence. (Frances Howard, another lady poisoner described in a subsequent chapter, would eventually make use of the same loophole.) Many found the claim unbelievable, as Sforza's first wife died in childbirth, and he would later have more children with his third wife. But whether it was true or not, Lucrezia's father was the pope and he had the authority to make it so. Angry and humiliated by the whole affair, the spurned Giovanni Sforza lashed out, and many believe he is responsible for starting the rumor of the pope's incestuous relationship with his daughter.

Lucrezia was much keener on the second marriage her father arranged for her, to Alfonso of Aragon, Duke of Bisceglie. She soon gave birth to a son, whom she named Rodrigo after her father. While she was settling into her domestic duties, her brother Cesare was building a harrowing reputation for himself as violent, brutal, and obsessed with power. He had been made a bishop at fifteen, a cardinal at eighteen, and was now head of the papal army— all thanks to nepotism. His single-minded pursuit of power and his use of fear tactics was one inspiration for Machiavelli's political treatise for the power hungry, *The Prince.* As her father and brother shifted their alliances, Lucrezia and her new husband found themselves suddenly on the opposing political side.

It was not a winning strategy to oppose Cesare Borgia. Alfonso was violently attacked by an unknown assailant on the steps of St. Peter's Basilica, but he survived. Of the uncompleted task, Cesare is thought to have ominously said, "What is not accomplished at noon may be done at night." Fearful of someone returning to finish the job, perhaps with poison, Lucrezia insisted on personally preparing all of her husband's meals. Despite the family's reputation, poison was not Cesare's style. He was fonder of traditional violence (you know, strangling, stabbing, throwing bodies in the river—the classics), so he sent one of his henchmen to suffocate his sister's husband. Lucrezia was devastated, but what could she do? She was bound by deep Borgia family loyalty. And Borgia blood was thicker than water, or wine dosed with cantarella.

With his daughter suddenly single again, the pope returned to his favorite hobby of marrying Lucrezia off for political gain. This time he wanted to shoot for the stars. He set his sights on Alfonso d'Este, son and heir to the Duke of Ferrara. This was a real stretch for a family of upstart foreigners from Spain, especially since Lucrezia's reputation had suffered through the suspect annulment of her first marriage and the murder of her second husband. Now she was in the market for a third husband in a culture that prized women's chastity. The highborn Este family were appalled by the mere suggestion! But the pope worked his magic powers of negotiation until they came to an agreement.

Upon her arrival in Ferrara in 1502, a local chronicler wrote, "She is most beautiful of face, with vivacious, laughing eyes, upright in her posture, acute, most prudent, most wise, happy, pleasing, and friendly." Lucrezia's charm slowly won over her new family. Unlike her brother, she preferred to be loved rather than feared. And her husband wasn't displeased with the arrangement either. Lucrezia would be in an almost constant state of pregnancy throughout their marriage, although she would also be weakened by her many difficult pregnancies and illnesses. In Ferrara she came to be admired and respected, rising above her tainted legacy as a Borgia daughter.

The following year her father and brother both became seriously ill after dining at the house of a new cardinal. The legend is that the scheming father and son planned to murder their host and brought him a gift of wine spiked with their notorious cantarella poison. But, in a moment of delicious karma, the Borgias allegedly made a mistake and drank their own poisoned wine. Cesare eventually recovered, but Pope Alexander VI did not. Johann Burchard, a Vatican scribe, wrote of the corpse's ghastly appearance: "Its face had changed to the color of mulberry or the blackest cloth and it was covered in blue-black spots. The nose was swollen, the mouth distended where the tongue was doubled over, and the lips seemed to fill everything. The appearance of the face then was far more horrifying than anything that had ever been seen or reported before." His terrifying appearance only fueled the rumors of poisoning. However, historians

later suggested his death was likely from an acute case of malaria, a common problem in the sweltering Roman summers, and his uniquely unfortunate appearance was due to the effects of the heat on a rapidly decaying corpse.

Unfortunately for the Borgia siblings, all their power stemmed from their father being the pope. Now that he was gone they had no protection and many enemies, including the new pope, Julius II, who sought to bring the Borgias down. Cesare was soon arrested and sent to prison in Spain. He later managed to escape, but he was killed in battle in 1507. The new pope also waged war on Alfonso d'Este, which made the remaining years of Lucrezia's life very tumultuous. While her husband, now the Duke of Ferrara, was away fighting, she was often put in the position of being the de facto ruler of Ferrara, managing affairs of state while also running a household and dealing with her pregnancies and declining health.

Lucrezia died in 1519 at age thirty-nine, after a difficult labor from which she did not recover. Despite her best efforts, she never escaped her scandalous reputation as a sinful woman who engaged in incestuous relationships and used a ring full of poison to murder her family's enemies at their behest. How could she compete with the scintillating and wicked character she was rumored to be? The truth is that she was very much a woman of her time, caught in between her father's and brother's pursuit of power, who proved herself to be a capable and intelligent leader in her own right.

Where did this vitriol toward the Borgias come from, if they were indeed not so different from other powerful families of the time? In Alexander Lee's article for *History Today*, "Were the Borgias Really So Bad?," he explains that they were always perceived as outsiders who dared to try to beat the Italians at their own game. The ambition that made them famous also led to their undoing. The Borgia family's flame burned too hot, too quickly, and ultimately was extinguished. But in some ways Pope Alexander VI's dream of creating a lasting family legacy came true; history has certainly never forgotten the Borgias.

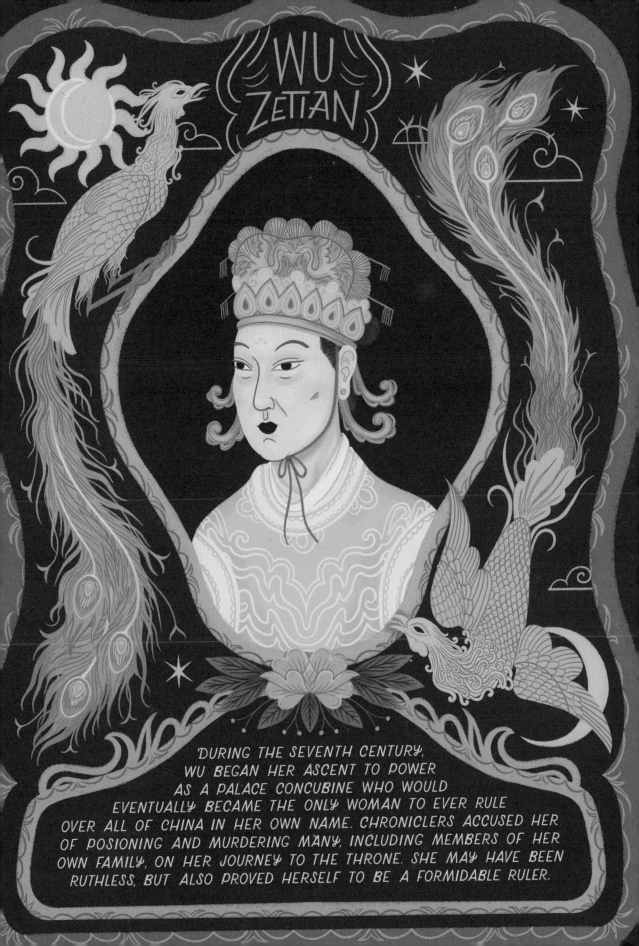

WU ZETIAN

DURING THE SEVENTH CENTURY,
WU BEGAN HER ASCENT TO POWER
AS A PALACE CONCUBINE WHO WOULD
EVENTUALLY BECAME THE ONLY WOMAN TO EVER RULE
OVER ALL OF CHINA IN HER OWN NAME. CHRONICLERS ACCUSED HER
OF POSIONING AND MURDERING MANY, INCLUDING MEMBERS OF HER
OWN FAMILY, ON HER JOURNEY TO THE THRONE. SHE MAY HAVE BEEN
RUTHLESS, BUT ALSO PROVED HERSELF TO BE A FORMIDABLE RULER.

The chroniclers of history determine how we perceive its players. During a rebellion in seventh-century China against an unlikely female ruler, the following allegations were made against her: "This woman Wu has seized the empire, ascending through false means, unyielding and cold." The account continued, "With the heart of a serpent and the nature of a wolf, she gathered sycophants to her cause, and brought destruction to the just. She slew her sister, butchered her brothers, killed her prince, and poisoned her mother. She is hated by men and gods alike, unwelcome in heaven and earth." When this damning proclamation was recited to the woman it described, she responded with bemusement, saying something like, "That was well written. Why isn't this guy writing for me?"

The story of Wu's rise to power is almost Cinderella-like—if the story ended with Cinderella deposing her enemies, staying in power for decades, and becoming the sole ruler of an empire entering its golden age. Wu Zetian, as historians would come to know her, rose from a position as a low-level palace concubine to the first and only woman to ever rule China in her own name. Many of the records of her rise and reign were composed by men who seemed to be scandalized by the very notion of a woman in a position of political power. She is accused of ruthlessness and merciless cruelty toward both members of her own family and anyone else who opposed her, and on multiple occasions she was accused of poisoning her enemies. She defied convention,

and traditional gender roles, to become one of the most notorious women in Chinese history.

When Wu was born in China in 624, during the Tang dynasty, no one in her family could have predicted her ascent to the throne. (Wu is her family name; her first name is not known.) Her father, Wu Shihou, had done some social climbing too, elevating himself from lumber merchant to governor-general of two prefectures. Her mother, Lady Yang, an aristocrat by birth, took great care to ensure that her beautiful daughter was also well educated, and when she was just thirteen or fourteen years old, Wu was summoned to the palace to be an imperial concubine.

The teenager left home and entered a world where backstabbing alliances, treacherous coups, and violent seizures of power were the norm. Emperor Taizong, though respected and beloved by his people during his reign, did not come to power peacefully. He had been a brilliant soldier who helped engineer the collapse of the Sui dynasty and installed his own father as emperor, initiating the reign of the Tang dynasty. After hacking up blood at a family dinner one evening, the future emperor Taizong realized that one of his older brothers had attempted to poison him. To ensure he would be the heir to his father's throne, he instigated a cruel but effective campaign of killing off the competition, and he personally murdered his brothers. (Keep his story in mind as you consider criticisms of Wu's rise to power.)

Wu became one of the emperor's many concubines, landing pretty low in the pecking order. She was essentially a chambermaid,

responsible for changing the emperor's bedding. When Emperor Taizong's health waned in his final years, she was one of his nurses. It was in this role that she was able to meet and spend time with the crown prince, the future emperor Gaozong, who dutifully remained by his ailing father's bedside. It's believed that Wu and the prince engaged in a physical relationship at this time, one that clearly made a lasting impression on him.

When the emperor died in 649, custom dictated that all of the wives who had borne him children would get to "retire" to their own palace apartments, and all of the other concubines would be sent to live out the rest of their days as Buddhist nuns. In his detailed and spectacularly titled book about her life, *Wu: The Chinese Empress Who Schemed, Seduced, and Murdered Her Way to Become a Living God*, Jonathan Clements explains that "it was deemed disgraceful for anyone but an emperor to touch a woman who had known the arms of a ruler of the world." He goes on to say that "for the 22-year-old Wu, this could have seemed like a worse fate than death." She was sent to the Ganye Temple, where her head would have been shaved when she entered the convent. This should have been the end of Wu's story.

But it was going to take more than a deceased emperor and a nunnery to take the indomitable Wu down. She had plenty of patience and understood the importance of a well-timed comeback. A year later, when Emperor Gaozong visited the temple to pray on the anniversary of his father's death, he encountered the beautiful concubine who had been such a comfort to him the year before and rekindled their affair. This was a bit of a taboo. For a son to have sexual relations with his father's concubine was considered incestuous, but Wu was worth it.

By this time Gaozong was already married to his wife, Empress Wang, and had several concubines of his own—but that didn't stop him from stealing away for trysts with his favorite nun. But all was not sunshine and rainbows among the women of the imperial household. Empress Wang was well aware that her husband did not seem to like her very much. Compounding this was the fact that she had failed to conceive a male heir, which was necessary to ensure her position, and she became bitterly jealous of her husband's favorite palace concubine, Xiao Liangdi, who had already borne the emperor a son and two daughters. It was actually Empress Wang's idea to bring Wu out of the nunnery and into the palace. Her thinking was that with Wu around, the emperor would be distracted and snub her rival Xiao—a win for Wang. If inviting another potential rival into your home to spite your current enemy seems like a bad idea to you, you are correct! Xiao was an annoyance, but not nearly as dangerous as Wu would turn out to be.

Wu made her triumphant return, now an esteemed high-ranking concubine and pregnant with a son. Not to mention, she had also been toying with the idea that she should probably be empress. Realizing her mistake, Empress Wang and the concubine Xiao teamed up to try and get rid of this new threat. Wu, however, was always a few steps ahead. When Wu gave birth to a baby daughter, the empress came to pay a polite visit. After she left, Wu cried out that Empress Wang had heartlessly murdered her baby out of jealousy, but the dark legend is that Wu strangled the baby herself to create grounds for deposing the empress and having herself installed in her place. Gaozong was heartbroken by the sudden death of his daughter, but his ministers were largely opposed to his request to replace the empress.

Now aware of the severity of her situation, Empress Wang was desperate to get rid of Wu before Wu could get rid of her. Empress Wang and her mother allegedly turned to sorcery and

cast spells against their enemy, which was considered a serious crime. It was also alleged that Empress Wang and Xiao attempted to harm the emperor by sending him and Wu a jug of poisoned wine. According to X. L. Woo's book *Empress Wu the Great: Tang Dynasty China*, Wu stopped the emperor before he could drink the tainted gift, pouring the wine on the ground, where it turned black. According to another version of this story, Wu poisoned the wine herself and had one of the empress's attendants deliver it, setting the empress up to look guilty of attempted murder and treason.

Regardless of what actually occurred, this foiled plot was grounds for the empress's dismissal. An imperial edict stated, "As Empress Wang and Concubine Xiao have attempted to poison me, they must be deprived of their titles and put in confinement." The women were imprisoned and later executed. (And, if legends about Wu's cruelty are to be believed, she ordered that her rivals' hands and feet be cut off, and their bodies beaten, before they were dumped in a vat of wine to die, all while she cackled, "Now those witches can get drunk to their bones.")

In 655, Wu got her wish and formally became empress, and her son Li Hong became crown prince. She would eventually have four sons and one daughter by Gaozong. The emperor seemed a little too fond of everyone related to Wu and may have also engaged in intimate relations with her sister, Helan, and her niece, Guochu. At a family dinner in 666, Guochu began to choke and violently convulse before she suddenly expired. Wu quickly blamed two cousins that she didn't like, accusing them of poisoning her meal and then giving it to her niece by mistake. However, in the chronicles of the Tang dynasty, the authors insist it was Wu who deliberately poisoned her husband's new lover. It was also rumored that Wu poisoned her sister for the same reason.

And we can't forget the accusation that she may have poisoned her mother as well, although there would have been little reason to murder Lady Yang, who lived to be about ninety.

Meanwhile, Emperor Gaozong's health was failing. He was experiencing recurring strokes that affected his balance and vision, and he began to rely heavily on Empress Wu to help him with his imperial duties, which she was more than eager to do. After a second stroke that paralyzed him, Wu acted as his regent, essentially performing as emperor. She seized the opportunity to enact many reforms, including elevating the role of women and sponsoring biographies to be written about them. Wu also pioneered an early suggestion box at the palace, where common people could submit complaints and concerns directly to her, as well as tattle on one another.

Many were not pleased to see a woman pulling the political strings and hoped the infirmed Gaozong would abdicate so his son could rule, removing Wu from the picture. Crown Prince Li Hong was not shy about criticizing his mother's actions and policies. He died suddenly and mysteriously at only twenty-three, leading to rumors that his own mother poisoned him so she would not have to give up her newfound, and hard-earned, power. The next son in line for the throne was sent into exile after his mother ordered a search of his quarters and found suits of armor, which she felt was proof he was planning a coup. In 683, when she was fifty-nine and Emperor Gaozong was fifty-six, he finally passed away after she had ruled in his name for about twenty-three years. Wu was once again expected to disappear with the death of the emperor, but she would eventually take the phoenix for her personal symbol, and she had every expectation of arising from the ashes stronger than ever.

Her third son, Zhongzong, only managed to reign for six weeks before he too was deposed

after making a casual remark that if he wanted to, he could give the entire empire to his wife, Empress Wei, an ambitious woman not dissimilar to her mother-in-law. Wu alleged this was treasonous and they were both sentenced to exile. Now there was only one son remaining. By the time Ruizong took the throne, he had seen what happened to his brothers before him and had the good sense to stand back and let his mother call the shots. Smart kid. Wu explained that her son had a speech impediment and required that she speak for him, so she was once again able to act as emperor. The arrangement worked out for them both: Mom got to rule under the auspices of her son's reign, and Ruizong got to live.

In 690, when she was sixty-six years old, Wu changed history when Ruizong abdicated so his mother alone could take the throne. She became the first and only woman to rule over all of China, not as a regent or consort, but as empress in her own name. She was a very popular ruler—or it least seemed that way, as anyone who had opposed her had already been exiled or executed. She enacted policies to bring the most talented and capable people into government service, abolishing the tradition of simply giving appointments to those who were wealthy and connected. She also created policies that improved the economy and daily life for the common people. Yes, she had been ruthless, but she also proved she was a wise and formidable ruler. All of these contradictions make up the enigmatic personality of the woman behind the legends.

In 705, when she around eighty, there was a coup to bring her third son Zhongzong back and reinstate him on the throne. Wu abdicated after her fifteen-year reign and died soon after. Zhongzong's second run on the throne didn't last very long. His wife, Empress Wei, saw her chance to seize power and poisoned her husband, arguably a little too inspired by the escapades of her mother-in-law. Her attempt failed and Ruizong briefly returned to the throne just long enough to put his son, a grandson of Taizong, back on the throne of China.

Empress Wu Zetian upended a culture defined by the Confucian belief that there was a natural order to society, and that this order involved women being subservient to men. Was she really a heartless villain, or was she a woman who behaved much like a man? Other brutal male emperors were celebrated for their bold action, tenacity, and drive, the same attributes that were criticized in her. It's impossible to untangle the truth from the rumors, but we do know that despite what she may have done to seize power, Wu Zetian did wield it wisely, enacting meaningful reforms that had positive effects on the empire. The men who chronicled her reign, however, despised and feared her, and they wrote about her as a cautionary tale to prevent other women from ascending to the same powerful heights.

RANAVALONA I

QUEEN RANAVALONA I RULED MADAGASCAR
FROM 1828 TO 1861. SHE IS INFAMOUS FOR STORIES
OF HER BRUTALITY AND HER USE OF TRIAL BY ORDEAL ON HER
SUBJECTS. THIS INVOLVED THE ACCUSED INGESTING THE POISONOUS
TANGENA NUT AND SOME CHICKEN SKINS. ONLY IF THEY VOMITED UP
ALL OF THE SKINS WOULD THEY BE FOUND INNOCENT.

Can you imagine if your freedom—and your very life—depended on surviving a trial, not with judge, jury, and evidence, but by poison? For many of the people of Madagascar at the end of the eighteenth and well into the nineteenth century, trial by ordeal was a common practice. The accused would ingest poison from the infamous tangena nut and then their guilt or innocence would be determined entirely by what they vomited up. There was no questioning the outcome, as the accuracy of this practice was considered beyond reproach.

Queen Ranavalona I of Madagascar was particularly fond of this technique, and in fact subjected thousands of people in her kingdom to it in order to test their loyalty to her and to their traditional religion. Ranavalona is known for many things—including her fierce conservation of traditional beliefs and enacting policies that kept European powers from colonizing her country—but it is the extreme measures that she took to maintain power and that resulted in the deaths of at least a third, if not half, of her own country's population that define her legacy as queen.

Trial by ordeal was not a new concept at the time, nor was it unique to the region. The notion may remind you of the practice of "swimming a witch," a trial by water that was popular in Europe during the witch hunt craze. Accused witches were stripped to their undergarments, their hands and feet bound, and then they were thrown into the nearest body of water. If they floated, then it was perceived as the water rejecting them and they were found guilty of witchcraft. If they sank, they were innocent, which was too bad because they often died anyway.

In Stephen Ellis's article "Witch-Hunting in Central Madagascar 1828–1861," he explains that among the traditional beliefs of the Malagasy people was the idea that spiritual forces were the source of all power. These forces included invisible forms, such as the spirits of ancestors and past kings, as well as every part of nature, including trees, rocks, and a powerful poisonous nut. He writes, "The nut of the *tangena* tree was thus understood to be animate, containing an inherent power evidenced by the alarming effects produced by eating it." As a member of the Malagasy community explained, ". . . people imagined that the *tangena* contained a sort of spirit which could sound out the human heart and which entered the stomach of the accused person with the poison, punishing the guilty while sparing the innocent."

Ranavalona ruled over the Merina people in the Kingdom of Imerina on Madagascar, the Great Red Island, which is located off the southeastern coast of Africa. The land was first populated by sailors and immigrants from different areas of Asia and Africa, resulting in the island's unique cultures, traditions, languages, and religions. European colonists began to take an interest in Madagascar's strategic location in the Indian Ocean in the 1500s, and for centuries thereafter they would vie for strongholds in the region. Some Malagasy monarchs welcomed the Western influence, while others,

like Ranavalona, made it their life's mission to thwart them. Although she deftly wielded power once it was hers, this queen had an unusual and unexpected path to the throne.

Before King Andrianampoinimerina came to power in 1783, a loyal citizen alerted him to a murderous plot being hatched by the soon-to-be-king's uncle. When he ascended the throne, the king rewarded the man by adopting his daughter and marrying her to his own son and heir. Additionally, he decreed that any children the couple produced would be first in line to inherit the throne. It was this act that thrust the twenty-two-year-old woman who would become Queen Ranavalona I into the spotlight. When the king died, his son succeeded him and became King Radama I.

Although Ranavalona was one of the king's senior wives, she was by no means his favorite, and the couple produced no children. It's possible that she wasn't particularly fond of her husband either, especially after he had several of her close relatives put to death—which could put a damper on any relationship. Radama vastly expanded Imerina's borders and established a friendly allegiance with Britain, which was competing with France for control over the island. Through the British Radama obtained arms, ammunition, and military training. He agreed to ban slavery and seemed focused on modernizing his country along Western lines, including welcoming Christian missionaries to preach and open schools in Madagascar. But the conservative members of the king's council were increasingly concerned about the growing Western influence and religion that was overtaking their national customs.

When King Radama I died, without children by Ranavalona, custom dictated that the throne should have passed to his oldest sister's oldest son, Prince Rakotobe. Only two of his closest officers knew about the king's death

in order to minimize the possibility of anyone preventing the heir's accession, but one of those two men was Ranavalona's lover, and he informed his mistress of the critical situation. According to Malagasy tradition, any children she had, even after the passing of her husband, would still be legally considered his descendants. This ability to produce future heirs of Radama made her a threat to the incoming king, and she recognized that it was in his best interest to have her executed. So this newly widowed woman decided the best way to stay alive was to stage a coup of her own and seize power in the brief window between the death of one king and the planned coronation of the next.

Ranavalona was conservative. Unlike her husband, she wanted nothing to do with European powers or Christianity, and she was committed to the traditional religion of the Malagasy people. This earned her supporters, who would help her organize and implement a stealthy coup to make her the first female monarch in Imerina history. She was proclaimed queen of Madagascar in August 1828, and she promptly began massacring all of her late husband's relatives. (Brutal as it sounds, many monarchs would have done the same thing to prevent challengers to the throne.)

Her rule would be dominated by undoing much of her husband's work, eschewing foreign influence, and promoting Malagasy traditions. At her coronation the following year, she addressed the crowd, promising them a capable and unyielding ruler. In Keith Laidler's book about her life, *Female Caligula: Ranavalona, the Mad Queen of Madagascar*, he cites her legendary speech: "Never say she is only a feeble and ignorant woman, how can she rule such a vast empire? I *will* rule here, to the good fortune of my people and the glory of my name! I will worship no gods, but those of my ancestors. The ocean shall be the boundary of my realm,

and I will not cede the thickness of one hair of my realm!"

She gave birth to her son and heir in 1829, at age forty-one. During her reign she fought off French colonizers in battle and decorated the beaches of her kingdom with their decapitated heads on pikes. By 1834 Queen Ranavalona had lost what little tolerance she had for the foreign missionaries and the Christian converts they had made in her country. She didn't mind if the European visitors practiced Christianity, as that was the religion of their ancestors, but she was infuriated by the Malagasy people who seemed to be rejecting their own traditions. She decided to crack down, and the first judicial murders of Malagasy Christians began.

The tangena ordeal was typically used against suspected perpetrators of treason and witchcraft, but Ranavalona used it for any number of offenses. The substance used— sometimes spelled *tanghin, tangin,* or *tanguena*—is a poison nut from a tree or shrub of the Apocynaceae family. In "The Ordeal Poisons of Madagascar and Africa," George Robb explains that the toxicity comes from the presence of a cardiac glycoside, which, in addition to causing vomiting, causes the slowing of the heartbeat and respiratory system, ultimately causing death. He adds that the medicine men administering the test could be bribed into giving weaker doses of the poison, but he notes, ". . . in spite of these corrupt practices, the people usually had an unswerving faith in the ordeal's inherent justice, and drank the poison with willingness and assurance."

During these trials the accused, in the presence of a judge, would be fed some rice soup or rice water before swallowing three pieces of chicken skin, each about an inch square. Then they ingested the poison, which had been mashed and mixed with juice or leaves. The powerful poison acted quickly. If the person vomited up all of the chicken skin they were found innocent and released, but if they failed, they were deemed guilty and subjected to one of a number of grisly executions. These included beheadings, the crushing of testicles, and crucifixion, as well as skinning alive or sawing the victims in half. Some had their bodies sewn inside the hide of a buffalo with only their head sticking out and were then left to die. Ranavalona also sometimes dusted her feet with poison and then invited the accused to kiss or lick the royal feet. Refusal to do so was punishable by death—so, damned if you do, and damned if you don't.

In *An Economic History of Imperial Madagascar, 1750–1895: The Rise and Fall of an Island Empire*, Gwyn Campbell explains that "most slaves of the elite were subjected to the tangena; in 1854 it was estimated that all slaves who served Ranavalona I since the commencement of her reign in 1828 had survived at least seven such ordeals." She goes on to say that David Griffiths, a member of the Madagascar

Mission, "claimed an average fatality rate of 33 to 50 percent from tangena, which, it is estimated, killed an average of 1,000 people annually (possibly 0.44 percent of the population) in the early 1820s, rising to 3,000 from 1828 to 1861. . . . [I]n 1838 it killed an estimated 20 percent of Imerina's population (possibly 100,000 people) . . ."

Queen Ranavalona I ruled for thirty-three years before dying peacefully in her sleep on August 15, 1861. Her brutal policies significantly reduced her country's population, but she upheld the promise that she made on her coronation day to keep colonizing forces and Western religion out of her country. After her death, her son succeeded her to the throne as King Radama II and quickly overturned his mother's crueler policies. He abolished the tangena ordeal, granted religious freedom, and allowed missionaries and their schools to return. His reign did not last very long, however; he was strangled to death in a violent coup. In 1865 the tangena ordeal was officially outlawed, and in 1896 Madagascar became a French colony. One can only imagine Ranavalona turning in her grave at these outcomes that defied everything she stood for.

Ranavalona has been trotted out by many non-Africans as an example of an uncontrollable and "uncivilized" queen. Many of the accounts we have of her reign were written by British missionaries who saw her rejection of Christianity as proof of her barbaric nature. They represented her in stark contrast to their own (Christian, moral, compassionate, married, white) Queen Victoria. Although Victoria's colonial expansion in India and elsewhere carried heavy consequences and resulted in high death tolls, she was nevertheless seen as benevolent by her British subjects. Make no mistake about it: Ranavalona was brutal and used violence to maintain her control. In her own way, however, she fought for her ideals, her people, and their traditions, and for her, trial by poison was an effective means to do that.

Florentine-born Catherine de' Medici is credited with bringing many novel ideas with her to France: riding side-saddle, ballet and opera, the use of forks, the wearing of underpants, and the Italian art of poisoning. Much like the name "Borgia," the "Medici" surname connotes scandal, power, privilege, money, sex, and murder. According to legend, in order to maintain power, Catherine coldly poisoned her enemies, including a fellow queen on whom she bestowed a pair of tainted gloves, and kept an elaborate library of toxins in a special room that contained hundreds of tiny cabinets—making her both deadly and organized. She is not remembered for being a pragmatic and devoted leader who did her best to carry her adopted country through the bloody Wars of Religion; instead, she is thought of as a wicked queen with a lust for power and penchant for poison.

There were two major acts in Catherine's life: Act one began with her hapless childhood, and act two with her ascension in middle age to one of the most powerful positions in Europe held by a woman. She was born in 1519 to Lorenzo II de' Medici, Duke of Urbino, and Madeleine de la Tour d'Auvergne, a wealthy French countess. Tragically, both of her parents died within a month of her birth, after which the newly orphaned infant would be cared for by different family members. As if this weren't a rough enough start to life, she was imprisoned in various convents for three years as a child when the Medicis were overthrown in Florence. When she was freed in 1530, she joined her uncle, who happened to be Pope Clement VII, in Rome. The pope busied himself securing an advantageous marriage for the traumatized child, and he succeeded in making a match between her and Henry, Duke d'Orléans, the second son of the king of France.

Catherine and Henry were married in 1533 when they were both fourteen years old. Because Henry was the second son, he never expected to be king, but everything changed three years later, when his older brother, the heir to the throne, died suddenly after a rousing game of tennis. Gossips were quick to blame poison and the new Italian bride, thinking it was a calculated grab for power. As Eleanor Herman explains in *The Royal Art of Poison: Filthy Palaces, Fatal Cosmetics, Deadly Medicine, and Murder Most Foul*, the association between Catherine's country of origin and poison was so deeply ingrained that poisoning someone was casually referred to as "Italianating" them. The grieving king pinned the death of his eldest son on a page, who was also Italian. The page confessed under torture to poisoning the prince (he later recanted), but it is far more likely the prince succumbed to tuberculosis. The page was executed by having all four of his limbs tied to four different frenzied horses and then violently torn apart.

Catherine's position in the royal family remained precarious as she struggled to conceive a child for the first ten years of her marriage. To make matters worse, her husband wasn't too keen on her and instead was completely smitten with his beautiful mistress,

Diane de Poitiers, who had been his boyhood tutor and was nineteen years his senior. In her desperation to become pregnant, Catherine turned to some unpleasant-sounding potions and poultices, including drinking mule's urine and applying a mixture of cow's dung and ground-up antlers to her nether regions. After a decade of trying everything under the sun (and applying it where it doesn't shine) the couple consulted a doctor, and whatever he told them was a total game changer. Catherine soon gave birth to ten children in twelve years, seven of whom would live to adulthood. And when the king died in 1547, Henry and Catherine became king and queen, and their many children the princes and princesses of France.

After her husband's untimely death (from taking a lance through the eye while jousting), three of Catherine's sons would go on to take the throne successively under the watchful guidance and true leadership of their mother. Unfortunately, most of her children were sickly, plagued by tuberculosis, and not destined to live very long. Catherine acted as regent for her young sons and made her transition into the second act of her life, from ignored wife to the true power behind the throne.

All the while, tensions in France were growing to a fever pitch as the country was divided along religious lines, between the traditional Catholics and the French Protestants, who called themselves Huguenots. The Wars of Religion, a series of brutal conflicts over a thirty-six-year period, would plague Catherine's life and reign as the Queen Mother. Her initial approach was to foster unity among her divided people, but her attempts to broker treaties always left someone unsatisfied.

Catherine turned to her favorite practice for solving complex problems: arranging fancy marriages. She approached Jeanne d'Albret, the Huguenot queen of Navarre, with a proposal that Jeanne's son Henri and Catherine's Catholic daughter Marguerite should wed. What better way to foster unity than by marrying two young people who don't like each other very much? Jeanne was resistant to the idea, having been scandalized by rumors about Catherine and her court. The queen of Navarre wrote to the Queen Mother of France, "Madam, you say that you desire to see us, and not in order to harm us. Forgive me if I feel like smiling when I read your letters. . . . I do not suppose, as the saying is, that you eat little children." Catherine plowed ahead with her dream wedding to unite the warring factions of her country, and eventually Jeanne gave in to the relentless Queen Mother. Neither of them could have known the role the wedding would play in one of the most violent events in French history.

Jeanne made the trip to Paris to work out the wedding arrangements with Catherine, and then decided to do some shopping while she was in town. Just a few days later, the queen of Navarre would be dead, and suspicions would swirl about Catherine and a pair of beautiful poisoned gloves.

You have to hand it to anyone who might conceive of using a glove as a murder weapon. The story goes that the Queen Mother enlisted the help of her Italian perfumer, Maître Rene, to sell Jeanne a pair of stylish "sweet gloves" that he had coated with poison. Sweet-smelling gloves were among the many innovations Catherine de' Medici is thought to have brought from Italy to France. Ornately decorated leather gloves were one of the most popular fashion accessories of the day, but the process for making them was far from pretty. To turn rough, raw hides into supple leather, tanners treated the surface with animal excrement, which

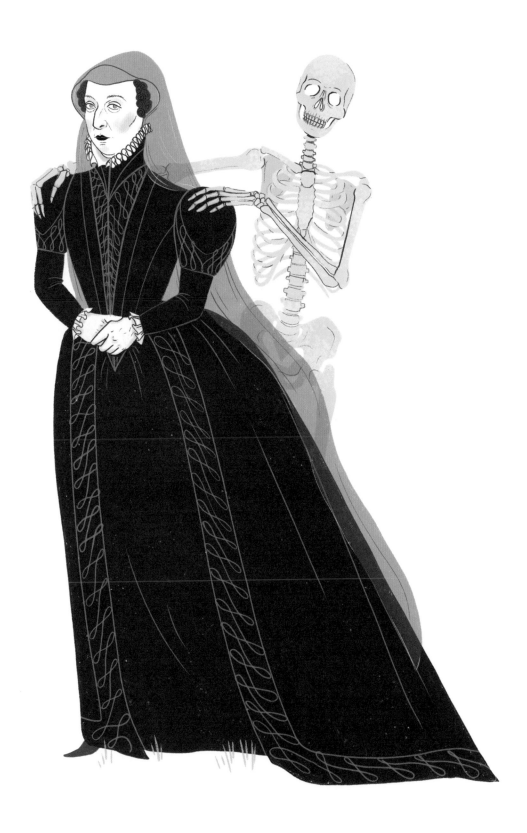

resulted in leather that was very soft but woefully smelly. Sweet gloves, by contrast, had been perfumed with cloves, orange blossom, violets, jasmine, and other fragrant flowers and herbs to mask the stench.

Jeanne's autopsy revealed that she had died of plain old tuberculosis, but that didn't stop the legend of the poisoned gloves from spreading. Two months after his mother's death, Henri of Navarre was indeed married to Catherine's daughter Marguerite in a lavish ceremony that brought massive numbers of Huguenots into the Catholic city of Paris for the event. It was here that Catherine made a decision that would haunt her for the rest of her reign and taint

her legacy forever. She resolved that Admiral Gaspard II de Coligny, a Huguenot leader, must be discreetly disposed of, not because of his religious faith, but for political reasons: He was pressuring her son, the king, to go to war with Spain. According to some sources, just a few days after the wedding, on the morning of Saint Bartholomew's Day, the admiral was out walking and had just bent down to fix his shoe when a shot rang out from a nearby window that struck him in the arm and hand. The timing of his shoe troubles had likely saved his life, but he was badly injured. Fear and panic bubbled among the Huguenots at this attempt on the life of one of their leaders, and Catherine

was stuck with a botched assassination that just made everything much, much worse.

Her son, King Charles IX, vowed to catch the criminal responsible, not knowing that his mother had a hand in the attack. She now feared a full-scale war would break out and developed a new plan to finish off Coligny and a list of thirty other Huguenot leaders to prevent them from leading a rebellion. She explained this to the king, claiming that if they didn't attack, the Huguenots might strike first; he signed off on the assassinations. It began with the bedridden Coligny being stabbed in the chest and thrown out a window. What was supposed to be a limited strike quickly escalated into an indiscriminate slaughter of all of the Huguenots in the city. The unchecked violence lasted for three days, and the mayhem spread into the provinces, where it continued for another two months. When all was said and done, the final death toll was between twenty and thirty thousand people according to some experts.

The Huguenots believed this had been the Queen Mother's wicked plan all along, to gather them under the pretense of a royal wedding to make them easier to slaughter. It was after this event, known as the Saint Bartholomew's Day Massacre, that Catherine's reputation as evil and mad for power really grew. A few years later Charles IX died of tuberculosis at the age of only twenty-three, and Catherine's next-oldest son ascended the throne as Henry III. By now Catherine had been wife to one king of France and mother to three more. The Wars of Religion raged on, while Catherine found herself outliving most of her frail children.

Catherine died in her home in January 1589, at nearly seventy years old. It was here, at the Château de Blois, where she had the room containing 237 small cabinets that allegedly held her poison library. The truth is far less interesting, however, as she likely just used the compartments to house small objects and personal papers.

Less than a year after his mother's demise, Henry III was attacked by an assassin dressed as a monk, and with him died the Valois dynasty that Catherine had worked tirelessly to sustain. The next in line for the throne was Henri of Navarre. In 1598 he signed the Edict of Nantes allowing peaceful coexistence of the two faiths and putting an end to the decades-long Wars of Religion in France.

Catherine de' Medici put a lot of trust in astrologers and soothsayers—she even knew Nostradamus—but no one could have foreseen the extraordinary events of her life's story, a story that was overshadowed by rumors of poisoning and her reputation as a wicked woman hungry for power at all costs. She is not remembered for trying to broker peace between warring religious faiths, her devotion to her husband and children, or her sound, pragmatic leadership. Her reputation was just one more victim of the bloody Saint Bartholomew's Day Massacre.

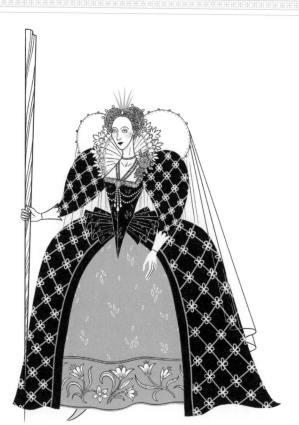

SOME OF THESE WOMEN WERE BORN INTO POWER AND PRIVILEGE, AND OTHERS seized the opportunity to take power when the moment was right. Poison is an efficient helpmate for a busy ruler, whether they need to depose a corrupt sovereign, rearrange the order of succession, or get rid of pesky political opponents. After all, dead men can't raise armies.

And yet, the two most infamous female poisoners in this book, Lucrezia Borgia and Catherine de' Medici, may not have actually poisoned anyone. It's impossible to know if Catherine de' Medici poisoned her rivals, if Lucrezia Borgia really wore a ring full of poison, or if Wu Zetian poisoned the family members who challenged her. The power of their legends eclipses the less scintillating truth of their stories.

Neither Ranavalona I of Madagascar nor Empress Wu Zetian of China was supposed to be in line for the most powerful office in her country, but they both took bold action to usurp the throne, and then used their power to enact policies in line with their values. Accounts of their reigns highlight and exaggerate their brutality to weave cautionary tales about the danger of letting women take power. Poison became part of the narrative that labeled these women as unfit, corrupt, and evil.

CHAPTER FIVE
Anger and Revenge

THEY SAY THAT REVENGE IS A DISH BEST SERVED COLD, AND PERHAPS ALSO lightly dusted with cyanide. Spite and vengeance seem as timeless as any criminal motive—but revenge is different from rage. It is not a spur-of-the-moment crime of passion. Instead, revenge stews and simmers in a broth of bubbling resentment, and it takes its time before it acts. When it does, the plan is calculated and deliberate. There is a unique cruelty to revenge killings, especially those accomplished by poisoning, which requires precise planning and creates many opportunities for the murderer to decide not to go through with it. When the cogs of the nefarious plan stay in motion through to the end, it says something about the depth of the poisoner's vitriol.

For much of history, women have been expected to behave in a calm, demure, and nurturing way. Outbursts of emotion rendered them "hysterical," and often resulted in even more restrictions to their agency and freedom. Women feel anger, just like men, but they have often been deprived of outlets for their frustration. Men could argue, or resort to fisticuffs or duels, when their honor was at stake. Men have been allowed to scream and bellow and make themselves heard. Women have had to be more careful, more accommodating.

In her book *Poisoned Lives: English Poisoners and Their Victims*, Katherine Watson claims, in regard to poisoning crimes between 1750 and 1914 in England and Wales, "Men seem to have been more likely to use poison as a means of settling scores. . . . Women, on the other hand, carried out revenge poisonings

after suffering what they considered to be personal slights or rejections, and targeted either the object of their anger (usually a man) or someone close to them." Poison is the perfect tool for quiet—even polite—rage. It slips into food and drink silently. The murderer can get her revenge without making a peep, and no one suspects her.

No good can come of poisoning someone. None of the stories shared here are happy ones. The poisoners are not the heroes; they became known as wicked women, a pastiche of every malicious Disney villainess. However, they also dared to fight back when they had been wronged, challenging the conventions of male-dominated societies that demanded passivity from them. They were feared for upsetting the status quo more than anything else, and they were often the victims of unfair and prejudiced rumors. If you find that you feel a frisson of satisfaction in reading about their dastardly schemes, you'll find no judgment here. As they say, hell hath no fury like a woman scorned and packing rat poison in her purse.

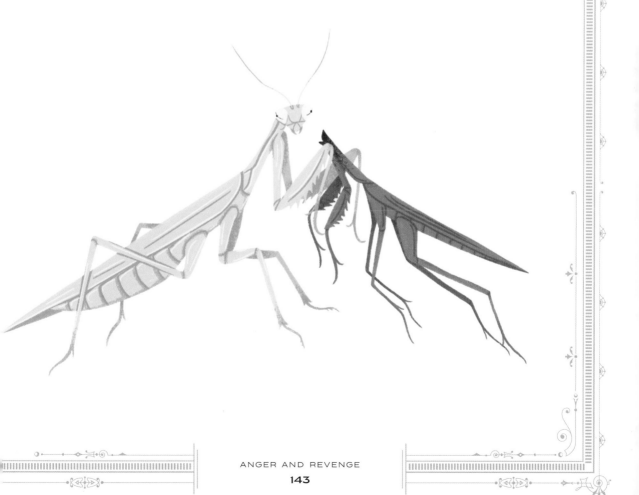

Marquise de BRINVILLIERS

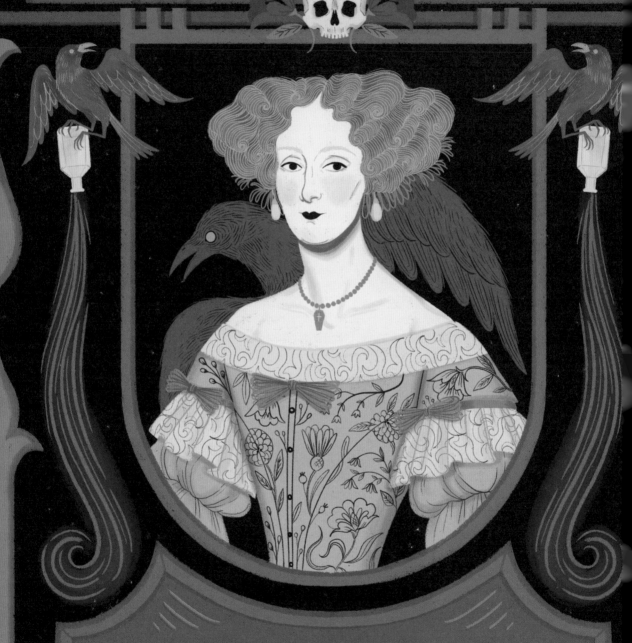

WHEN HER FATHER AND BROTHERS HAD HER LOVER IMPRISONED,
THE HIGH-BORN MARQUISE DE BRINVILLIERS VOWED VENGEANCE.
WITH THE HELP OF HOUSEHOLD SERVANTS, SHE POISONED THEM
AND COLLECTED THEIR MONEY. IN 1676 SHE WAS EXECUTED.
HER ACTIONS LED TO THE AFFAIR OF THE POISONS IN FRANCE.

Prior to the arrest and conviction of the Marquise de Brinvilliers in 1676, the people of France didn't think about poison very much. They fancied that it was the purview of their more devious neighbors in Italy. They were wrong, of course; poisoning has been practiced throughout the centuries and across the continents by all manner of people. But it wasn't until the highborn Marquise de Brinvilliers confessed to poisoning her father and two brothers out of revenge and greed that everyone, including the king, realized that no one was safe from the dark machinations of poisoning. Her actions led not only to her own demise, but also to the panic that incited the infamous Affair of the Poisons in France.

In 1630, Marie-Madeleine Marguerite d'Aubray was born with a silver spoon in her adorable little mouth. Her father, the venerable Antoine Dreux d'Aubray, counted among his many achievements holding the lucrative position of civil lieutenant of the city of Paris. At age twenty-one, Marie was married to fellow aristocrat Antoine Gobelin, and the two held the lofty titles of Marquis and Marquise de Brinvilliers. In her article *Women and Poisons in 17th Century France*, Benedetta Faedi Duramy refers to Hugh Stoke's work *Madame de Brinvilliers and Her Times 1630–1767*, in which Marie's new husband is described as a debauched gambler and "a man without morals. Far worse, he was a man without strong personal character, weak as water and unstable as sand."

When Marie's disappointing husband invited the charming Gaudin de Sainte-Croix, an old pal from his army days, to stay in his home, Sainte-Croix began a passionate and not-very-subtle affair with his wife. The open affair was a cause of embarrassment to the illustrious d'Aubray family. Marie's father and brothers pleaded with her to put an end to her scandalous liaison, but she was not interested in upholding the family's sterling reputation. She had put up with her husband's bad behavior, and now it was her turn to do as she pleased.

Her father requested a lettre de cachet —an order from the king—for the arrest of Sainte-Croix. The lovers were in the Marquise de Brinvilliers's coach when guards intercepted them and arrested him. Sainte-Croix was taken to the Bastille. He was imprisoned for only six weeks, but Marie was overcome with anger at her father's audacity and disrespect. He had just made a powerful enemy in his own daughter—and he would not live to regret it for very long.

In *The Affair of the Poisons: Murder, Infanticide, and Satanism at the Court of Louis XIV*, Anne Somerset shares details of the Marquise de Brinvilliers's crimes. She writes that Marie "...later recorded that she had murdered him to gain revenge for her 'vexation at this man's imprisonment.' At another time she mused, 'One should never annoy anybody; if Sainte-Croix had not been put in the Bastille perhaps nothing would have happened.'"

As soon as he was released from prison, Marie and her lover began planning their revenge. While in the Bastille, Sainte-Croix supposedly met Exili, a notorious poison expert who happened to be imprisoned there

as well—what are the odds? He claimed Exili had shared his poison secrets. Wanting to test out his newfound knowledge, Sainte-Croix rented a property to use as a laboratory so he could conduct experiments.

It was said that Marie wanted to use the perfect poison on her father, so she began testing out Sainte-Croix's lethal concoctions on other unwitting subjects. She reportedly baked the poisons into treats that she brought to the patients in the public hospital, whom she then carefully observed, taking notes on the effects of each toxin. Somerset suggests that while this rumor likely wasn't true, it was widely believed by the time of her execution.

By 1666 the poison was ready. Marie and her lover planted a servant in her father's home to deliver the toxin slowly, adding it to his food.

But if you want something done right, sometimes you have to do it yourself. She ultimately confessed that she poisoned her father "with her own hands twenty-eight or thirty times." Her father wasted away and suffered a great deal before his passing. Marie looked forward to an inheritance in addition to sweet vengeance. By now the marquise had found herself in dire financial straits; between her husband's reckless gambling and her lover's impulsive spending, her great wealth had been decimated. After her father's death, the new fortune was frittered away in just four short years.

Marie moved on to her brothers and their money, not forgetting for a minute that they had taken her father's side when he reprimanded her for the affair. She and Sainte-Croix found a new servant to be their man on the inside,

La Chaussée, who appeared to be more capable than the one before. He was placed in her brother's home and the slow, deliberate poisoning began.

Her older brother went first, and then the younger, both passing away from the same symptoms in 1670. Marie would likely have discovered at this time that she was not included in her brothers' wills and would have to seek additional funds elsewhere. She considered poisoning both her sister and sister-in-law for their money next. She would also later confess to poisoning her own husband several times, regretting it, giving him an antidote, and then nursing him back to health.

In 1672 Sainte-Croix died. This was fortunate for her sister and sister-in-law, because it meant Marie never got around to poisoning them. Many believe that his death was accidental—an experiment in his dark laboratory gone wrong—but more likely it was the result of a long illness. At any rate, it was very unfortunate for Marie. He was the keeper of all of the marquise's secrets, and it turns out that sometimes dead men do tell tales. He had died in a great deal of debt, and after his demise his property was assessed to meet the demands of his creditors. Among the many weird and incriminating things found among his possession, there was one standout item: a casket that, when opened, revealed itself to be full of poison. Sainte-Croix had left a note on it saying that everything inside the casket belonged to and should be returned to none other than the Marquise de Brinvilliers.

Marie panicked and tried several times to get the casket full of poison with her name on it back from the authorities, but she was unsuccessful, and her attempts only made her look

guiltier. With this new information having come to light, her brother's widow contacted authorities and demanded an investigation into his death. Marie took the hint and bolted.

In her absence, the servant La Chaussée was brought before a judge who sentenced him to torture to get him to reveal his accomplices. After being subjected to a device that crushed his legs, he broke down and conceded his involvement in the murder of the d'Aubray brothers. Even though he told the truth, his situation would only get worse after that. He was sentenced to be broken on the wheel, a particularly monstrous punishment in which he was tied to a large wagon wheel, beaten violently, and left to die.

Marie remained on the lam as long as she could, trying to escape her fate. She traveled throughout Europe, not staying in any one place for long. She eventually made a fatal error and rented a room at a convent in French-occupied Liège, Belgium. In 1676 she was arrested and extradited to France to face judgment. Under questioning she blamed much of the whole affair on her deceased lover, who couldn't say otherwise. She was found guilty and sentenced

to torture and execution. A small "mercy" was thrown her way: She would be beheaded before her body was set on fire—you take what you can get.

The Marquise de Brinvilliers was to face a very specific kind of water torture. There were two versions of it: The first was called the "ordinary question" and the second the "extraordinary question." During the "ordinary question" she was stripped of her clothes with her feet chained to the floor and her hands chained to the wall behind her, forcing her body to bend backward in an unnatural position. Then ten pints of water—a massive amount—would be funneled down her throat while she was asked about the poison murders. Then came the "extraordinary question," which was just a more extreme version of the same thing. She was arched backward even more severely, and even more water was force-fed down her throat.

None of it was necessary. Before the torture began Marie confessed that it was she who had orchestrated the poisoning of her father and brothers. Though she thought the torture would kill her, she survived to face execution. A mass of people, incredulous that a woman of such wealth and status could be implicated in something so nefarious, flocked to witness her death. Gabriel Nicolas de La Reynie, the chief of police, is reported to have said, "Who would have believed it of this woman of highly respectable family, of a delicate little creature such as this, with her apparently gentle disposition?"

Just before her execution Marie said something that would haunt everyone who witnessed it. "Out of so many guilty people must I be the only one to be put to death? . . . [And yet] half the people in town are involved in this sort of thing, and I could ruin them if I were to talk." This suggestion that there were many involved in the poison trade in Paris ignited a panic that would lead King Louis XIV to reestablish the investigative body known as the Chambre Ardente. The tribunal would mandate 367 orders of arrest and 36 executions in an effort to weed out Paris's poisoners—including La Voisin, whom we met in chapter one.

Marie-Madeleine d'Aubray, Marquise de Brinvilliers, was publicly beheaded in 1676, her body subsequently thrown on a fire. She left something lingering in the air along with her ashes: a palpable fear that there were murderers hatching poison plots around every corner. If a highborn family like the d'Aubrays wasn't safe, then no one was safe. The Marquise de Brinvilliers only sought to get revenge on her father and brothers, but everyone's sense of safety was thoroughly shaken.

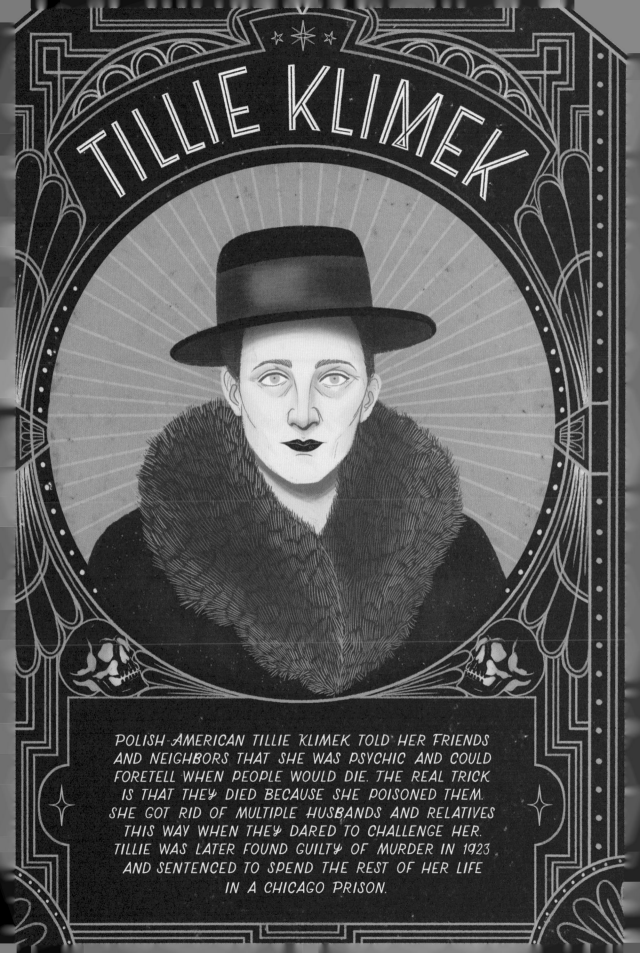

TILLIE KLIMEK

POLISH-AMERICAN TILLIE KLIMEK TOLD HER FRIENDS
AND NEIGHBORS THAT SHE WAS PSYCHIC AND COULD
FORETELL WHEN PEOPLE WOULD DIE. THE REAL TRICK
IS THAT THEY DIED BECAUSE SHE POISONED THEM.
SHE GOT RID OF MULTIPLE HUSBANDS AND RELATIVES
THIS WAY WHEN THEY DARED TO CHALLENGE HER.
TILLIE WAS LATER FOUND GUILTY OF MURDER IN 1923
AND SENTENCED TO SPEND THE REST OF HER LIFE
IN A CHICAGO PRISON.

nlike the marquise, Tillie Klimek was not rich, powerful, or beautiful. She astounded and terrified neighbors with her startling self-professed psychic abilities. She could predict exactly what day a specific person would die.

Her trick wasn't really that clever. Tillie knew when people around her were going to die because she was the one poisoning them—ta-da! She also used poison to get revenge on people who annoyed her, or challenged her, or who she just wanted out of her life. Tillie and her cousin Nellie were alleged to have racked up around twenty unlucky victims.

Tillie is hardly one of the most infamous female murderers to face trial in 1920s Chicago at the notorious and alliterative Cook County Courthouse (if you are familiar with the musical *Chicago*, this is where you can begin humming the score). Newspaper reports from the era claim, in no uncertain terms, that if she had been better looking, Tillie Klimek would have had a much better shot at getting away with murder. As one *Chicago Tribune* reporter would later note, "Tillie went to the penitentiary because she had never gone to the beauty parlor."

Otylia "Tillie" Gburek was born in Poland in 1876 and immigrated to the United States with her parents when she was a baby. Her family settled in the northwest part of Chicago in a neighborhood called Little Poland, where she would spend most of her life. Not much is known about her before her first marriage to John or Joseph Mitkiewicz (in the records, several of her husbands are alternatively named "John" or "Joseph"). Before her first husband's death in 1914, Tillie regaled a neighbor with a story about a dream she had foretelling John/Joseph's death on a specific date. The neighbor was thoroughly spooked when that day arrived and Tillie's husband became gravely ill and died later that night. Tillie collected about a thousand dollars from a life insurance policy for her late husband and embarked on a career in black widowhood.

In her book *Black Widow Tillie Klimek*, Cara Davidson suggests that Tillie was a little late to the black widow game, not beginning her murder spree until her midthirties. She married her next husband, Joseph Ruskowski, just a few short months after the passing of her first. He would also meet his end on the date Tillie foretold. She made out even better this time, claiming $1,200 in cash and $722 in life insurance. Sometime after Joseph's death, Tillie had a boyfriend or sweetheart named John Guszkowski, who is often described as having jilted her—not a good idea. The story is that she told him he'd better comply with her because she'd killed other men, but instead of yielding he threatened to go to the police. Anyone could have predicted that he wouldn't be long for this world after daring to challenge Tillie.

She married her third husband, Frank Kupczyk, in 1919. He was likely fond of the delicious stew Tillie was well known for cooking.

It had, of course, a secret ingredient he just couldn't place—a few dashes of arsenic. Tillie was said to have taunted Frank on his deathbed. A 1925 article for the *New York Daily News* details bizarre accounts from Mrs. Florence Biering, who lived in the same building as Frank and Tillie. Florence claimed that Tillie sat at her dying husband's bedside making a fetching new hat, which she morbidly assured him she would wear at his funeral. According to that same article, "Another witness declared that the poisoner bought a coffin for $30 at a bargain sale and stored it away against the fast-approaching day of Kupczyk's death. She is said to have informed the unfortunate man of

her purchase, and waved the coffin sale advertisement in his face, boasting of her economic prowess." Mrs. Biering also said that while Tillie's husband was in bed ailing, she would throw a jazz record on the phonograph and loudly sing along.

Tillie's fourth and final husband would be the one to bring her "poison banquets" to an end. She supposedly met Joseph Klimek in the romantic setting of her recently deceased husband's funeral. Friends and relatives tried to discourage him from pursuing the clairvoyant and seemingly unlucky woman. Joseph was probably lured in by that captivating funeral hat she had made, or perhaps it was talk of

COFFIN SALE

$

Prices
TO
DIE
for

Tillie's interred husbands. Arsenic was found in the bodies of her first two spouses, and in Frank Kupczyk's body they found enough arsenic "to kill four men." It was also revealed that Nellie had some relatives mysteriously die under her care as well. Newspapers began to publish lists of the suspected victims, noting them as either Tillie's or Nellie's. On November 19, 1922, the *Chicago Tribune* published a list of twenty supposed victims of the two women. In addition to Tillie's four husbands and former sweetheart, it also included several relatives who had made the mistake of getting into arguments with Tillie.

Among them were her cousin Rose Chudzinski, who died in 1919 after quarreling with Tillie and doubting her powers of clairvoyance. There were also three young cousins, the Zakrzewski sisters, all between fifteen and twenty-three years of age, who died after Tillie had an argument with their mother. There were also several relatives who reported becoming ill after eating food at Tillie's home but then recovered. One woman, Mrs. Rose Splitt, claimed she became ill after eating candy Mrs. Klimek had given her, perhaps as revenge for having seen Mrs. Splitt talking with Tillie's husband.

Then there were the alleged victims of Nellie Koulik. Nellie is often treated like an afterthought in Tillie Klimek's story, though the evidence suggests she may have been responsible for several murders as well. Nellie was friendlier than her cousin. She acted more traditionally feminine with the media, for example, primping before her photo was taken. She didn't receive quite the same vitriol from the public that Tillie did. Nellie's first husband, Wojcik Stermer, had died in 1918. After his exhumation, tests proved the presence of arsenic in his body. Her twin babies Sophie and Benjamin died just a year before their father, and Nellie's granddaughter Dorothy also died

her exquisite cooking and skill with getting discount coffins. When he became ill in 1921, experiencing numbness in his extremities, his brother insisted he go to the hospital. The doctor proved he was suffering from arsenic poisoning. Joseph remained in the hospital for three months and lived to tell the tale, but his legs would remain paralyzed from the ordeal.

Tillie was arrested for the attempted murder of her husband on October 26, 1922. She allegedly told the arresting officer, "The next one I want to cook a dinner for is you." Tillie initially insisted on her innocence under questioning, but she soon confessed to poisoning Joseph. She explained that she had gotten the arsenic from her cousin and neighbor, Nellie Koulik. The next day Nellie was arrested and brought in for questioning as well. Relatives and friends of the two women began to write letters to the police reporting other mysterious deaths that had occurred after someone had dared to dine with the "K cousins," as the press was calling them.

As police investigated further into her past, they called for the exhumation of several of

while in her care. One can imagine them, Tillie and Nellie, sharing their troubles and their rat poison, helping each other commit the murders and covering for one another.

Though they may have worked together, it was decided they would be tried separately. Tillie's trial for the attempted murder of Joseph Klimek and poisoning murder of Frank Kupczyk began March 6, 1923. She was found guilty by an all-male jury, becoming the first woman in Cook County to be sentenced to life in prison. Nellie was acquitted of the charges, even though her children had testified against her.

In her 1927 article reflecting on the case, reporter Genevieve Forbes recognized that there was a clear pattern showing which women in jazz-age Chicago were condemned . . . and which were not. "For Tillie was a fat, squat Polish peasant woman, 45 years old but looking 55, with a lumpy figure, capacious hands and feet, and dull brown hair skinned back into a knot at the back of her head. No jugglery of words or setting could bring her into the sorority of ladies, beauteous or wistful or

dashing, who could pull the trigger and smile their way out."

Tillie died in the Joliet Penitentiary on November 20, 1936. We will never know how many neighbors and relatives who dined on her stew were actually poisoned by her. And in fact there seemed to be multiple motives behind Tillie Klimek's actions. In the article "Testing Existing Classifications of Serial Murder Considering Gender: An Exploratory Analysis of Solo Female Serial Murderers," the authors suggest that she did indeed murder her husbands for profit, but she also murdered out of anger (the boyfriend who jilted her) and for revenge (the cousins who disagreed with her). She was a complicated woman with a lot of poison.

Tillie liked to be right. If you undermined her or argued with her, Tillie would get her revenge by predicting the date of your death and then taking care to kill you on that date, just so she could be right again. Her looks may not have kept her out of prison, but looks are only skin deep; poison, however, sinks much deeper, destroying everything in its path.

Frances Howard Carr

FRANCES WAS A MEMBER OF THE POWERFUL HOWARD FAMILY WHO ROCKED
THE JACOBEAN COURT WHEN SHE ANNULLED HER MARRIAGE TO HER
HUSBAND IN ORDER TO MARRY HER LOVER. HER LOVER WAS ROBERT CARR,
WHO WAS THE KING'S FAVORITE, AND POSSIBLE LOVER. BUT ONE MAN,
THOMAS OVERBURY, STOOD BETWEEN FRANCES AND WHAT SHE WANTED. HE
ENDED UP IN THE TOWER OF LONDON WHERE HE DIED IN AGONY. FRANCES
CONFESSED TO HER INVOLVEMENT IN HIS POISONING IN COURT IN 1616.

The greatest scandal of the Jacobean court in early seventeenth-century England centered around the love life of one woman, and the man who made the mistake of getting in her way. Frances Howard Carr found an expedient way out of the unbreakable bonds of marriage so she could remarry for love. She also eventually confessed to poisoning the one man who could have undermined her whole plan. A popular satirical poem of the time called her "a wife, a witch, a poysoner, and a whore," but Frances successfully got her revenge on a system that aimed to control her, and that made her a threat.

Frances was born into the powerful Howard family in the early 1590s. Her father, keen to increase his family's prestige, arranged politically advantageous marriages for all of his children. On her wedding day, Frances was thirteen and her new husband, Robert Deveraux, the third Earl of Essex, was fourteen. Fortunately, everyone agreed that it would be best if the young couple waited a few years before living as husband and wife and completed their educations first. Robert Deveraux went on the customary European tour and young Frances came to court. There are many rumors about Frances during this time, but David Lindley, in his book *The Trials of Frances Howard: Fact and Fiction at the Court of King James*, takes care to remind his readers that much of what we think we know is hearsay or from stories written by people who wanted to make a villain out of her.

Some say that while her husband was away Frances had an affair with Prince Henry—that

is, until she laid eyes on the handsome young Robert Carr, the king's favorite who was quickly rising through the ranks and accumulating power and prestige. Historians dance around it, and some suggest—but stop short of explicitly stating—that Carr and the king were likely lovers. Riding on Carr's successful coattails was his friend—and another possible lover—Thomas Overbury.

Carr was the pretty face of the operation, but Overbury was the brains. As the king continued to grant his favorite more responsibility, Carr increasingly struggled to live up to the job, and Overbury wound up actually doing much of the work. Overbury, who had known Carr since his teens, was a highly educated man who was also a writer and poet. The two men became increasingly powerful; both were knighted and given many unique privileges. Overbury's arrogance made him unpopular at court, but he was protected by Carr, who was beloved by the king.

So Frances set her sights on Robert Carr, who collected lovers like flowers in a daisy chain. This was not your regular love triangle; it was more like a lust rhombus or sex trapezoid. Carr returned the young Frances's affections, and the Howard family was pleased because Carr was an even better catch than Deveraux. There was just one problem: Frances was already married. There was only one acceptable way out of a marriage in seventeenth-century England, and it involved somebody dying—but there was one other drastic option. Few dared to put themselves through the public scrutiny and embarrassment, but Frances Howard dared, and in 1613 she initiated a hearing to

annul her first marriage on the grounds of her husband's impotence.

The law stated that if a marriage remained unconsummated for three full years after the wedding, then the couple had grounds to annul the union. Lindley explains that "merely by raising the spectre of male impotence Frances Howard compounded the transgression against male authority that her initiation of the suit began." He adds, "But in challenging his potency, Frances Howard triggered a more general male anxiety which was bound to produce the hostile reaction to her that has been enshrined in all subsequent accounts."

There was no physical examination made of her husband, but Frances was subjected to an inspection to prove her virginity. Many of the courtiers guffawed at this because of her reputation of having participated in multiple affairs at court. She insisted on wearing a heavy veil during the examination to preserve her modesty, but many thought she used this ploy to sneak in a body double. A panel of five matrons and two midwives found her to be a virgin and physically healthy enough for copulation and childbirth. That she had to publicly prove her virginity while Carr was known to have all sorts of lovers speaks to a long-held double standard with regard to women, sex, and "virtue."

Overbury vocally disapproved of his friend/lover/meal ticket's plan to marry Frances. Once he realized the annulment might actually be granted and that she would be free to remarry, he began to spread nasty rumors about Frances, calling her a base and filthy woman, which, of course, infuriated her. He also had a loud fight with Carr over the matter that the servants overheard. Maybe he was jealous, or afraid to lose his lover and friend; maybe he was afraid of losing the power that Carr gave him. Maybe he just didn't like Frances. If he knew that she and Carr had committed adultery, he had

the power to prevent her annulment. Overbury could ruin everything, and Frances wasn't about to let that happen.

It's unclear who hatched the plan for what happened next. It might have been Frances or Carr, or the two of them together (what a troubling couple's activity!), or it could have been the Howard family, conspiring to improve their familial connections. But someone thought of getting rid of Overbury by offering him the post of ambassador to Russia. If he took it, he'd be too far away to meddle in their business, and if he refused he would be imprisoned for disobeying the king. Either way, problem solved. Overbury refused the post and the king had him thrown into the Tower of London. The next step was for the Howards to replace the staff who guarded Overbury with their own people. They instated Sir Gervase Elwes as the lieutenant of the Tower of London and installed Richard Weston, a servant of Frances's friend Anne Turner, as Overbury's keeper.

Frances and Mrs. Turner then sought out James Franklin, an apothecary and known shady character. He would later testify that they bought several different types of poison from him, and that Frances and Mrs. Turner baked meals and treats and sent them to Overbury, saying they were from Carr. Franklin testified, "There were continual poisons given him in all of his meats." Overbury became gravely ill, but he thought his condition might inspire the king to grant him clemency. He continued to write letters to Carr, his trusted friend, asking for his help. Carr assured his friend/enemy that he was doing everything he could—which was nothing.

The king sent doctors to check on Overbury after he ate the poisoned tarts and jellies sent to him by Frances. Apparently, enemas were not uncommon treatments, as many prisoners suffered from constipation, and doctors of the time sought to draw the bad humors out

of the body that way. The legend is that Frances offered the apothecary's assistant twenty pounds to provide the doctor with corrosive sublimate, aka mercury, instead of the typical solution for the enema. Mercury poisoning can produce violent vomiting and diarrhea, a weak pulse, and difficulty breathing before resulting in death. In short, the poison up the bum did the trick. Overbury would have been in agony before he died on September 14, 1613. His body was apparently ravaged by boils and scabs and was so "foul" that he was buried as soon as possible.

Conveniently, Frances's annulment was granted just about one week later. Everything was coming up Frances! She and Carr married that December, and the king bestowed upon them the titles Earl and Countess of Somerset. She had gotten her poisoned cake and Overbury had eaten it too. But the vengeful victory didn't last long. About two years later rumblings of suspicion regarding Overbury's death caught the king's ear and he initiated an investigation. It may well have been political. Carr's opponents wanted to take him down, and the king had a new favorite by now, a man named George Villiers, on whom he was lavishing titles and favors.

From October to December of 1615, everyone associated with the alleged poison plot was brought to trial and executed—everyone who wasn't wealthy and noble, that is. In rapid succession Richard Weston, Mrs. Turner, Sir Gervase Elwes, and Dr. Franklin were all tried, found guilty, and hanged. The Earl and Countess of Somerset were charged as accessories to the murder. It seems remarkably unfair, as they would have been the masterminds and everyone else was simply doing their bidding.

Frances pled guilty and took full responsibility for the crime. Though Robert Carr maintained his innocence, he and his wife were both found guilty and sentenced to hang. But their rank, power, money, and connections protected them. While many people were executed for their alleged crime, Frances and Carr were spared, though they were stripped of their titles and sent to live in the Tower of London. Frances still deeply loved the man she had risked so much for, but he no longer reciprocated, instead stewing over what he had lost.

Frances was pardoned in 1616, but Carr remained imprisoned until 1625. She died of uterine cancer in 1632, and Carr died in 1645. One artifact of what is now known as the "Overbury Affair" is a poem written by Thomas Overbury himself, called *A Wife*. In it he describes all the virtues a good woman should have before a man deigns to marry her—an obvious condemnation of Frances and a warning to Carr.

Was Frances a lovestruck pawn caught up in the schemes of her relatives, or an ambitious social climber who was playing them all? We'll never know. What we can say is that she was a woman who challenged conventions, exposed many men's fears, and remains the butt of a joke for allegedly killing her enemy with a poison enema.

ritings by a physician in seventeenth-century China warned Han men, members of the largest ethnic group in China, of a dangerous poison that was created by the even more dangerous women who lived in the country's southern region. These women, driven by malice and revenge, were said to poison their visiting Han lovers before they left after asking them exactly when they would return. If the man came back when he promised, she would give him the antidote. If he didn't, the *gu* poison she had given him would destroy him from the inside out.

The concept of *gu* is complex and does not easily translate into English. Written about since medieval China, it has evolved to encapsulate many ideas, including poison, witchcraft, worms, seduction, and demons. The character for *gu* shows three worms or insects inside a vessel, which reflects the legend of how the poison is made and also communicates the idea of the human body as a vessel that can be possessed by all kinds of things, including demonic forces. Essentially, *gu* is a kind of black magic that is harnessed to cause harm, and it is produced almost exclusively by spiteful women.

The recipe for *gu* involves collecting all the creepy, crawly insects that you can, such as venomous snakes, scorpions, and centipedes. They would all be placed in a jar together, which is then buried in the ground. According to the legend, this should be done on the fifth day of the fifth lunar month. Inside the jar, an epic cage battle will ensue between the trapped creatures, which inevitably start devouring each other, consuming each other's toxins until only one incredibly poisonous survivor remains. Imagine one snake or scorpion stuffed with other venomous creatures who are themselves stuffed with venomous creatures, like a poison turducken that contains a supertoxin made from the combination of these different animals. Up to a year after the creatures are buried, the jar is unearthed and the remains of the victor are ground into a powder that can be sprinkled into food or drink.

Sixteenth-century physician Xu Chunfu wrote of the mythic poison's effects. He warned that when someone is "struck by *gu*" his abdomen and heart will painfully swell while the *gu* consumes his organs, eating his insides with the ferocity of demonic worms. Without treatment he might die in as few as ten days, or live up to one year, depending on the potency and dose. Xu takes care to include more than a dozen possible antidotes so that the victim need not return to the *gu po*, or *gu* witch, who poisoned him.

In her essay "The Miao and Poison: Interactions on China's Southwest Frontier," Norma Diamond explains that it was understood that the poison was created almost exclusively by women, and that there were ways for careful travelers to identify the purveyors of this deadly substance. Diamond also shares accounts from twentieth-century ethnologist Chen Guoqun; his interviews explain that the women in possession of *gu* are said to have yellowing, jaundiced skin, have red eyes, and are always

scratching themselves. Importantly, these symptoms could also describe those who are ill and suffering from any number of conditions that could affect poor folks with limited access to medical care.

As a precaution, one could carry silver-tipped chopsticks when traveling. If the ends changed color when they came in contact with food, then it was surely poisoned and one should make a hasty exit; better hungry than dead. Another red flag: If someone's home was too clean, then they could be a maker of *gu*. It was also said that after victims died of *gu* poisoning, all their wealth and property would be transferred to the poisoner and their spirit would become her servant—which sounds like a really great deal for her.

Historians and toxicologists both agree that *gu* poison is not real. The idea nonetheless thrived for hundreds of years as a legend born out of fear of regional cultural differences and women's freedoms. In her book *Speaking of Epidemics in Chinese Medicine: Disease and the Geographic Imagination in Late Imperial China*, Marta Hanson explains how the *gu* myth came to be so prevalent: "The association between southern women, labeled as Miao, and the *gu* poisoning of Han men became more clearly articulated a century later in the 1730s. Han expansion south, meeting with considerable Miao resistance, generated new fantasies of *gu* poisoning."

Diamond recounts anthropologists in China being convinced of *gu*'s existence as late as the 1930s and '40s. She writes, "The *gu* form of magic is allegedly of Miao origin, but in fact it is a Han Chinese creation that goes far back in time. . . . The written term goes back at least 3000 years and the poisoned pot complex as an instrument of revenge, love magic or means to gaining wealth surfaces repeatedly in various writings over the past 2000 years."

As time went on, *gu* poisoning became more firmly associated with the women who lived in the southern part of the country. *Miao* is a slang term that roughly translates to "barbarian." It was used by the early modern Chinese to refer to several different local groups in Yunnan and Guizhou, but the people there do not use this term to refer to themselves, and the concept of *gu* is not part of their culture.

A series of scandalous images printed in the nineteenth century show the "Miao" women behaving in ways that were contrary to traditional expectations of Chinese women. They were depicted with large unbound feet, singing and dancing with men in public, choosing their own marriage partners, and participating in life outside the sphere of domestic duties. There was fear that Han women might see these images and seek more freedoms for themselves. Perpetuating the myth about the poisonings was a way to stoke fear and hostility toward these "others."

The terrifying myth of *gu* poisoning was especially used as an excuse to villainize rural southern women. When a community experienced an unexpected death, they would seek out a scapegoat, usually an older, impoverished woman, and blame her for the tragedy. Some women were burned to death, in an eerie similarity to the women executed during the European and American witch trials. The association of southern women with dangerous black magic and seduction was fuel for discrimination. The legend of women using *gu* poison to enact revenge on lovers who abandoned them echoes larger global themes connecting women to witchcraft, as well as treating women's sexuality as something to fear.

THE ASSOCIATION OF WOMEN WITH POISONING THRIVES ON STORIES LIKE these that depict women darkly plotting against their enemies—cackling maniacally as they sprinkle poison hither and thither, punishing the men who scorn their favors or refuse to do their bidding. Women using poison to enact revenge resulted in tremendous fear and panic among men. It meant that women were capable not only of executing the crime, but also of undermining traditional gender roles and social conventions. The actions of Marie de Brinvilliers led to the Affair of the Poisons in France, and the legend of *gu* poisoning by women in southern China led to fear and prejudice against them for centuries. Frances Howard Carr challenged the institution of marriage with her annulment and remarriage, and she poisoned the man who tried to stand in her way. Tillie Klimek and Marie de Brinvilliers killed those closest to them who dared to disagree with them. Legends of women like these led to the creation of myths and stories in which women poisoning their lovers with *gu* could be believed. No one got the last laugh in these tales of anger and revenge. Hurt people hurt people, perpetuating the vicious cycle.

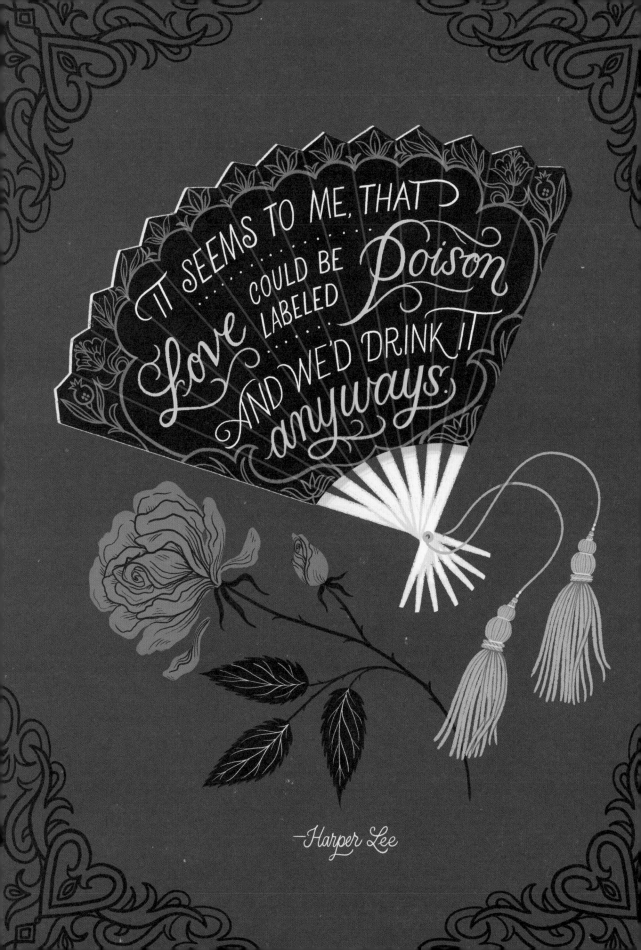

LOVE AND OBSESSION

ONE OF THE GREATEST LOVE STORIES EVER TOLD, SHAKESPEARE'S ROMEO AND *Juliet*, features a guest appearance by poison. The titular teenagers were so desperate to be together, in spite of the rancorous family rivalry that kept them apart, that—spoiler alert—Juliet took a special potion to make her appear dead so that she could avoid marrying someone else and secretly reunite with her lover. Tragically, the message about the plan never makes it to Romeo, and when he discovers that his beloved is "dead," he obtains poison to take his life by her side. It continues to go downhill for them after that. Many may not see this famous play as a cautionary tale about elaborate plotting and poison use, but I'm reading between the lines of iambic pentameter.

There are many variations on the theme of love and murder. There's the classic "person poisons spouse to be with lover." There is also "person poisons disappointing partner so they will be free to marry again." And then there's also the less popular, but not unheard of, "person poisons the object of their affection's spouse to make them available." There are infinite possibilities when it comes to love triangles (and more complex love geometries) that poison can be sprinkled onto.

For much of history, marriage (and the clear gender roles that went along with it) was considered essential for the survival of the community. Many women had to marry whomever their family selected, which was usually for financial rather than emotional reasons. Marriage was necessary; love was not. But

sometimes love (or plain lust) still happened outside of the confines of marriage, and that's when things got sticky. As Katherine Watson explains in her book *Poisoned Lives: English Poisoners and Their Victims* in regard to statistics from 1750 to 1914 in the United Kingdom, "Given the financial, legal and social constraints placed upon couples who experienced marital breakdown, it is easy to see why 25 per cent of poisoners were accused of murdering, or attempting to murder, a spouse: thwarted romantic aims and acute unhappiness can be powerful incentives."

Without divorce as an option, death was the only way out of an unhappy marriage and into the waiting arms of a lover. And while men were often expected to have affairs outside their marriages, women were not—and when they did, it was seen as a threat to the social order. Women who poisoned men were certainly also a threat, so an adulterous woman poisoner was doubly dangerous. Love can bring out the best in a human being, but obsession can bring out the worst. And when poison is involved, the situation can spiral quickly into a tragedy of Shakespearean proportions.

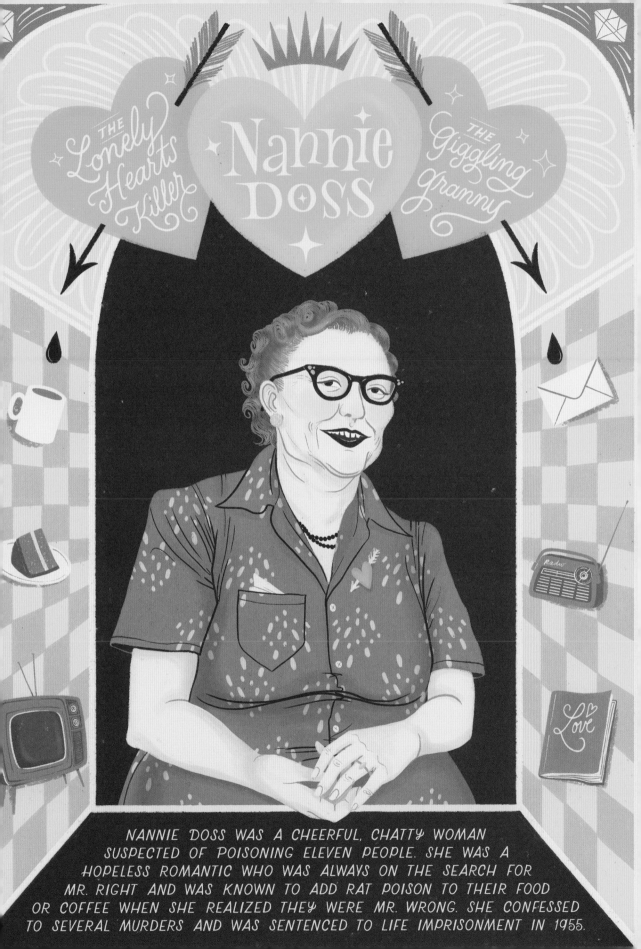

THE Lonely Hearts Killer

Nannie DOSS

THE Giggling Granny

NANNIE DOSS WAS A CHEERFUL, CHATTY WOMAN SUSPECTED OF POISONING ELEVEN PEOPLE. SHE WAS A HOPELESS ROMANTIC WHO WAS ALWAYS ON THE SEARCH FOR MR. RIGHT AND WAS KNOWN TO ADD RAT POISON TO THEIR FOOD OR COFFEE WHEN SHE REALIZED THEY WERE MR. WRONG. SHE CONFESSED TO SEVERAL MURDERS AND WAS SENTENCED TO LIFE IMPRISONMENT IN 1955.

People do unexpected things in the name of love. In one case, such things included moving across the country, changing her name, moving in with someone, and sneaking just a pinch of rat poison into her husband's coffee. Nannie Doss loved love. She thrilled in the way her heartbeat would quicken at the idea of meeting a new potential paramour. The woman was a hopeless romantic and believed in the idealized version of love she had read about in romance novels and magazines. When we're in love, our brains release lots of dopamine, the "feel-good" hormone. When that chemical dissipated, Nannie would introduce another chemical into the mix: arsenic.

At the time of her arrest in 1955, Nannie was nearly fifty years old, sporting fashionably curled hair, cat's-eye glasses, and a warm, cheerful smile. She was bubbly, charming, and flirtatious. She cracked jokes. The papers called her the "Giggling Granny," a title so silly and cute you could almost forget that she was suspected of murdering eleven people.

Nancy Hazle was born in Blue Mountain, Alabama, in 1905, the oldest of five children. Her father was a farmer who immediately put the little girl to work around the struggling farm. He was a strict man who forbade his daughters from wearing fancy clothes or makeup, or attending dances—you know, anything that might bring joy. Our young antiheroine would get lost in the dreamy tales she read in romance magazines and imagine her own future husband like a shining knight, sweeping her away on a white horse that she wouldn't even have to clean up after.

On a family trip to visit relatives, the train stopped suddenly and seven-year-old Nannie, as she was known, was sent flying into the metal bar in front of her. She sustained a severe concussion that knocked her unconscious. After this incident Nannie experienced headaches and mood swings. She would ultimately blame the head injury for some of her criminal actions later in life.

To escape the toils of farmwork, Nannie got a job at a linen factory when she was fifteen. There she met seventeen-year-old Charley Braggs, who wanted to marry her. Surprisingly, her stern father approved of Charley and the wedding. Nannie was giddy to experience everything she had read about in her romance novels and get the heck out of her parents' house and away from their dreary, boring farm.

Nannie was surprised to discover that Charley's mother was going to be living with them, and that she was just as strict and controlling as her own father had been. This was not the glamorous, grown-up life she had been dreaming about. Between 1923 and 1927 Nannie gave birth to four daughters, but all the while, the marriage was crumbling. She and Charley both accused each other of infidelity (justifiably), and Nannie was buckling under the stress of caring for her four children, her husband, and his difficult mother.

Nannie was known for her excellent cooking and baking, but one day in 1927 her two middle daughters died suddenly of what was

determined to be food poisoning. Charley had his suspicions about his wife's role in the mysterious deaths. He took their oldest daughter, Melvina, and ran—leaving Nannie with a baby and her curmudgeonly mother-in-law. But she wouldn't have to put up with the ailing old woman for long. Mother Braggs died within the year. When Charley returned, it was not to reconcile but to kick Nannie out of his house. She took her two surviving daughters, moved back in with her parents, and gladly signed the divorce papers.

OK, so the first marriage had been a dud. Nannie could see that. But now she had an opportunity to try again and actually find the man of her dreams. She returned to the lonely hearts columns of magazines that she had pored over in her girlhood and started writing to some of the men who had advertised there. When she saw one she liked, she would compose a reply, send a photo of herself, and throw in some irresistible home-baked goodies to sweeten the deal. In 1929 she got a letter from Robert Franklin Harrelson, who went by Frank. At twenty-two years old, he had a good factory job, had movie-star good looks, and wrote the kind of poetic love letters Nannie fantasized about. She didn't need any more convincing. Within two short months they were married and she took her daughters to move into his Jacksonville home.

Amidst the love letters and gifts of their whirlwind courtship, Frank had somehow forgotten to mention that he was a serious alcoholic who had served time for assault, making him Prince Less-Than-Charming. Nannie put up with his drinking and abuse for sixteen years. Her daughters grew up, married, and started families of their own. Melvina had a son named Robert and later gave birth to a daughter, but the baby died shortly after birth. In a postdelivery fog, Melvina could swear she saw her mother do something to the baby. Sometime later, while Nannie was babysitting her grandson, the boy suddenly died. The cause of death was determined to be asphyxia and was left at that.

It was now 1945 and Frank went out to celebrate the end of World War II with his buddies, which turned into a night of raucous drinking. When he returned that night, Nannie tried to put off his inebriated advances but he forced himself on her. While he slept, Nannie stewed in her anger and resentment, developing a plan. She knew that Frank kept a bottle of moonshine buried in the garden, so she dug it up, added some rat poison, and then put it back where she found it. It wasn't long until he snuck out for some sips of his secret hooch and then keeled over dead. The alcohol seemed to be the obvious cause of death, so no one questioned it. Nannie cashed in on his life insurance policy and bought some land of her own. This might sound like a familiar story, but Katherine Ramsland, in her book *The Human Predator: A Historical Chronicle of Serial Murder and Forensic Investigation*, says of Nannie Doss, "... at her trial she claimed she had done it for love—'the real romance of life'— not money." The money was kind of a bonus.

After Frank's death Nannie returned to her old standby, the lonely hearts column. This time would be different. She was forty-two now, older and wiser. She got a response to her listing from Arlie Lanning of Lexington, North Carolina, and he swiftly became husband number three. Much to her dismay, Arlie also liked to drink and cavort with other women. When he came home drunk—or didn't come home at all—Nannie would send him a clear message by leaving town for a while. When she returned, he would be repentant and promise to do better. This cycle went on for several years before Nannie decided it was time to end it by sprinkling rat poison in his food. The cause of Arlie's death was listed as heart failure, but it was Nannie who'd had her heart broken.

She decided to try a new tactic this time and joined a dating group called the Diamond Circle Club. This is how she met Richard Morton of Kansas, whom she married in 1952. Richard was quite taken with his new bride and, according to the *Shreveport Times* of Louisiana, he wrote to the operator of the dating club ". . . asking that his and Nannie's names be taken from the membership rolls. 'We have met and are happily married. She is a sweet and wonderful person.'" Richard was not a heavy drinker—but he was known for being a womanizer, and Nannie had no patience for it anymore. He was done in by drinking some coffee Nannie had prepared for him that was spiked with rat poison.

Just one month after burying Richard, Nannie married her fifth and final husband: Samuel Doss of Tulsa, Oklahoma. Samuel was a different type of man. He was a churchgoer and didn't drink or run around with other women. Would this be the happily ever after Nannie so desperately wanted? According to that same *Times* article, "She tired of him quickly, though, because 'he was so religious he wouldn't let me watch television or have any magazines in the house and made me go to bed early.'" Samuel was no fun at all, and that just wouldn't do. Nannie whipped up a dish of stewed prunes and rat poison for him, commenting on the cuisine later, "He sure did like prunes." The prunes sent him to the hospital for twenty-three days, but much to Nannie's dismay, her husband recovered and came home. She corrected her error and added liberal amounts of arsenic to his coffee, which finally did the trick.

Samuel's doctor, who had treated him in the hospital and saw him recover, was shocked to see him back again, and this time in the morgue. He asked Nannie

fall 1949

Romance

for permission to conduct an autopsy, and for some reason Nannie agreed. In the body of the fifty-eight-year-old man they found "enough poison to kill a horse." Nannie was arrested and her relatives began making phone calls to the police department to report the other suspicious deaths that had occurred in Nannie's orbit over the decades.

Interrogators questioning Nannie Doss were in for one of the strangest experiences of their careers. An article for the *Shreveport Times* explains, "Her jolly disposition never changed as she denied knowing anything about the arsenic that killed Doss. . . She joked and giggled through the entire session and admitted nothing." She later gave in and confessed to poisoning Samuel. The bodies of her other husbands had been exhumed and also tested positive for arsenic, the main ingredient in rat poison. Confronted with this information, Nannie slyly admitted to poisoning four of her five husbands. It was likely she murdered closer to eleven people, including family members. Investigators had more than enough to prosecute, and she was charged with the murder of Samuel Doss.

The "Giggling Granny," also known as the "Lonely Hearts Killer," became a media darling. She gave chatty interviews and made jokes, smiled for photographers, and flirted with cameramen. She had been corresponding with several men as Samuel was dying and they counted their lucky stars that she was caught before they became her next victims. After all this time, and all that rat poison, she was still looking for Mr. Right. She pled guilty to Samuel Doss's murder, and in 1955 Nannie was sentenced to life in prison. During an interview about her time in the McAlester prison in Tulsa, Nannie expressed frustration that she was only permitted to work in the laundry and not, as she would have preferred, in the prison kitchen—banned, as she was, for obvious reasons. She died of leukemia in the prison hospital on June 2, 1965.

It's hard to reconcile Nannie's grandmotherly image and chatty, cheerful personality with her murderous actions. A person can be sweet, pleasant, bake a mean cake, and still be a killer. Would Nannie really have given up her murderous ways if she had found her perfect partner, or would they all have eventually failed her in one way or another, unable to live up to the expectations set by her romance magazines and books? Nannie rushed into relationships with men she hardly knew and then was hurt when they weren't who she thought they were. She wanted to write a storybook romance and ended up with a grisly pulp crime book instead.

TO: CHRISTIANA EDMUNDS

CHRISTIANA EDMUNDS FELL IN LOVE WITH A MARRIED DOCTOR IN 1870s BRIGHTON, ENGLAND. SHE ATTEMPTED TO POISON THE DOCTOR'S WIFE WITH CHOCOLATES LACED WITH STRYCHNINE. TO CAST SUSPICION AWAY FROM HERSELF, CHRISTIANA POISONED MORE CHOCOLATES AND DISTRIBUTED THEM TO THE MASSES. HER POISONING PLANS CONTINUED TO ESCALATE UNTIL SHE WAS CAUGHT AND SENTENCED TO SPEND THE REMAINDER OF HER LIFE IN THE BROADMOOR ASYLUM.

When you were a child, your mother probably told you not to take candy from strangers. She wanted to protect you from "stranger danger," those who might do you harm, and people like Christiana Edmunds, the well-heeled Victorian lady who traveled around Brighton, England, giving poisoned chocolates to children. The mass poisoning was part of an elaborate plan to candy-coat the truth and redeem herself in the eyes of a married man she was obsessed with. Her unrequited love and rejection ignited a terrifying chain of events that led Christiana to become known as the Chocolate Cream Killer.

Born in 1828, Christiana was the first child of successful architect William Edmunds and his wife Ann. William's work provided a good living for his family, and his five children received excellent educations and lived in relative luxury, but everything changed during Christiana's teenage years, when she noticed a distinct change in her father's behavior and he became erratic and violent. Eventually the decision was made to commit him to an insane asylum, where he died in 1847 when Christiana was nineteen. Some years later history would repeat itself when her brother suffered a similar fate. To escape the judgment of their neighbors and the stigma associated with mental illness, Christiana's mother sold everything and the family moved away to Canterbury.

In her comprehensive book about Christiana's life and crimes, *The Case of the Chocolate Cream Killer: The Poisonous Passion of Christiana Edmunds*, Kaye Jones explains that Christiana was prone to fits of anxiety, emotion, and paralysis, thereby earning the Victorian catchall diagnosis of "hysteria." Hysteria was a nervous condition that was applied only to women, because physicians thought it was caused by the uterus. The Greek philosopher Plato believed that the uterus was like an animal that roamed haphazardly inside a woman's body, causing pain and other trouble, and the notion of the "wandering womb" lingered in medicine for centuries. So Christiana, an unmarried woman who was by now nearly forty years old, was diagnosed with a pesky, misbehaving uterus when she and her mother moved again, this time to Brighton.

In Victorian society it was a great sin for a woman to be single. Marriage, childbirth, and domestic duties were thought to be a woman's reason for living, and failing to achieve these things struck others as unnatural. In her article "Female Poisoners of the Nineteenth Century: A Study of Gender Bias in the Application of the Law," Randa Helfield explains that "... consequently, there was nothing more pitiful or tragic than the spinster. Statistics show that thirty out of every one hundred women were spinsters, or 'redundant women' as they were called." But Christiana was certain that her spinsterish existence was over because she had finally met the one.

The man in question was Dr. Charles Beard, a kind physician who lived nearby. He

befriended Christiana and invited her to his home for social occasions, and in return she wrote him countless affectionate letters. There was only one problem: Dr Beard was happily married and had five children. The true nature of the relationship between the doctor and Christiana has never been determined, but it is generally accepted that she was quite smitten with him and that he politely humored her, or perhaps enjoyed the attention, or at least didn't discourage it at first. Whether anything actually happened between the two is unknown, but it is possible (and perhaps even likely) that the relationship was the product of Christiana's imagination.

In September 1870, while Dr. Beard was away, Christiana went to his home to pay his wife, Emily, a friendly visit. Like any good friend, she brought chocolates with her. They were from the popular local sweet shop, Maynard's. Christiana insisted her friend eat some of the chocolate and even went so far as to pop one into her mouth—totally casual. Emily, upon detecting an unexpected metallic taste, awkwardly smiled and hurried away to spit it out. Later that night Emily experienced increased salivation and diarrhea. When her husband returned she informed him of the strange incident. Dr. Beard immediately suspected Christiana.

He confronted his admirer about the attempt to poison his wife, but Christiana responded indignantly, hurt at the accusation. She constructed a careful story that she, too, had been a victim of the tainted chocolate and had also become ill after eating it. She blamed the chocolatier Maynard for selling a dangerous product. Dr. Beard was not convinced, and he ended their friendship for good. Devastated, Christiana hatched a truly maniacal plan. It wasn't a lie if she could make it true, so she

decided that other people needed to get very sick from eating Maynard's chocolates.

So Christiana did what any hopeless romantic Victorian spinster with an inherited predisposition to mental illness might do: She purchased several bags of chocolate creams from Maynard's, adulterated them with poison, and then set out to give them to children in a plan to frame Maynard for what happened to Emily Beard and win back Dr. Beard's companionship. Thirteen-year-old Benjamin Coultrop accepted a bag of sweets from a veiled woman who bought a newspaper from him. Another boy, William Halliwell, became very ill after the same woman left a bag of chocolates in his family's shop. Nine-year-old Jesse Baker vomited for three days after eating candy a strange woman had given her. Fortunately, they all recovered.

Christiana needed more poison, but there was a problem. A law had been passed in the United Kingdom a mere three years prior to prevent people like her from acquiring dangerous substances. The 1868 Pharmacy Act endeavored to create more stringent rules for the sale of poisons to make it harder for would-be criminals to get their hands on the stuff. As a result, only doctors, pharmacists, and registered druggists would be allowed to sell poisons. Any such sales would have to be to someone known by them, or else witnessed by someone known to both parties. Importantly, these purchases would be recorded in a poison register with the person's name, address, and signature, so the poison could be traced later by investigators if necessary.

Knowing this, Christiana went to see chemist Isaac Garrett armed with a false name and backstory. She was Mrs. Wood from Hillside. She told the chemist that her garden was plagued by cats and she needed strychnine to kill them. Uneasy, Garrett insisted on a

witness to oversee the transaction, as required by the Pharmacy Act because he did not know the veiled, cat-hating woman. Christiana went to the nearby hat shop, picked up another veil—for increased mystery—and asked the milliner to witness a poison purchase at the chemist's. The milliner could not think of a good reason to deny her request, so Christiana signed the poison book with a false name and walked out with ten grains of strychnine.

In some ways it was fortunate that Christiana chose strychnine as her method of poisoning. Unlike arsenic, which is odorless and tasteless, strychnine has an extremely bitter taste, which led many of her victims to spit out the chocolates before they had eaten too much. Of all the poisons, however, strychnine causes some of the most excruciating effects, with the victim experiencing violent convulsions and spasms until they die from exhaustion or asphyxiation. "Mrs. Wood" returned to the druggist two more times for even more strychnine.

She decided it was time to work smarter, not harder, and reconsidered her system of buying the chocolates and distributing them herself. Christiana began paying errand boys to pick up bags of chocolate creams from Maynard's for her. When they returned, she would tell them they had purchased the wrong kind. Then she would execute a bait and switch, replacing the bag with chocolates she had poisoned and asking them to return the chocolates. Back at Maynard's, the adulterated candies got mixed back in with the others and were then unknowingly distributed to the candy-loving masses.

Charles Miller purchased some chocolate creams from Maynard's

and shared the treats with his four-year-old nephew, Sidney. The child was immediately sickened and began to convulse. The frantic family called for a doctor, but it was too late. Sidney died within twenty minutes of eating the candy. The doctor suspected poisoning and informed the police and coroner. Sidney's stomach and some chocolates from Maynard's were brought to London for chemical analysis by Dr. Henry Letheby, who found traces of strychnine in both. The Brighton coroner called for an inquest into Sidney's death.

Christiana was asked to appear at the inquest, as she had previously complained to Maynard about his chocolates making her ill. She was the type of criminal who liked to involve herself in the investigation, reveling in the attention and watching her plan at work. The child's death was ruled to be accidental,

and Mr. Maynard said he would destroy his supply of the chocolate creams that may have been contaminated.

Aglow with triumph, Christiana penned a letter to Dr. Beard expecting her vindication and the renewal of their friendship. Addressing it "Cara Mio" (my dear), she wrote, "I have been so miserable since my last letter to you. I can't go on without ever speaking to you." She signed it "a long, long, bacio [kiss]." Soon after she received a visit from Dr. Beard, but it wasn't the warm reconciliation she had hoped for. He told her to stop sending him letters and that he had shown her recent correspondence to his wife. Christiana was beside herself, and her mother later saw her pacing the room and repeating, "I shall go mad! I shall go mad!"

Around this time Albert Barker, the father of the child who had died from eating poisoned chocolate, received three anonymous letters. All of them criticized the outcome of the inquest and almost desperately insisted he seek justice against Maynard. He turned the letters over to the police. Police inspector Gibbs had his suspicions about Christiana and asked her for some more information about her experience with Maynard's. She immediately wrote him a letter with the details, and now Gibbs had a sample of her handwriting.

While she was on a letter-writing campaign, Christiana thought of a new and more convenient way to get poison. She sent one of the local errand boys with a note to Isaac Garrett, the chemist. This note—which she had forged—claimed to be from Glaysier and Kemp, two well-known local chemists, asking their colleague for some strychnine. Garrett sent them what he had. Now she could sit back and get her poison delivered without lifting a finger.

When she tried forging the names of the chemists again, asking for arsenic this time,

Garrett became suspicious and went over to talk to his colleagues, when he discovered they hadn't sent him any notes. Panicked, he realized he had no idea who he had been sending poison to and went to the police. It was of no consequence to Christiana, as she just pulled the same trick on a different chemist. In spite of all of the chocolates she had poisoned and the people she had made sick, the whole affair still wasn't getting the public attention or response that she wanted, so Christiana decided to up the ante and make sure everyone noticed her.

After she took a trip out of town, several prominent people in Brighton received packages—all with notes signed with initials that were unknown to them—filled with various cakes, tarts, and fruits. Among the recipients were the editor of the *Brighton Gazette*, a surgeon, the chemist Isaac Garrett, and, of course, Emily Beard. To round it out, Christiana had sent herself a box too. Emily Beard and her neighbor Elizabeth Boys both received boxes, and in both cases their servants partook of the goodies inside. A doctor was summoned to both households to help the violently ill servants and was shocked by the similarity of the situations. He took care to collect some of the treats and samples of the vomit and went to the authorities.

The police made a public appeal for information. And finally, now that two attempts had been made on his wife's life, Dr. Beard came forward and told them about Christiana's fixation with him. Now the police had a suspect and a motive. On August 17, 1871, when she was forty-three years old, Christiana was taken into custody. A handwriting expert testified that it was indeed Christiana who had written the notes to recipients of the boxes. A toxicologist also testified that arsenic was found in all of the

preserved fruits, and one 'was literally stuffed with it.' She was initially charged only with the attempted murder of Emily Beard, but as her hearing continued more charges were added, including the attempted murders of Elizabeth Boys and Isaac Garrett, as well as the murder of Sidney Barker.

Her barrister based his defense on the argument that Christiana was insane at the time the crimes were committed. But, though many would agree her actions were not rational, Christiana would fall into a gray area with respect to the legal definition of insanity. To meet the requirements, her lawyer would have to prove that she did not understand the difference between right and wrong. Christiana was interviewed by a panel of experts, one of whom described her as "on the border land between crime and insanity." They found her "morally insane," but her sanity was hotly debated in the press.

Throughout her trial newspaper reporters commented on how disaffected Christiana was, seemingly totally unaware of how serious her situation was. Christiana was found guilty and sentenced to death, but later the home secretary had her reexamined by two more experts. They concluded that she was insane, and the sentence was commuted to life in the Broadmoor asylum. Attention-seeking Christiana arrived at Broadmoor wearing rouge, false teeth, and additional false hair. She remained there until her death in 1907.

Brighton's Chocolate Cream Killer revealed two major flaws in the legal system: The first was that stricter regulations for the sale of poisons were necessary, and the second was that the legal definition of insanity was too limited and didn't reflect the nuances of mental health conditions. Christiana probably never gave any thought to how her actions were harming others, as she was so singularly focused on her obsession with Dr. Beard that nothing else mattered. She was transformed from a woman with a romantic crush into an agent of chaos who didn't care who she harmed.

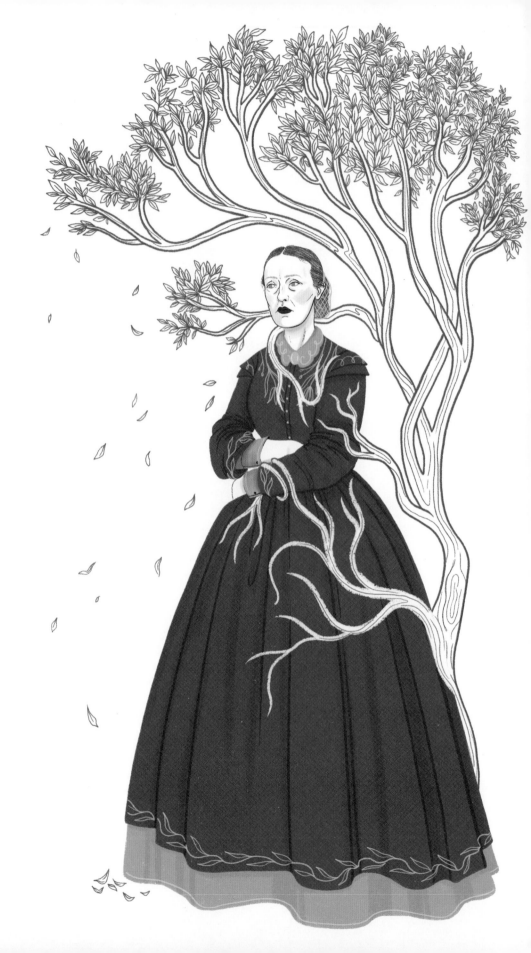

In 1889 Louisa Collins, aka "the Borgia of Botany Bay," stood on the scaffold with the hangman "Nosey Bob"—so named not because of his curiosity, but because he had lost his nose after having been kicked in the face by a horse. The condemned woman had been accused of poisoning her first husband when she fell in love with another man, and later of poisoning her lover too. Louisa, who had given birth to ten children and faced four trials over the span of six months, was to be the last woman hanged in New South Wales. Her alleged crimes, her gender, and the death sentence imposed upon her made Louisa Collins one of the most contentious topics of her day.

But before she stared down Nosey Bob's noose, she was a young wife and mother. Louisa was born in August 1847. Her father had been a convict, which was not at all unusual for the time and place. Australia (then called New South Wales) was used as a penal colony by the British. By the time Louisa was fourteen she would have begun working as a domestic laborer in town, and by sixteen she had developed a reputation for her flirtatious charms and fun personality.

Her mother arranged for her to marry a butcher and widower named Charles Andrews. On their wedding day in 1865, Louisa was eighteen and her groom was thirty-two. While Louisa was young and exuberant, Charles was more somber. His first wife had passed away and his father had tragically taken his own life. In her meticulously researched *Last Woman Hanged: The Terrible, True Story of Louisa Collins*, Caroline Overington explains that "in years to come, Louisa would complain to neighbors that Charles had always been boring. She liked to dance and he didn't. She liked to drink and he would scold her for getting drunk."

The couple quickly found themselves in the family way and Louisa would be in a state of nearly continuous pregnancy over the next two decades. She had nine children with Charles, seven of whom lived to adulthood—six boys and one little girl named May. The growing family often struggled to make ends meet, and they moved several times as Charles looked for work. In Botany Bay they began to take boarders into their home as a way of earning some extra money, and Louisa enjoyed the attention she received from the male guests.

One handsome young boarder particularly struck her fancy. His name was Michael Collins, and he reciprocated his landlady's affections. He was in his midtwenties and she was at least a decade older, but the pair engaged in a lusty affair that had all of the neighbors talking. According to the *Evening News*, "they would go down to the bay and canoodle in the bushes." It must have been exciting for Louisa, who loved to drink, dance, and flirt. She was smitten, but stuck. She had a boring husband, seven hungry children, judgy neighbors, and an empty bank account. Was there any way she could get everything she wanted?

When Charles became aware of his wife's adulterous liaisons, he angrily threw Michael out of their house to put an end to it. Louisa was incensed by her husband's actions and

had no intention of breaking off the affair with her lover. Then Charles rather conveniently became ill. He complained of severe stomach pain, vomiting, and diarrhea. A doctor was sent for, and he prescribed some medicine, fully expecting Charles to recover. But Louisa knew he wouldn't, and she had his will revised to leave everything to her. Charles also had a hefty life insurance policy in his name, making his death worth about two hundred pounds to his wife. After twenty-seven years of marriage, Charles died on February 1, 1887, and Louisa did what any grieving spouse would do: She left her children alone in the house with the corpse and went into town to collect her late husband's insurance and savings. His cause of death was deemed to be acute gastritis, and at the time, no one suspected a thing.

At her trials, much was made of Louisa's strange behavior after her husband's death. She refused to wear the usual black Victorian mourning dress and even threw a big party in an empty house nearby to celebrate. Now flush with cash, Louisa took the opportunity to spoil her young lover with new clothes and a new gold watch. He was a gambler, and Louisa paid off his debts. Within two months Michael Collins had moved back into the house, no longer as a boarder but as Louisa's husband. They were married in April of that year. Time heals all wounds, and Louisa healed fast.

She may well have been pregnant with Michael's child, her tenth, at the time of their wedding. Unfortunately, the baby did not survive, and Michael was crushed by the loss. Tensions in their relationship started to flare when the money began to run out. Michael turned to gambling and Louisa turned to drinking. Eventually Michael found work doing the same job Charles had been doing, carting skins for a wool merchant. While doing this job, just a few months after their wedding, Michael

developed gastrointestinal symptoms oddly similar to those of his predecessor. The debilitating abdominal pain left him bedridden.

This time, Louisa seemed much more distressed about her husband's sudden illness, insisting that he see a doctor several times as his condition continued to deteriorate. She gave him all the medication that the doctor prescribed, and served him milk in a small glass tumbler. His doctor was more suspicious than the one who had tended to Charles, and he collected samples of Michael's urine and vomit to test for arsenic. The doctor chatted about the unusual case with a colleague, who happened to be the doctor who tended to Louisa's first husband. They recognized the eerie similarity of symptoms and circumstances, and they connected the dots until they formed a picture of a wife named Louisa. The doctors went to the police to express their concerns that a serial murderess was at work in Botany Bay. The constable came and confiscated from the home items that might be evidence, including some of the prescribed powders and the small glass tumbler, much to Louisa's distress.

Michael Collins died on July 8, 1888. The doctor refused to issue a death certificate and instead the body was brought in for autopsy. Michael's stomach was tested and found to contain "between 2 and 3 quarter grains of arsenic." The glass used to serve him milk was also tested and found to contain a tenth of a grain of arsenic. Louisa was arrested for murder on July 12. She issued a statement that suggested her own theory about her husband's death: that Michael had poisoned himself, having been depressed ever since the death of their child. She didn't have a motive to poison him, she claimed. "His life was not insured," Louisa insisted. "He has left me penniless and in debt."

The jury at the coroner's inquest didn't buy her story and found Louisa guilty of murder,

meaning the case would go to trial. Charles Andrews's body was also exhumed at the time and found to contain a "minute amount of arsenic" (truly miniscule—only one–five hundredth of a grain, which, in Victorian times, when everything was so riddled with arsenic, really could have come from anywhere). Louisa was now charged with two counts of murder, and the first of her numerous trials began.

Louisa Collins would be tried for the crime of murder not once, not twice, but four times in a row. The first three trials did not yield the guilty verdict the Crown wanted, so they simply kept trying. This is problematic for a number of reasons. In the first three trials the jury could not reach a verdict because the evidence against Louisa was purely circumstantial (as was the case for many poisoning cases), and there was reasonable doubt surrounding the deaths of both husbands. Suspicion alone is not enough to convict a person of a crime. Louisa had the same defense lawyer for all four trials, a Mr. H. H. Lusk, who, though well intentioned and working for his client pro bono, was not the most capable attorney. The first, second, and fourth trials were for Michael Collins's death, and the third was for Charles Andrews's, just to switch it up and keep everyone on their toes.

Painfully, Louisa's own children testified against her in court. Her daughter May, who was only ten years old, delivered the damning testimony that she had seen rat poison in the home right before the deaths of both men. She described the packaging of the popular arsenic-based product Rough on Rats. (It had the best slogan: "Rough on Rats—a leading cause of cat unemployment!") Both doctors testified that the symptoms Charles and Michael exhibited were consistent with arsenical poisoning, but there was no proof that Louisa had ever purchased poison, and no witnesses who had ever seen her administer it. She had a motive to get rid of her first husband—to collect his life insurance payout and clear the path to be with her lover—but she didn't have a similar motivation for Michael Collins's death, and his was the body in which investigators had found more arsenic. It was a proper pickle, and thirty-six (all male) jury members in the first three cases could not reach a verdict.

But if at first you don't succeed, you go to trial one last time. At her fourth and final trial Louisa was finally found guilty of the murder of her second husband, Michael Collins, by poison. Chief Justice Darley sentenced her to death and asserted, "The murder you have committed is one of particular atrocity. You were day by day giving poison to the man whom above all others you were bound to cherish and attend. You watched his slow torture and painful death, and this apparently without a moment's remorse. You were indifferent to his pain, and gained his confidence by your simulated affection." Louisa would hang for the murder.

Whether or not Louisa should face capital punishment was the most discussed and contentious topic of the day. While most agreed she was guilty, not everyone thought a woman should hang. Petitions were circulated in Melbourne and Sydney, and both collected hundreds of signatures from those hoping to spare Louisa Collins the death penalty. Letters were also written on her behalf to the governor. We will never know if Louisa was guilty of the crimes or not, but the debate at the time wasn't really about that. Instead, she was a symbol for women, who were beginning to fight for greater rights and independence at the time. Many

claimed that if women wanted equality, then Louisa should face the same punishment that a man would for murder—but Louisa didn't have the same rights and privileges as a man. She could not vote, hold office, or serve on a jury, and she was subjected to laws that she and other women had no say in making. As Caroline Overington notes, ". . . before long, many of the women who had stood firm for Louisa were also standing up for women's rights more generally. Such as the vote. Such as the right to work in jobs that paid the same as jobs for men."

Unfortunately for Louisa, her hold on the public imagination didn't save her life in the end. The reprieve never came, and Louisa would receive the ultimate punishment for her crime. Leave it to Nosey Bob to botch the execution. When the moment came for the drop, her neck was torn open and she was nearly decapitated during the grisly event. As a result she became the last woman hanged in New South Wales. Just five years later, women in South Australia would become the first in the world to get the right to vote, and some of the fire in their bellies that pushed them to lobby for their rights was the case and conviction of accused poisoner Louisa Collins.

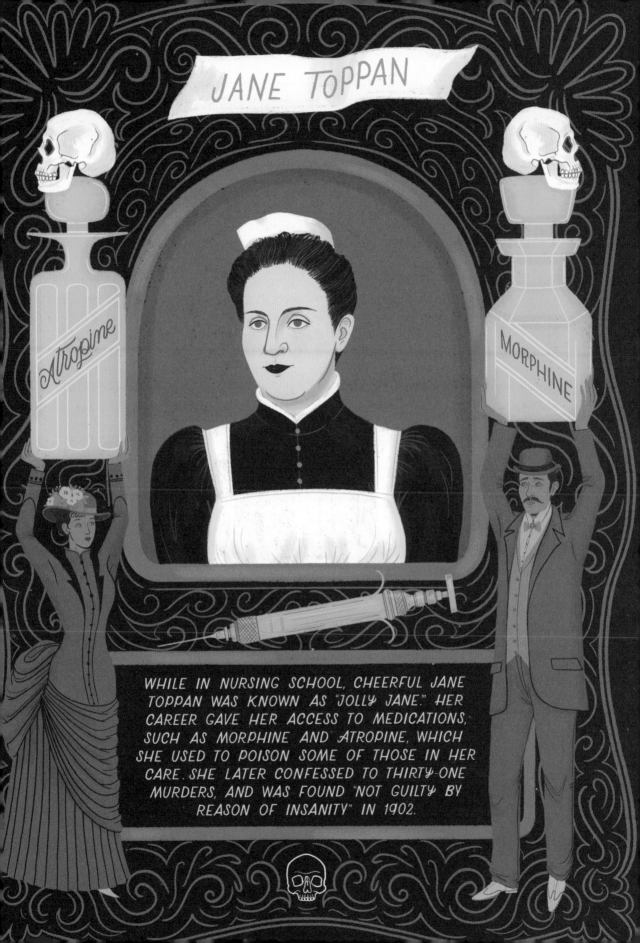

JANE TOPPAN

Atropine

MORPHINE

WHILE IN NURSING SCHOOL, CHEERFUL JANE TOPPAN WAS KNOWN AS "JOLLY JANE." HER CAREER GAVE HER ACCESS TO MEDICATIONS, SUCH AS MORPHINE AND ATROPINE, WHICH SHE USED TO POISON SOME OF THOSE IN HER CARE. SHE LATER CONFESSED TO THIRTY-ONE MURDERS, AND WAS FOUND "NOT GUILTY BY REASON OF INSANITY" IN 1902.

Sometimes love isn't something felt for *someone* but for *something*. Jane Toppan loved poison: how it made her feel, what she could do with it, and what she could get away with. Nurse Toppan was often called "Jolly Jane" by those who knew her because of the jovial and affable personality that made her a favorite among her patients. But once you learn how Jane got her jollies, this will all sound less charming. She used her position as a medical professional and the trust she garnered as a friend to poison scores of people, simply because she enjoyed watching them die. Jane Toppan couldn't pick just one motivation for her confounding killing spree. She dabbled in all of them, and then some.

She was born Honora Kelley during the 1850s to an Irish immigrant family in Boston, Massachusetts. Her mother died when she was a baby, leaving Honora and her three sisters in the care of their erratic father. Peter Kelley, known as "Kelley the Crack" (short for "crackpot"), was described as drunk and unhinged. The most bizarre rumor about Peter, who was a tailor, was that he had sewn his own eyelids shut. Around 1864 he surrendered two of his daughters, including Honora, to the Boston Female Asylum, an orphanage that was known to be a source of cheap child labor. Some of the girls in the asylum would end up getting adopted, but most were sent to stay with families as their indentured domestic servants.

After two years at the orphanage, Honora was indentured to Mrs. Ann Toppan and went to live at her home in Lowell, Massachusetts. In some ways, the girl was lucky—the Toppans provided her with a safe home—but essentially she was just an unpaid child maid for a well-to-do family. Though they never formally adopted her, she still took the name Jane Toppan. Even as a child, she had a cheerful, gregarious personality. But little Jane was also prone to lying, weaving grand tales that made her background sound more glamorous than it really was. She felt shame about her Irish heritage and hid the history of mental illness in her family. She also harbored a bitter resentment for her foster sister, Elizabeth, the biological daughter of the Toppans whom the adults showered with the love and affection that Jane desperately wanted. Jane was just like Cinderella, if poor, neglected Cinderella never got to go to the ball or meet the prince, and just became a serial killer.

The two young women grew up together, one a beloved part of the family, the other never allowed to forget that she was an outsider. Elizabeth married Oramel Brigham and became the woman of the house after Ann died. Though her indentureship was formally complete when she turned eighteen, Jane remained in the Toppan home another ten years, generally acting as a servant. In a book about her life and crimes, *Fatal: The Poisonous Life of a Female Serial Killer*, Harold Schechter sets the stage for the ensuing mayhem perfectly: "And so, in 1887, Jane Toppan—a classic psychopathic personality who longed to do harm . . . decided to become a nurse."

Did Jane know when she applied to nursing school at Cambridge Hospital that her training would bring her into contact with dangerous

substances, or was that an opportune discovery she stumbled upon? The program was rigorous, and Jane seemed well suited to its challenges, but her fellow trainees picked up on her habit of lying. Hospital staff also noticed that items would go missing from rooms after Jane had passed through.

It was here, studying medicine and vowing to "do no harm," that she first encountered the two drugs that fascinated her most: morphine and atropine. Morphine is a narcotic derived from opium that is used as a painkiller, while atropine, an alkaloid that occurs naturally in the deadly nightshade plant (*Atropa bella-donna*), is used to treat pain and a myriad of other conditions. Combining the two was her secret weapon. Together they created an array of puzzling symptoms that stymied even the most experienced medical professionals. The symptoms the two drugs caused were often contradictory; for example, morphine causes the pupils to shrink, while atropine makes them dilate, resulting in pupils that look normal— even though the victim would be anything but.

Jane, along with more recent murderers like the nurse Kristen Gilbert and Dr. Harold Shipman, falls into the category of "Angels of Death" or "Angels of Mercy." Describing those who use their role as medical providers or caregivers to kill, Deborah Schurman-Kauflin explains in her book *The New Predator— Women Who Kill: Profiles of Female Serial Killers*, "Often they are seen as the *angel of death* in cases where the killer is charged with the care of elderly, infirm, or very young victims who cannot defend themselves."

Jane was a capable nurse who didn't kill all of her patients—only the ones she wanted to. On several occasions she was heard flippantly saying that there was no point in keeping the elderly alive. But there was another force compelling her to poison her patients, one that breaks the mold for her as an "angel of mercy"

and as a woman serial killer: Jane Toppan found watching her victim's deaths, soaking in their last anguished moments of life, sexually thrilling. This sexual motivation separates Jane from the vast majority of female serial killers. According to Scott Bonn, in an article for *Psychology Today*, it's rare for a female serial killer to act from sexual or sadistic motives, which are much more often associated with men who kill.

Harold Schechter recounts the tale of one woman who was poisoned by Nurse Toppan and survived, only to be troubled by a weird memory of what had occurred. Amelia Phinney was a patient in the hospital following an abdominal procedure. She recalled her nurse giving her some bitter medication that made her feel numb, just before she slid into unconsciousness. She was in this trapped and vulnerable state when she felt the bizarre sensation of someone climbing into the hospital bed beside her. Nurse Toppan had taken the opportunity to feign comforting her, holding and kissing her face with building excitement. At the sound of someone approaching the nurse hurried away, and Amelia later recovered. She kept the memory to herself for many years, thinking it must have been a strange dream.

In 1888 Jane transferred to the Massachusetts General Hospital. When she completed her studies she was discharged but granted no license, so she forged one. By her own admission, Jane estimated she killed about a dozen patients during her time in nursing school. This wasn't the reason she wasn't granted her license; it was because of the smaller infractions she committed that the hospital knew about. It was no matter: Jolly Jane decided to pursue a career as a private nurse anyway.

Nurse Toppan was soon to be regarded as one of the finest and most sought-after nurses in the area. Her warm and chatty nature made her popular with patients, and her clients

overlooked her fibbing and petty thefts because they liked her so much. But without any hospital oversight or colleagues to get in the way, Jane was now free to murder more easily. In 1895 she poisoned her elderly landlord, and two years later she did the same to his wife. With them dispatched, she went on to poison another widow she was hired to nurse, Mary McNear. Jane never felt any remorse or gave them a second thought. By the time they breathed their last she had set her poisonous sights on someone else.

Jane had remained on friendly terms with her foster sister, Elizabeth, through the years and the two women decided to take a summer trip to Cape Cod together. Jane saw in Elizabeth everything she didn't have—money, a marriage, a home of her own, the love of a family—and it filled her with vengeful spite. In late August 1899, she seized her chance. Jane used her favorite method: dissolving poisons in a glass of mineral water and encouraging her victim to drink it. Elizabeth became violently ill, and Jane did not miss the opportunity to climb

into her death bed with her and savor it. Later, when she confessed to the crimes, Jane said she murdered Elizabeth to "have my revenge on her," and added that she was the first victim she "actually hated and poisoned with a vindictive purpose." She concluded the admission by saying, "I held her in my arms and watched with delight as she gasped her life out."

While living with new landlords, Jane was paid an unexpected visit that would kick off the most brazenly murderous summer imaginable. Mary "Mattie" Davis came to collect the five hundred dollars Jane owed her family from staying in their cottages in Cataumet every summer for the past five years. The Davis family was fond of Jane and were happy to give her loans, but they had reached the tipping point and wanted to settle the debt. Jane was very fond of the Davis family, too, so it was a real shame that she would have to do what she did next.

On their way to Jane's bank to collect the funds, Mrs. Davis became woozy and needed to lie down. Jane had given her a glass of her

special mineral water laced with morphine earlier. Now that she was drugged, the woman was completely at Jane's mercy—but, unfortunately for Mrs. Davis, this particular nurse was not capable of mercy. She poisoned and tortured the woman for a week before she succumbed. The sixty-year-old woman was buried in early July 1901, but Jane was just getting started. She had resolved to poison the entire Davis family.

It was this recklessness of murdering an entire family that would lead to her capture and downfall. The Davis family was made up of four members: Mattie, the mother; Alden, the father; and their two married adult daughters, Genevieve Gordon and Minnie Gibbs. The family was well known in town, thanks to the patriarch running a successful hotel there. They were all grief-stricken by Mattie's sudden death, so Jane offered to stay and nurse them. The family was grateful for her care and attention.

Thirty-one-year-old Genevieve was next to go. Less than two weeks later Jane shamelessly poisoned Alden, whose official cause of death was determined to be a cerebral hemorrhage. Finally there was Minnie, whom Jane would later describe as her "best friend." The thirty-nine-year-old was overcome by grief at the loss of her family, but she was in good health otherwise. In a uniquely disturbing move, while Minnie died of poisoning, Jane held and cradled her young son. Within one summer the entire Davis family was dead and buried. Jane later said of one of the Davis burials, "I went to the funeral and felt as jolly as could be," adding, "and nobody suspected me in the least." But some people were in fact suspicious of the sudden deaths, including Captain Gibbs, Minnie's father-in-law, who had just visited her and seen that she was well.

Jane was unraveling and she was getting sloppy. Her next move was to visit her widowed brother-in-law, Oramel Brigham, to enact the most awkward, unwanted, and unsuccessful seduction in history. She had decided she wanted the bald sixty-year-old church deacon to marry her, perhaps in a final effort to take everything from Elizabeth that she had so envied. She had poisoned his wife and his housekeeper already, but when Jane showed up at his home she was surprised to find his seventy-seven-year-old sister, Edna Bannister, there with him. Even though she posed no romantic threat, the increasingly warped Jane felt she had to go. In Peter Vronsky's book *Female Serial Killers: How and Why Women Become Monsters*, he quotes Jane as saying, "Everything seemed favorable for my marrying Mr. Brigham. I had put the three women to death who had stood in the way."

When killing everyone around him didn't seem to work, Jane attempted other strategies. But all she knew how to do was cause harm. First, she tried poisoning him, to make him ill so he would need her. Then she tried blackmailing him, threatening to spread a rumor that he fathered her (fictitious) child. When that didn't work, Jane poisoned herself to gain his pity. He sent for a doctor to treat her, and then had the good sense to kick her out of his home. Having failed miserably, Jane decided to get out of town and visit her friend Sarah Nichols.

It was during her time with the Nichols family that the investigation into the demise of the Davises began in Cataumet. Minnie and Genevieve's bodies were exhumed and tested by a doctor from Harvard, Edward Wood. Initially, he incorrectly stated that the women were poisoned with arsenic. (The embalmer had used an arsenic-based process, and Jane had used two quite unusual poisons.) Sometime later the doctor identified the presence of morphine and atropine in their bodies, and more exhumations were called for. Jane was arrested at her friend's house. It was in just the nick of time

for the Nichols family; Jane was contemplating poisoning them too.

Initially, she ardently denied having anything to do with the deaths. The November 10, 1901, issue of the *St. Louis Post-Dispatch* quoted her as saying, "Each of the people who died I knew personally and was on friendly terms with. I would not kill a chicken." The press had a field day with the forty-five-year-old spinster nurse with the cheery personality facing murder charges. A panel of psychiatrists were arranged to interview her. It was then that Jane calmly confessed to a dozen murders. She was found to be "morally insane," what we would now call a psychopath. Her guilt in the homicides was not up for debate at her trial. That was known. It was a question of whether or not she was sane enough to be criminally responsible for her actions. The jury decided that she wasn't, and Jane Toppan was sentenced to live out the rest of her days in the Taunton Insane Hospital.

After the trial, she confided to her lawyer that she thought she was responsible for thirty-one murders. Many sources speculate the real number is much higher, closer to one hundred victims in all. Originally Jane quite liked life in the mental hospital, but as time went on she became paranoid. In a delicious ironic twist, she became obsessed with a fear that the staff was trying to poison her—talk about karma. According to one story, toward the end of her life Jane waved over one of the nurses in the mental hospital, saying, "Get the morphine, dearie, and we'll go out into the ward. You and I will have a lot of fun seeing them die." She remained there until her own death in 1934 at around the age of eighty-one.

Jane Toppan was likely a remorseless psychopath who took pleasure in the pain of others. She also tried on every motivation explored in this book. She wanted to escape her difficult childhood and refashion her identity, and she profited financially from her many petty thefts during her decade-long career. Jane also relished the power she enjoyed over her victims, and she committed murder to get revenge on her foster sister, Elizabeth. Jane wanted to experience the love and admiration of a family and a husband, but instead she is remembered as one of the most prolific—and heartless—female serial killers in history.

IN THE RIGHT HANDS, LOVE AND OBSESSION CAN INSPIRE GREAT WORKS OF art and literature, but in the calculated palms of a poisoner, it only results in mayhem and misery. Nannie Doss's endless pursuit of the perfect husband took four men to their graves, and Christiana Edmunds's obsession with a married man nearly destroyed a town. Louisa Collins's efforts to be with her lover sparked a debate about gender roles and capital punishment, and Jane Toppan's love affair with poison made her one of the most ruthless female serial killers in history. Wedding vows traditionally involve couples taking each other in sickness and in health, till death do they part—but poisoners create sickness and invite death whenever it suits them. Poison is the opposite of love: pure destruction.

Acknowledgments

THIS BOOK WOULD NOT HAVE BEEN POSSIBLE WITHOUT THE HELP AND SUPPORT of many. I owe particular gratitude to my friend Sara Barnes, who sent me an article on Giulia Tofana some years ago and said, "You should do something with this." Sara provided much emotional support as well. I also want to thank Natalie Butterfield, my editor, who heard my pitch and immediately believed in it and me. I could not have asked for a better aesthetic collaborator than the book's designer, Kayla Ferriera, who understood my vision and helped my lush visual goals come true. Additional thanks are due to Sharron Wood, who rigorously copyedited and fact-checked my manuscript. Special thanks to my brother, Marc Perrin, for his insights and feedback throughout the writing process. I also want to thank my readers Alyssa Eckles and Emily Bamforth for their brilliant comments. Thank you to Martha Ericson and Priyanka Kumar for their guidance. Many thanks to my colleagues and students at the Maryland Institute College of Art for their touching enthusiasm and support. The librarians at the Decker Library, Enoch Pratt libraries, and the Johns Hopkins University libraries were a great help as I conducted my research. And I would be remiss if I didn't thank the brilliant authors and historians referenced throughout this book, from whom I learned so much.

SOURCES

INTRODUCTION

Blum, Deborah. "The Imperfect Myth of the Female Poisoner." *Wired,* January 28, 2013. https://www.wired.com/2013/01/the-myth-of-the-female-poisoner.

"Global Study on Homicide, 2019 Edition." United Nations, Office on Drugs and Crime, 2019. https://www.unodc.org/unodc/en/data-and-analysis/global-study-on-homicide.html.

Gross, Hans. *Criminal Psychology,* 1898. Quoted in Susanne Kord, "The Female Self: Poisoners," in *Murderesses in German Writing, 1720–1860: Heroines of Horror*, 154. Cambridge: Cambridge University Press, 2013.

Jones, Ann. *Women Who Kill*. New York: Feminist Press, 2009.

Keating, Dan. "The Weapons Men and Women Most Often Use to Kill." *Washington Post*, November 7, 2015. https://www.washingtonpost.com/news/wonk/wp/2015/05/07/poison-is-a-womans-weapon.

Koushik, Sarang. "Why Internet Craze the 'Tide Pod Challenge' Is Dangerous, Potentially Deadly." ABC News, January 16, 2018. https://abcnews.go.com/Health/internet-craze-tide-pod-challenge-dangerous-potentially-deadly/story?id=52379523.

Latson, Jennifer. "How Agatha Christie Became an Expert on Poison." *Time*, September 15, 2015. https://time.com/4029233/agatha-christie-poison.

Matthews David, Alison. *Fashion Victims: The Dangers of Dress Past and Present*. London: Bloomsbury, 2015.

Mekonnen, Serkalem. "Daffodils—Beautiful but Potentially Toxic." Poison Control, National Capital Poison Center. Accessed May 21, 2021. https://www.poison.org/articles/daffodils.

Petruzzello, Melissa. "Can Apple Seeds Kill You?" Encyclopædia Britannica. Accessed May 19, 2021. https://www.britannica.com/story/can-apple-seeds-kill-you.

Scot, Reginald. *The Discoverie of Witchcraft*. London: Andrew Clark, 1665. https://quod.lib.umich.edu/e/eebo/A62397.0001.001/1:12.3?rgn=div2;view=fulltext.

Trestrail, John Harris. *Criminal Poisoning Investigational Guide for Law Enforcement, Toxicologists, Forensic Scientists, and Attorneys*. Totowa, NJ: Humana Press, 2000.

Watson, Katherine. *Poisoned Lives: English Poisoners and Their Victims*. London: Hambledon Continuum, 2004.

Watson, Thomas. "When She Kills a Woman Chooses Poison." *Tacoma (WA) News Tribune*, June 18, 1939.

Whorton, James C. *The Arsenic Century: How Victorian Britain Was Poisoned at Home, Work, and Play*. Oxford: Oxford University Press, 2010.

POISON PRIMER

TOXIC TIMELINE

Barrell, Helen. "Poison Panic & The History of Arsenic." Historic UK. Accessed December 9, 2022. https://www.historic-uk.com/HistoryUK/HistoryofBritain/Poison-Panic.

Blum, Deborah. *The Poisoner's Handbook: Murder and the Birth of Forensic Medicine in Jazz Age New York*. New York: Penguin Books, 2011.

Burnham, Paul M. "Strychnine." Strychnine – Molecule of the Month, October 2009. http://www.chm.bris.ac.uk/motm/strychnine/strychnineh.html.

"Certifying Forensic Toxicologists since 1975." American Board of Forensic Toxicology. Accessed December 9, 2022. https://www.abft.org.

Cilliers, L., and F. P. Retief. "Poisons, Poisoning and the Drug Trade in Ancient Rome." *Akroterion* 45 (2014). https://doi.org/10.7445/45-0-166.

Davis, Jenni. *Poison, a History: An Account of the Deadly Art & Its Most Infamous Practitioners*. New York: Chartwell Books, 2018.

Edwards, Steven A. "Paracelsus, the Man Who Brought Chemistry to Medicine." American Association for the Advancement of Science (AAAS), March 1, 2012. https://www.aaas.org/paracelsus-man-who-brought-chemistry-medicine.

Emsley, John. *The Elements of Murder: A History of Poison*. Oxford: Oxford University Press, 2005.

Frith, John. "Arsenic – the 'Poison of Kings' and the 'Saviour of Syphilis.'" *Journal of Military and Veterans' Health*. Accessed December 9, 2022. https://jmvh.org/article/arsenic-the-poison-of-kings-and-the-saviour-of-syphilis.

Hawksley, Lucinda. *Bitten by Witch Fever: Wallpaper & Arsenic in the Victorian Home*. London: Thames & Hudson, 2016.

Hempel, Sandra. *The Inheritor's Powder: A Tale of Arsenic, Murder, and the New Forensic Science.* New York: W. W. Norton & Company, 2013.

Herman, Eleanor. *The Royal Art of Poison: Filthy Palaces, Fatal Cosmetics, Deadly Medicine, and Murder Most Foul.* New York: St. Martin's Press, 2018.

Hubbard, Ben. *Poison: The History of Potions, Powders and Murderous Practitioners.* London: Welbeck Publishing, 2020.

Hyden, Marc. "Mithridates' Poison Elixir: Fact or Fiction?" World History Encyclopedia. https://www.worldhistory.org#organization, June 2, 2016. https://www.worldhistory.org/article/906/mithridates-poison-elixir-fact-or-fiction.

"Insurance, Philadelphia and ISOP: A Shared History and Vision." Insurance Society of Philadelphia. Accessed December 9, 2022. https://www.insurancesociety.org/page/History.

Johnston, Matthew. "Anniversary of the Pharmacy Act: 150 Years of Medicines Safety." The Pharmaceutical Journal, August 1, 2018. https://pharmaceutical-journal.com/article/news/anniversary-of-the-pharmacy-act-150-years-of-medicines-safety.

Kaufman, David B. "Poisons and Poisoning among the Romans." *Classical Philology* 27, no. 2 (1932): 156–67. https://doi.org/10.1086/361458.

Matthews David, Alison. *Fashion Victims: The Dangers of Dress Past and Present.* London: Bloomsbury, 2015.

"Medicinal Botany." US Forest Service. United States Department of Agriculture. Accessed December 9, 2022. https://www.fs.usda.gov/wildflowers/ethnobotany/medicinal.

Newman, Cathy. "Toxic Tales Article, Poison Information, Toxicology Facts." Science. *National Geographic*, May 3, 2021. https://www.nationalgeographic.com/science/article/poison-toxic-tales.

Nugent-Head, JulieAnn. "The First Materia Medica: The Shen Nong Ben Cao Jing." *The Journal of Chinese Medicine*, no. 104 (February 2014): 22–26. https://www.thealternativeclinic.org/wp-content/uploads/2020/03/The-First-Materia-Medica-The-Shen-Nong-Ben-Cao-Jing.pdf.

Parascandola, John. *King of Poisons: A History of Arsenic.* Washington, DC: Potomac Books, 2012.

"Part II: 1938, Food, Drug, Cosmetic Act." U.S. Food and Drug Administration. FDA, November 27, 2018. https://www.fda.gov/about-fda/changes-science-law-and-regulatory-authorities/part-ii-1938-food-drug-cosmetic-act#:~:text=FDR%20signed%20the%20Food%2C%20Drug,adequate%20directions%20for%20safe%20use.

"Poisons – Timeline." Science Learning Hub, September 4, 2012. https://www.sciencelearn.org.nz/resources/1904-poisons-timeline.

Rosner F. Moses Maimonides' Treatise on Poisons. *JAMA.* 205, no. 13 (1968): 914–16. doi:10.1001/jama.1968.03140390038010.

Smith, Roger. "Arsenic: A Murderous History." Dartmouth Toxic Metals. Accessed December 9, 2022. https://sites.dartmouth.edu/toxmetal/arsenic /arsenic-a-murderous-history.

Trestrail, John Harris. *Criminal Poisoning Investigational Guide for Law Enforcement, Toxicologists, Forensic Scientists, and Attorneys*. Totowa, NJ: Humana Press, 2000.

"Visible Proofs: Forensic Views of the Body: Galleries: Biographies: Mathieu Joseph Bonaventure Orfila (1787–1853)." U.S. National Library of Medicine. National Institutes of Health, February 16, 2006. https://www.nlm.nih.gov/exhibition /visibleproofs/galleries/biographies/orfila.html.

Whorton, James C. *The Arsenic Century: How Victorian Britain Was Poisoned at Home, Work, and Play*. Oxford: Oxford University Press, 2010.

Zawacki, Alexander J. "How a Library Handles a Rare and Deadly Book of Wallpaper Samples." Atlas Obscura, January 23, 2018. https://www.atlasobscura.com /articles/shadows-from-the-walls-of-death-book.

POISONOUS PLANTS

Brown, Michael. *Death in the Garden: Poisonous Plants and Their Use throughout History*. Havertown, PA: White Owl, 2018.

"Chemical Emergencies." Centers for Disease Control and Prevention. https://www .cdc.gov/chemicalemergencies/index.html.

Farrell, Michael. *Criminology of Serial Poisoners*. Cham, Switzerland: Springer International Publishing, 2018.

Forest Service, U.S. Department of Agriculture. https://www.fs.usda.gov.

Inkwright, Fez. *Botanical Curses and Poisons: The Shadow-Lives of Plants*. London: Liminal 11, 2021.

Mellan, Eleanor, and Ibert Mellan. *Dictionary of Poisons*. New York: Philosophical Library, 1956.

Poison Control, National Capital Poison Center. https://www.poison.org.

Stewart, Amy. *Wicked Plants: The Weed That Killed Lincoln's Mother and Other Botanical Atrocities*. Chapel Hill, NC: Algonquin Books, 2009.

Tornio, Stacy. *Plants That Can Kill: 101 Toxic Species to Make You Think Twice*. New York: Skyhorse Publishing, 2017.

Warner, Mallory. "The Power of the Poppy: Exploring Opium through 'The Wizard of Oz.'" National Museum of American History, November 9, 2016. https://americanhistory.si.edu/blog/opium-through-wizard-oz.

POISONOUS AND VENOMOUS ANIMALS

"The Biological Effects, Including Lethal Toxic Ingestion, Caused by Cane Toads (*Bufo marinus*)." Australian Government, Department of Climate Change, Energy, the Environment and Water, April 12, 2005. https://www.awe. gov.au/environment/biodiversity/threatened/key-threatening-processes /biological-effects-cane-toads.

Bonn, Scott A. "'Black Widows' and Other Female Serial Killers." *Psychology Today,* November 23, 2015. https://www.psychologytoday.com/us/blog/wicked-deeds/201511/black-widows-and-other-female-serial-killers.

Borke, Jesse, and David Zieve, eds. "Black Widow Spider." Mount Sinai Health System, July 20, 2021. https://www.mountsinai.org/health-library/poison/black-widow-spider.

Bücherl, Wolfgang, Eleanor E. Buckley, and Venancio Deulofeu. *Venomous Vertebrates.* Vol. 1 of *Venomous Animals and Their Venoms.* New York: Academic Press, 1968.

Buehler, Jake. "What's the Difference between a Poisonous and Venomous Animal?" *National Geographic,* January 7, 2020. https://www.nationalgeographic.com/animals/article/venomous-poisonous-snakes-toxins.

"Cane Toad: *Rhinella marina.*" Florida Fish and Wildlife Conservation Commission. Accessed March 5, 2022. https://myfwc.com/wildlifehabitats/profiles/amphibians/cane-toad.

Gould Soloway, Rose Ann. "Black Widow Spider Bites Can Be Dangerous." Black Widow Spiders. Poison Control, National Capital Poison Center. Accessed February 11, 2022. https://www.poison.org/articles/black-widow-spiders.

Helmenstine, Anne Marie. "'Indian Red Scorpion Facts." ThoughtCo, August 8, 2019. https://www.thoughtco.com/indian-red-scorpion-4766814.

"King Cobra." Smithsonian's National Zoo and Conservation Biology Institute, August 20, 2018. https://nationalzoo.si.edu/animals/king-cobra.

Mekonnen, Serkalem. "Blister Beetles: Do Not Touch!" Poison Control, National Capital Poison Center. Accessed April 29, 2022. https://www.poison.org/articles/blister-beetles-do-not-touch-194.

Mellan, Eleanor, and Ibert Mellan. *Dictionary of Poisons.* New York: Philosophical Library, 1956.

Moed, Lisa, Tor A. Shwayder, and Mary Wu Chang. "Cantharidin Revisited: A Blistering Defense of an Ancient Medicine." *Archives of Dermatology* 137, no. 10 (2001): 1357–60. https://doi.org/10.1001/archderm.137.10.1357.

Witkop, Bernhard. "Poisonous Animals and Their Venoms." *Journal of the Washington Academy of Sciences* 55, no. 3 (1965): 53–60. http://www.jstor.org/stable/24535517.

POISONOUS ELEMENTS AND CHEMICALS

Emsley, John. *The Elements of Murder: A History of Poison.* Oxford: Oxford University Press, 2005.

"Facts about Cyanide." Centers for Disease Control and Prevention, April 4, 2018. https://emergency.cdc.gov/agent/cyanide/basics/facts.asp.

"The Facts about Cyanides." Department of Health, New York State. Accessed February 4, 2022. https://www.health.ny.gov/environmental/emergency/chemical_terrorism/cyanide_general.htm.

Farrell, Michael. *Criminology of Serial Poisoners.* Cham, Switzerland: Springer International Publishing, 2018.

Hawksley, Lucinda. *Bitten by Witch Fever: Wallpaper & Arsenic in the Victorian Home*. London: Thames & Hudson, 2016.

"Health Effects of Exposures to Mercury." Environmental Protection Agency. Accessed January 10, 2022. https://www.epa.gov/mercury/health-effects-exposures-mercury.

Herman, Eleanor. *The Royal Art of Poison: Filthy Palaces, Fatal Cosmetics, Deadly Medicine, and Murder Most Foul*. New York: St. Martin's Press, 2018.

Hubbard, Ben. *Poison: The History of Potions, Powders and Murderous Practitioners*. London: Welbeck Publishing, 2020.

"Learn about Lead." Environmental Protection Agency. Accessed January 9, 2022. https://www.epa.gov/lead/learn-about-lead.

Matthews David, Alison. *Fashion Victims: The Dangers of Dress Past and Present*. London: Bloomsbury, 2015.

The National Institute for Occupational Safety and Health (NIOSH). "Thallium: Systemic Agent." Centers for Disease Control and Prevention, May 12, 2011. https://www.cdc.gov/niosh/ershdb/emergencyresponsecard_29750026.html.

National Research Council, Committee on Medical and Biological Effects of Environmental Pollutants. *Arsenic: Medical and Biologic Effects of Environmental Pollutants*. Washington, DC: The National Academies Press, 1977. https://doi.org/10.17226/9003.

"The Poisoner in the House." *Leader* (London, England), December 15, 1855.

Trestrail, John Harris. *Criminal Poisoning Investigational Guide for Law Enforcement, Toxicologists, Forensic Scientists, and Attorneys*. Totowa, NJ: Humana Press, 2000.

Whorton, James C. *The Arsenic Century: How Victorian Britain Was Poisoned at Home, Work, and Play*. Oxford: Oxford University Press, 2010.

CHAPTER ONE
PROFESSIONAL POISONERS

INTRODUCTION

Kaufman, David B. "Poisons and Poisoning among the Romans." *Classical Philology* 27, no. 2 (1932): 156–67. https://doi.org/10.1086/361458.

Reis, Elizabeth. *Damned Women: Sinners and Witches in Puritan New England*. Ithaca, NY: Cornell University Press, 1997. http://www.jstor.org/stable/10.7591/j.ctt1rv61zm.

LOCUSTA

Cilliers, L., and F. P. Retief. "Poisons, Poisoning and the Drug Trade in Ancient Rome." *Akroterion* 45 (2014). https://doi.org/10.7445/45-0-166.

Juvenal. "VI." In *The Satires of Juvenal*, translated by Charles Badham. London: A. J. Valpy, 1814. https://lccn.loc.gov/41030935.

Kaufman, David B. "Poisons and Poisoning among the Romans." *Classical Philology* 27, no. 2 (1932): 156–67. https://doi.org/10.1086/361458.

Ramsland, Katherine M. "The Darkest Ages." In *The Human Predator: A Historical Chronicle of Serial Murder and Forensic Investigation*, 4–6. New York: Berkley Books, 2007.

Tacitus, Cornelius. *The Annals of Tacitus*, Books XII and XIII. London: Methuen & Co., 1939.

CATHERINE MONVOISIN

Duramy, Benedetta Faedi. "Women and Poisons in 17th Century France." *Chicago-Kent Law Review* 87, no. 2 (April 2012).

Herman, Eleanor. *The Royal Art of Poison: Filthy Palaces, Fatal Cosmetics, Deadly Medicine, and Murder Most Foul*. New York: St. Martin's Press, 2018.

Somerset, Anne. *The Affair of the Poisons: Murder, Infanticide, and Satanism at the Court of Louis XIV*. New York: St. Martin's Press, 2004.

GIULIA TOFANA

Dash, Mike. "Aqua Tofana." In *Toxicology in the Middle Ages and Renaissance*, edited by Philip Wexler, 63–69. London: Academic Press, 2017.

Dash, Mike. "Aqua Tofana: Slow-Poisoning and Husband-Killing in 17th Century Italy." A Blast from the Past, April 6, 2015. https://mikedashhistory.com/2015/04/06/aqua-tofana-slow-poisoning-and-husband-killing-in-17th-century-italy.

Elhassan, Khalid. "History's Most Prolific and Deadly Female Poisoner Helped Women Get Rid of Their Husbands." History Collection, April 18, 2019. https://historycollection.com/historys-most-prolific-and-deadly-female-poisoner-helped-women-get-rid-of-their-husbands.

Herman, Eleanor. *The Royal Art of Poison: Filthy Palaces, Fatal Cosmetics, Deadly Medicine, and Murder Most Foul*. New York: St. Martin's Press, 2018.

Hubbard, Ben. *Poison: The History of Potions, Powders and Murderous Practitioners*. London: Welbeck Publishing, 2020.

ANA DRAKŠIN

"Accuse 92-Year-Old Herb Doctor of Prescribing Potions for Wives Who Sought to Get Rid of Their Aged Husbands." *Brooklyn (NY) Daily Eagle*, June 30, 1929.

"Aged Love Poisoner May Have Killed 60. Claims 'Love Potions' Were Given as Tonics." *Angola (NY) Record*, August 8, 1929.

"Aged Woman in Jugoslav Poison Plot. Score of Wealthy Husbands Cleverly Disposed of by Relatives. 'Witch' Supplies Peasant Women with 'Magic Water' for a Price." *Honolulu Star-Bulletin*, August 2, 1928.

VISHA KANYA

Jamshedji Modi, Jivanji. "The Vish-Kanyâ or Poison-Damsels of Ancient India, Illustrated by the Story of Susan Râmashgar in the Persian Bur. Zo-Nâmeh." *Folklore* 38, no. 4 (1927): 324–37. https://doi.org/10.1080/00155 87x.1927.9716754.

Penzer, Norman Mosley. *Poison-Damsels and Other Essays in Folklore and Anthropology.* London: Privately Printed for Chas. J. Sawyer, 1952. https://archive.org/details/McGillLibrary-rbsc_poison-damsels_OCTAVO-6550-17777/page/n5/mode/2up.

Wujastyk, Dominik. *The Roots of Ayurveda: Selections from Sanskrit Medical Writings.* London: Penguin, 2003.

CHAPTER TWO

ESCAPE AND DEFIANCE

INTRODUCTION

Jensen, Vickie, ed. *Women Criminals: An Encyclopedia of People and Issues.* Santa Barbara, CA: ABC-CLIO, 2012.

Thistlethwaite, Susan Brooks. *Women's Bodies as Battlefield: Christian Theology and the Global War on Women.* New York: Palgrave Macmillan, 2015.

ANGEL MAKERS OF NAGYRÉV

Bodó, Béla. *Tiszazug: A Social History of a Murder Epidemic.* Boulder, CO: East European Monographs, 2002.

Bussink, Astrid, director. *The Angelmakers.* SZFE Budapest, Edinburgh College of Art, 2005.

Telfer, Tori. *Lady Killers: Deadly Women throughout History.* New York: Harper Perennial, 2017.

SALLY BASSETT

Crowther, Kathleen. "Poison and Protest: Sarah Bassett and Enslaved Women Poisoners in the Early Modern Caribbean." Nursing Clio, March 1, 2018. https://nursingclio.org/2018/03/01/poison-and-protest-sarah-bassett-and-enslaved-women-poisoners-in-the-early-modern-caribbean.

Maxwell, Clarence V. H. "'The Horrid Villainy': Sarah Bassett and the Poisoning Conspiracies in Bermuda, 1727–30." *Slavery & Abolition* 21, no. 3 (2000): 48–74. https://doi.org/10.1080/01440390008575320.

Swan, Quito. "Smoldering Memories and Burning Questions: The Politics of Remembering Sally Bassett and Slavery in Bermuda." In *Politics of Memory: Making Slavery Visible in the Public Space*, edited by Ana Lucia Araujo, 71–91. New York: Routledge, 2012.

CLEOPATRA

Draycott, Jane. "Cleopatra's Daughter." *History Today*, May 22, 2018. https://www
.historytoday.com/miscellanies/cleopatras-daughter.

Hubbard, Ben. *Poison: The History of Potions, Powders and Murderous Practitioners*.
London: Welbeck Publishing, 2020.

Lorenzi, Rossella. "Cleopatra Killed by Drug Cocktail?" NBCNews.com, July 1, 2010.
https://www.nbcnews.com/id/wbna38036040.

Retief, F. P., and L. Cilliers. "The Death of Cleopatra." *Acta Theologica* 26, no. 2 (2006).
https://doi.org/10.4314/actat.v26i2.52563.

Schiff, Stacy. *Cleopatra: A Life*. New York : Little, Brown and Company, 2010.

MARIE LAFARGE

Bertomeu-Sánchez, José Ramón. "Managing Uncertainty in the Academy and the
Courtroom: Normal Arsenic and Nineteenth-Century Toxicology." *Isis* 104, no. 2
(2013): 197–225. https://doi.org/10.1086/670945.

Downing, Lisa. "Murder in the Feminine: Marie Lafarge and the Sexualization of the
Nineteenth-Century Criminal Woman." *Journal of the History of Sexuality* 18, no.
1 (2009): 121–37. http://www.jstor.org/stable/20542721.

Hempel, Sandra. *The Inheritor's Powder: A Tale of Arsenic of Nagyrév, Murder, and
the New Forensic Science*. New York: W. W. Norton & Company, 2013.

Levine, Philippa. "'So Few Prizes and So Many Blanks': Marriage and Feminism in
Later Nineteenth-Century England." *Journal of British Studies* 28, no. 2 (1989):
150–74. http://www.jstor.org/stable/175593.

CHAPTER THREE
MONEY AND GREED

INTRODUCTION

Bonn, Scott A. "'Black Widows' and Other Female Serial Killers." *Psychology
Today*, November 23, 2015. https://www.psychologytoday.com/us/blog
/wicked-deeds/201511/black-widows-and-other-female-serial-killers.

MARY ANN COTTON

Connolly, Martin. *Mary Ann Cotton, Dark Angel: Britain's First Female Serial Killer*.
Barnsley, England: Pen & Sword History, 2016.

Davis, Jenni. *Poison, a History: An Account of the Deadly Art & Its Most Infamous
Practitioners*. New York: Chartwell Books, 2018.

"The Great Poisoning Case; Execution of Mary Ann Cotton." *Courier and Argus*
(Dundee, Tayside, Scotland), March 25, 1873.

Hubbard, Ben. *Poison: The History of Potions, Powders and Murderous Practitioners*.
London: Welbeck Publishing, 2020.

Telfer, Tori. *Lady Killers: Deadly Women throughout History*. New York: Harper Perennial, 2017.

BELLE GUNNESS

Cipriani, Frank. "Madam Bluebeard! The Crimes of Belle Gunness of Indiana's Murder Farm." *Chicago Tribune*, April 12, 1936.

De la Torre, Lillian. *The Truth about Belle Gunness: The True Story of Notorious Serial Killer Hell's Belle*. New York: MysteriousPress.com/Open Road, 2017.

Schechter, Harold. *Hell's Princess: The Mystery of Belle Gunness, Butcher of Men*. New York: Little A, 2018.

ROBERTA ELDER

"Evidence Barred in Mrs. Elder's Trial." *Atlanta Daily World*, September 30, 1953.

Fowlkes, William A. "Atlanta's Mrs. Bluebeard: The Strange Case of Roberta Elder!" Four-part weekly series, *Pittsburgh Courier,* August 28 to September 18, 1954.

"Indict Mrs. Elder on Three Murder Charges." *Chicago Defender*, March 21, 1953.

Lynn, Denise. "Roberta Elder: The Case of a Black Woman Serial Killer." The African American Intellectual History Society (AAIHS), May 28, 2019. https://www.aaihs.org/roberta-elder-the-case-of-a-black-woman-serial-killer.

Rhodes, David. "Can Eating More Than Six Bananas at Once Kill You?" BBC News, September 12, 2015. https://www.bbc.com/news/magazine-34225517.

ANNA MARIE HAHN

Franklin, Diana Britt. *The Good-Bye Door: The Incredible True Story of America's First Female Serial Killer to Die in the Chair*. Kent, OH: Kent State University Press, 2006.

Garretson, Joseph. "'Isn't There Anybody Who Will Help Me?' Mrs. Hahn Asked." *Cincinnati Enquirer*, December 8, 1938.

"Ohio's Hahn 'Just an Evil Person.'" WOSU 89.7, NPR News, September 18, 2006. https://news.wosu.org/news/2006-09-18/ohios-hahn-just-an-evil-person.

Telfer, Tori. *Lady Killers: Deadly Women throughout History*. New York: Harper Perennial, 2017.

AMY ARCHER-GILLIGAN

Ermenc, Christine. "Amy Archer-Gilligan: Entrepreneurism Gone Wrong in Windsor." Windsor Historical Society, July 16, 2018. https://windsorhistoricalsociety.org/amy-archer-gilligan-entrepreneurism-gone-wrong-in-windsor.

McEnroe, Colin. "'Arsenic' Play Immortalized an Unlikely Femme Fatale." *Hartford (CT) Courant*, January 30, 2000.

Phelps, M. William. *The Devil's Rooming House: The True Story of America's Deadliest Female Serial Killer*. Guilford, CT: Lyons Press, 2011.

YIYA MURANO

Benson, Ana, and Richard Poche. *Swindlers & Killers: An Anthology of True Crime.*
 Duluth, MN: Trellis Publishing, 2021.

Murano, Martín. *Mi Madre, Yiya Murano.* Buenos Aires, Argentina: Planeta, 2016.

"'Yiya' Murano mató a tres amigas para no pagarles deudas: Hace veinte años
 condenaban a la 'Envenenadora de Monserrat.'" *Clarín,* June 28, 2005.
 https://www.clarin.com/ediciones-anteriores/hace-veinte-anos-condenaban-
 envenenadora-monserrat_0_Hk7GWtd1oYl.html.

CHAPTER FOUR
POWER AND POLITICS

INTRODUCTION

Herman, Eleanor. *The Royal Art of Poison: Filthy Palaces, Fatal Cosmetics, Deadly
 Medicine, and Murder Most Foul.* New York: St. Martin's Press, 2018.

Hubbard, Ben. *Poison: The History of Potions, Powders and Murderous Practitioners.*
 London: Welbeck Publishing, 2020.

Karamanou, Marianna, George Androutsos, A. Wallace Hayes, and Aristides
 Tsatsakis. "Toxicology in the Borgias Period: The Mystery of *Cantarella*
 Poison." *Toxicology Research and Application* 2 (2018). https://doi
 .org/10.1177/2397847318771126.

LUCREZIA BORGIA

Bradford, Sarah. *Lucrezia Borgia: Life, Love, and Death in Renaissance Italy.* London:
 Penguin, 2005.

Karamanou, Marianna, George Androutsos, A. Wallace Hayes, and Aristides
 Tsatsakis. "Toxicology in the Borgias Period: The Mystery of *Cantarella*
 Poison." *Toxicology Research and Application* 2 (2018). https://doi
 .org/10.1177/2397847318771126.

Lee, Alexander. "Were the Borgias Really So Bad?" *History Today,* October 1, 2013.
 https://www.historytoday.com/history-matters/were-borgias-really-so-bad.

Retief, F. P., and L. Cilliers. "Poisoning during the Renaissance: The Medicis and the
 Borgias." *Southern African Journal of Medieval and Renaissance Studies* (2020).

EMPRESS WU ZETIAN

Clements, Jonathan. *Wu: The Chinese Empress Who Schemed, Seduced and Murdered
 Her Way to Become a Living God.* London: Albert Bridge Books, 2014.

Dash, Mike. "The Demonization of Empress Wu." *Smithsonian Magazine,*
 August 10, 2012. https://www.smithsonianmag.com/history
 /the-demonization-of-empress-wu-20743091.

Lee, Yuen Ting. "Wu Zhao: Ruler of Tang Dynasty China." *Education about Asia* 20,
no. 2 (2015): 14–18. https://www.asianstudies.org/publications/eaa/archives
/wu-zhao-ruler-of-tang-dynasty-china.

Woo, X. L. *Empress Wu the Great: Tang Dynasty China*. New York: Algora, 2008.

QUEEN RANAVALONA I

Campbell, Gwyn. *An Economic History of Imperial Madagascar, 1750–1895: The Rise
and Fall of an Island Empire*. Cambridge: Cambridge University Press, 2005.

Chernock, Arianne. "Queen Victoria and the 'Bloody Mary of Madagascar.'"
Victorian Studies 55, no. 3 (2013): 425–49. https://doi.org/10.2979
/victorianstudies.55.3.425.

Ellis, Stephen. "Witch-Hunting in Central Madagascar 1828–1861." *Past & Present*, no.
175 (2002): 90–123. http://www.jstor.org/stable/3600769.

Laidler, Keith. *Female Caligula: Ranavalona, the Mad Queen of Madagascar*.
Chichester, England: Wiley, 2005.

Robb, George L. "The Ordeal Poisons of Madagascar and Africa." *Botanical Museum
Leaflets, Harvard University* 17, no. 10 (1957): 265–316. http://www.jstor.org
/stable/41762174.

CATHERINE DE' MEDICI

Freida, Leonie. *Catherine de Medici: Renaissance Queen of France*. New York: Harper
Perennial, 2006.

Herman, Eleanor. *The Royal Art of Poison: Filthy Palaces, Fatal Cosmetics, Deadly
Medicine, and Murder Most Foul*. New York: St. Martin's Press, 2018.

Sutherland, N. M. "Catherine de Medici: The Legend of the Wicked Italian Queen."
Sixteenth Century Journal 9, no. 2 (1978): 45–56. https://doi.org/10.2307/2539662.

CHAPTER FIVE

ANGER AND REVENGE

INTRODUCTION

Watson, Katherine. *Poisoned Lives: English Poisoners and Their Victims*. London:
Hambledon Continuum, 2004.

MARQUISE DE BRINVILLIERS

Davis, Jenni. *Poison, a History: An Account of the Deadly Art & Its Most Infamous
Practitioners*. New York: Chartwell Books, 2018.

Duramy, Benedetta Faedi. "Women and Poisons in 17th Century France." *Chicago-
Kent Law Review* 87, no. 2 (April 2012).

Somerset, Anne. *The Affair of the Poisons: Murder, Infanticide, and Satanism at the
Court of Louis XIV*. New York: St. Martin's Press, 2004.

TILLIE KLIMEK

Davidson, Cara. *Black Widow Tillie Klimek*. Duluth, MN: Trellis Publishing, 2017.

Farrell, Amanda L., Robert D. Keppel, and Victoria B. Titterington. "Testing Existing Classifications of Serial Murder Considering Gender: An Exploratory Analysis of Solo Female Serial Murderers." *Journal of Investigative Psychology and Offender Profiling* 10, no. 3 (2013): 268–88. https://doi.org/10.1002/jip.1392.

Forbes, Genevieve. "'Guilty' Is Klimek Verdict." *Chicago Daily Tribune*, March 14, 1923.

"Hostess at Poison Banquet Gets Life for Her Crimes." *Daily News* (New York), July 5, 1925.

FRANCES HOWARD CARR

Emsley, John. *The Elements of Murder: A History of Poison*. Oxford: Oxford University Press, 2005.

Herman, Eleanor. *The Royal Art of Poison: Filthy Palaces, Fatal Cosmetics, Deadly Medicine, and Murder Most Foul*. New York: St. Martin's Press, 2018.

Lindley, David. *The Trials of Frances Howard: Fact and Fiction at the Court of King James*. Abingdon, England: Taylor and Francis, 1993.

GU POISONERS

Asper, Markus, ed. *Thinking in Cases: Ancient Greek and Imperial Chinese Case Narratives*. Vol. 11 of *Science, Technology, and Medicine in Ancient Cultures*. Boston: De Gruyter, 2020. https://doi.org/10.1515/9783110668957.

Diamond, Norma. "The Miao and Poison: Interactions on China's Southwest Frontier." *Ethnology* 27, no. 1 (1988): 1–25. https://doi.org/10.2307/3773558.

Hanson, Marta. *Speaking of Epidemics in Chinese Medicine: Disease and the Geographic Imagination in Late Imperial China*. New York: Routledge, 2011.

CHAPTER SIX

LOVE AND OBSESSION

INTRODUCTION

Plater, David, and Sue Milne. "'Assuredly There Never Was Murder More Foul and More Unnatural'? Poisoning, Women and Murder in 19th Century Australia." *Canterbury Law Review* 25 (2020): 53–94.

Watson, Katherine. *Poisoned Lives: English Poisoners and Their Victims*. London: Hambledon Continuum, 2004.

NANNIE DOSS

Davis, Jenni. *Poison, a History: An Account of the Deadly Art & Its Most Infamous Practitioners*. New York: Chartwell Books, 2018.

Green, Ryan. *Black Widow: The True Story of Giggling Granny Nannie Doss*. Self-published, 2019.

"Poisoner of 4 Husbands, Nannie Doss, Dies at 60." *South Bend (IN) Tribune*, June 3, 1965.

Ramsland, Katherine M. "The Darkest Ages." In *The Human Predator: A Historical Chronicle of Serial Murder and Forensic Investigation*, 4–6. New York: Berkley Books, 2007.

Rousek, Robert. "Nannie's Penchant for Poison May Have Set World Record." *Shreveport (LA) Times*, December 19, 1954.

CHRISTIANA EDMUNDS

Helfield, Randa. "Female Poisoners of the Nineteenth Century: A Study of Gender Bias in the Application of the Law." *Osgoode Hall Law Journal* 28, no. 1 (1990): 53–101.

Jones, Kaye. *The Case of the Chocolate Cream Killer: The Poisonous Passion of Christiana Edmunds*. Barnsley, England: Pen & Sword History, 2016.

Stratmann, Linda. *The Secret Poisoner: A Century of Murder*. New Haven, CT: Yale University Press, 2016.

LOUISA COLLINS

Cushing, Nancy. "Woman as Murderer: The Defence of Louisa Collins." *Journal of Interdisciplinary Gender Studies* 1, no. 2 (1996): 146–57.

Overington, Caroline. *Last Woman Hanged: The Terrible, True Story of Louisa Collins*. Sydney, Australia: HarperCollins Publishers Australia, 2014.

Sood, Suemedha. "Australia's Penal Colony Roots." BBC, January 26, 2012. https://www.bbc.com/travel/article/20120126-travelwise-australias-penal-colony-roots.

JANE TOPPAN

Bonn, Scott A. "'Black Widows' and Other Female Serial Killers." *Psychology Today*, November 23, 2015. https://www.psychologytoday.com/us/blog/wicked-deeds/201511/black-widows-and-other-female-serial-killers.

"Jane Toppan Will Plead Insanity as a Defense." *St. Louis Post-Dispatch*, November 10, 1901.

Schechter, Harold. *Fatal: The Poisonous Life of a Female Serial Killer*. New York: Pocket Star, 2003.

Schurman-Kauflin, Deborah. *The New Predator—Women Who Kill: Profiles of Female Serial Killers*. New York: Algora Publishing, 2000.

Vronsky, Peter. *Female Serial Killers: How and Why Women Become Monsters*. New York: Berkley Books, 2007.

INDEX

Tofana, Giulia, 11, 52–55, 56–57, 61, 63
Toppan, Ann, 182
Toppan, Jane, 181–86
Tour d'Auvergne, Madeleine de la, 135
Trestrail, John H., III, 117
Turner, Anne, 156, 157

V

Victoria (Queen of the United Kingdom), 134
Villiers, George, 157
Virgil, 62
Visconti, Primi, 49
Visha Kanya, 58–60, 61
Vronsky, Peter, 185

W

Wagner, Jacob, 105, 106
Wang (Empress of China), 127–28
Ward, George, 89
Watson, Katherine, 18, 142, 164
Watson, Thomas, 17
Wei (Empress of China), 129
Weston, Richard, 157
Whorton, James, 38
witches' gloves. *See* foxglove
Wolfe, Arthur, 110
wolfsbane, 32, 76
women
 disenfranchisement of, 63–64
 fear of, 18–20, 41–42, 161
 marriage and, 163–64, 171
 as poisoners, 16–18, 20–21, 161
 in positions of power, 119, 140
women's bane. *See* wolfsbane
Woo, X. L., 128
Wood, Edward, 185
Woodward, John, 101
Wujastyk, Dominik, 59

Wulffen, Erich, 17
Wu Shihou, 126
Wu Zetian (Empress of China), 125–29, 140

X

Xiao Liangdi, 127–28
Xu Chunfu, 159

Y

Yang, Lady, 126

Z

Zhongzong (Emperor of China), 128–29
Zulema, Carmen (Mema), 113, 114
Zulema, Diana, 114

PHOTO BY MICAH E. WOOD

Despite having written a book about poison, Lisa Perrin is a kind, friendly, and trustworthy person. Perrin is an award-winning illustrator and a professor at the Maryland Institute College of Art (MICA). Based in Baltimore, Perrin can often be found obsessively artmaking in the company of her beloved rabbit, Blanche DuBun. Her work explores the old world in a new way, combining humor with darkness and beauty with strangeness. This is her first book.

Foreword writers Holly Frey and Maria Trimarchi
are cohosts of *Criminalia*, a podcast that explores the
intersections of history and true crime. They first met
while writing and editing the curiosity-driven website
HowStuffWorks. Holly Frey is also the host of the pod-
casts *Stuff You Missed in History*, *Full of Sith*, and *Drawn:
The Story of Animation*. She lives in Georgia. Maria
Trimarchi is a writer based in Oregon.